PLASTIC CAMERAS

*To Ike Royer and Mary Ann Lynch
who harassed and inspired me in my
journey and made all of this possible.*

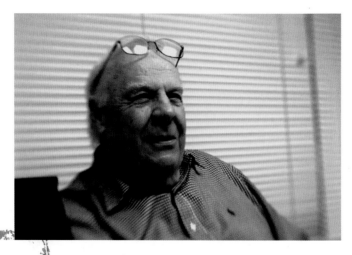

Ike Royer, 1932–2008, © Michelle Bates. Image of Ike made in his
office at Freestyle Photographic, with a Lensbaby lens on Nikon
DSLR.

PLASTIC CAMERAS

Toying with Creativity

Second Edition

Michelle Bates
Foreword by Mary Ann Lynch

ELSEVIER

Amsterdam • Boston • Heidelberg • London
New York • Oxford • Paris • San Diego
San Francisco • Singapore • Sydney • Tokyo

Focal Press is an imprint of Elsevier

Focal
Press

Contributing Editor: Mary Ann Lynch
Technical Editors: Frank Hamrick and Nic Nichols
Title page photo: *Coney Island*, © Michelle Bates, 1992.

Focal Press is an imprint of Elsevier
30 Corporate Drive, Suite 400, Burlington, MA 01803, USA
The Boulevard, Langford Lane, Kidlington, Oxford, OX5 1GB, UK

Second Edition, 2011

Library of Congress Cataloging-in-Publication Data
Application submitted.

British Library Cataloguing-in-Publication Data
A catalogue record for this book is available from the British Library.

ISBN: 978-0-240-81421-6

For information on all Focal Press publications
visit our website at www.elsevierdirect.com

11 12 13 14 5 4 3 2 1

Printed in China

Working together to grow
libraries in developing countries

www.elsevier.com | www.bookaid.org | www.sabre.org

ELSEVIER BOOK AID International Sabre Foundation

contents

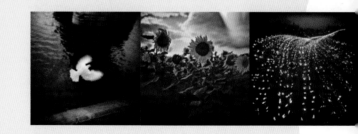

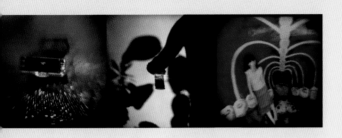

foreword

When a *New York Times* reporter asked Albert Einstein to comment upon one of his books, Einstein replied, "What I have to say about this book can be found inside the book." Unlike erudite texts aimed at academics, or handbooks that bombard the senses with visuals, *Plastic Cameras: Toying with Creativity* has as foundation the spirited voice of its author, photographer and plastic-camera evangelist, Michelle Bates. As for this New York-born, Seattle resident's unquenchable enthusiasm while leading the tour of the low-tech world—if at times it seems over the top, this can be forgiven. View it as a concession to the energy that drives her—that of the importance of play as a vital ingredient of both culture and creativity.

Once seduced by the unexpected delights of affordable, uncomplicated camera equipment, there's usually no forsaking it. Think of high-tech versus low-tech as the difference between piloting a jet aircraft and hang gliding: There can be times for both. Bates had a 35 mm camera in college and still uses both film and digital Nikons for certain assignments, but it was a Holga plastic camera, in 1991, that unleashed her passion for photography: Ultimately it led her away from her career as a bio technician, to become a fulltime photographer and teacher. Knowing that the parallel plastic subculture is still virgin land for many, Bates has made it her self-appointed mission to introduce others to the joy of using plastic cameras. In sharing her bliss, and even trade secrets, Bates offers an alternative to what she refers to as "those cultural tapes people have running in their heads about what makes a photograph good."

Those who pick up plastic and toy cameras are ready to push boundaries, disregard rules, experiment, intermingle low-tech and high-tech equipment and simultaneously move in both analog and digital worlds. Plastic camera images created as fine art and for other professional uses are widely embraced by photographers and educators, though no parallel critical attention has yet evolved. *Plastic Cameras* serves many audiences and uses by comprehensively covering both a wide range of imagery and cameras along with history, the diverse styles of profiled photographers, technical tips, and resources. It may also be a nudge to those who write about fine-art photography to seek out excellence within this realm, while considering the influence of that work upon the larger art world. This is fascinating territory ripe for exploration.

There's a second aspect to the appeal of these cameras, which accounts for the swelling numbers of their users: Communities form around them, and globally active ones at that. Unlike complicated equipment that can confound the brain and cost thousands of dollars, plastic cameras free up the spirit to let loose and play, to see what gifts the universe

may bestow. Those hungry for a social scene can find them in this subculture. Groups spring up overnight, blog, exchange images online, or arrange daylong shoot-ins and all-night screenings, such as those infamously held by the Lomographic community. If this book had a mantra, it would likely be "Let's toy with creativity."

As for those photographers not seeking communities, but working with plastic cameras for fine art and professional uses, in 2008 Holga Limited created the *Holga Inspire* initiative, sponsoring traveling exhibits of works by selected photographers to educate the public on artistic possibilities using their cameras. Moreover, in dire economic times, what could be better news than the existence of affordable cameras, whatever their intended use? In many areas, this includes teaching photography to children. The influence and appeal of toy cameras is also spreading to other realms.

Plastic Cameras: Toying with Creativity, when first published in 2006, soared out of the gate, garnering sales, enthusiastic press, and fan mail from throughout the world. Bates had broken new ground in contemporary photographic literature and found a ready audience. With the combined efforts of her book, workshops, lectures, and personal appearances, she helps to propel this dynamic subculture, where taking a break from "the tyranny of technology" is not just okay but healthy. *Plastic Cameras* is still the only comprehensive book that, with its content, makes a convincing argument for placing the low-tech and high-tech photography worlds on equal footing—so far as their possibilities for personal pleasure, commercial, professional, and artistic expression, and fine art. Whatever the camera, the outcome ultimately depends upon the intent, vision, and capabilities of the photographer.

When Bates approached me about working on the first edition, I agreed, knowing her to be the ideal author for this book. She is of the Holga tidal wave, still surging, but her purview grows to encompass new developments. This expanded second edition is another knockout. The present tsunami, of course, is digital, which is rapidly pulling many away from film (analog) completely, whether done with low- or high-tech equipment. And yet, there are increasing numbers of 21st century photographers who switch easily from analog to digital, valuing their respective social virtues and different characteristics. More and more of these semi-Luddites are bound to be pulled into the plastic camera camp, and as long as cameras such as the Holga, the newly reintroduced Diana+, and other toys offer opportunities for shooting film, that intimate golden-lit darkroom will still await those who choose to do their own developing and breathlessly wait for the image to appear.

Mary Ann Lynch
July 2010

acknowledgements

My ride in the world of plastic cameras has been tons of fun since it began in 1991. In addition to playing with the cameras, getting to know so many wonderful people has kept me going.

In the early days of my interest in photography, my parents, Mimi and Harold Bates, Richie Lasansky, Jim Hogan, and the Maine Photographic Workshops got me on the road to life with Holga by my side.

Over the years since, many people have been my companions and mentors, supporting my endeavors, including Ludmila Kudinova, Larry Busacca, Ike Royer, Llyle Morgan, Elizabeth Opalenik, James Wood, Richard Newman, Victoria Haas, Jennifer Loomis, Patrick Dellibovi, Marita Holdaway, Ray Pfortner, Angela Faris Belt, and Ctein. Freestyle Photographic Supply (Ike, Patrick, Geri Carmeli, and many others) has helped me more that I can say, and it's been great working with them.

This book, in its first and second editions, was made possible by my editors, Diane Heppner and Cara Anderson St Hilaire, Paul Gottherer (who came back for seconds!), and many other people at Focal Press.

Many people have lent technical advice, shared tips and favorite photographers, and given me cameras, among other things. My gratitude to Randy Smith of HolgaMods, Christine So and Don Knodt of Holga Limited, Cameratechs, Michael Barnes & toycamera.com, Nic Nichols, C Gary Moyer, Liad Cohen of the Lomographic Society, Nick Dangerfield of Superheadz, Mark Sink, Connie Begg, and many others. It's been especially thrilling to work with Holga Inspire and Christine. Mary Ann Lynch has contributed to both editions most generously by sharing photographers, advice, and her invaluable expertise in reviewing, editing and fine-tuning the manuscript and proofs; I can't overstate how appreciative I am.

I love teaching and speaking, and am thrilled to have had the chance to spread the Holga love at photographic schools and centers, bookstores, and conferences nationwide. Thanks to all of them, especially my home base, and the place where I first taught, Photographic Center Northwest, and to James Wood for helping me find my voice.

Thanks for the support of my family and community: Dad, Rob, and the Susans, my dear friends in Seattle and beyond (Mik, Tiberio, Peggy, Andrea, and so many more...), and to Tim Furst, Lighthouse Roasters, and Office Nomads for creating comfortable spaces to be and to work.

Thanks to all the photographers who contributed images to this book. I am in awe of what they create and am thrilled to have the opportunity to show their work to a wider audience.

And, most of all, my dad, who is always behind me 1000%.

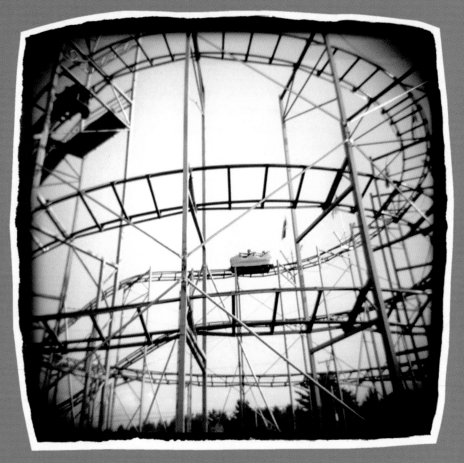

Helter Skelter, © Michelle Bates, 1991, at the Skowhegan State Fair, Maine. This was made with my first Holga. I made my hand-cut cardboard negative carrier for this photograph so I could include the entire image in the print.

introduction

Since the publication of the first edition of *Plastic Cameras: Toying with Creativity* in 2006, the world of these playful cameras has not only kept growing—it has exploded. At the time the first edition was done, it was meant to be a comprehensive collection of the cameras, photographers, publications, and exhibitions that had made up the genre to that point—and we accomplished that, without feeling we had omitted a vast amount of information, in terms of what had happened up to that point.

However, a brief 4 years later, so many people have fallen in love with the magic of low-tech photography that it would be impossible to even touch the surface of all the articles, books, and exhibitions throughout the world that show off the work of photographers who travel this jaunty plastic path. While the first edition stands as a snapshot of the history of plastic cameras to 2006, this updated edition is a survey of what led us up to today's exhilarating times. The heart of the second edition is a sampling of some of the best work being done with plastic cameras right now. There's also a snazzy collection of the most interesting and popular cameras on the market, a guide to shooting with plastic cameras in general, and specific Holga-related information, tips, and modifications.

The Holga is what launched me into the world of photography, nearly 20 years ago. I was first handed a Holga in 1991 at the Maine Photographic Workshops, now Maine Media Workshops. It was there that I created my own vision through the plastic lens, aided by a negative carrier that I self-fashioned out of cardboard, to allow printing the whole of a Holga image. I continued to shoot with my Holga after that summer in Maine, and, before long, I started exhibiting my Holga work, publishing Holga images in weekly newspapers, and even had an image on a CD cover.

In those early years I first met Mary Ann Lynch, Mark Sink, Gordon Stettinius, and Ann Arden McDonald, along with many other Holga and Diana photographers, at the openings of group exhibitions we all were in. At that time, the toy camera community was small, and it was always exciting to meet other people with similar interests and the inspired enthusiasm that characterizes all of us.

Socially, as well as professionally, the plastic camera culture has changed greatly now that the Internet allows us to connect from the comfort of home. Low-tech photography lovers have, since the early days of the Internet, taken advantage of its wonders to share work, advertise competitions, and meet one other. I found many of the book's contributors by tooling around the web, Googling, following links, and perusing many of the toy camera websites listed in the Resources section.

Ever since publication of the first edition, I've had the immense pleasure of taking my toy camera show on the road—teaching workshops and lecturing around the country. In fact, I went back to Maine Media Workshops after 15 years to teach at the place that gave me my start. I have also taught my toy camera workshops at many other art and photography centers and schools and have sat in with university photography classes. I've lectured at bookstores, photography conferences, photographic art centers, and other venues for photo fanatics and have juried toy camera exhibitions. While of course I love showing my own images, I especially enjoy opening my audiences to new outlooks on creativity by showing them the wide variety of works of photographers from *Plastic Cameras: Toying with Creativity*. Lecture attendees and workshop participants are wowed by what they see people doing with these simple instruments and are often inspired to pick up a plastic camera and take it for a spin.

It's an exciting challenge for me to entice photographers away from using only the latest technology and to instead take a photographic journey with the simplest of film devices. These toys become tools for them to learn, or perhaps relearn, the basic principles of photography, the art of composition, and how to create a cohesive body of work. Oh yes, some of them will first need to learn how to work with film, as a whole new generation of photographers has grown up using only digital cameras; our plastic cameras are firmly planted in the analog realm.

The awareness of toy cameras has reached far beyond the world of fine-art photography in the last few years. It is only recently that friends and people I meet have any idea what a toy camera is all about. Now it's common for them to even interrupt me as I'm explaining, with, "Oh, you mean the Holga?" After so many years in a plastic camera arena that was, to most outsiders, obscure, it still surprises me when this happens.

This revised edition is meant for two audiences, both those new to the world of these cameras and those who have already spent time with them and might already own one, or even a whole collection. The detailed history and technical information in the following pages will be of use and enjoyment to both newcomers and more experienced photographers.

This updated collection adds a large assortment of new material to the previous one. Images in these pages represent some of the most outstanding photography being done today, along with compelling images of historical interest, especially some from the earliest days of the plastic camera uproar, in the 1960s and 1970s. The photographs herein represent not only fine-art images, but commercial, wedding, editorial, and documentary photography, as well as photojournalism. This edition also highlights some newly added photographers who use plastic cameras almost exclusively, including Brigitte Grignet, Jennifer Shaw, Thomas Michael Alleman, and fotovitamina, as well as those who use them as just one photographic tool among many, including photo luminaries Sylvia Plachy, Michael Kenna, Nancy Siesel, and Louviere + Vanessa. All are stellar additions to the group of photographers we began with in the first edition, such as David Burnett, Teru Kuwayama, Pauline St. Denis, Ted Orland, Franco Salmoiraghi, and Harvey Stein.

Among all the photographers who make up this edition, there's great diversity in their work: Some create imagery in a straightforward manner, while others combine technologies, manipulate prints, or otherwise mix things up. In this world of alternative technology, there is no right way to go about any stage of the process; it's all about experimenting and finding your own artistic vision.

Plastic Cameras: Toying with Creativity can be read straight through or perused as needed when looking for specific information. Chapter 1 starts things off with a history of the genre, with examples of some of the earliest toy camera images made with the ground-breaking Diana cameras. Chapter 2 features 30 portfolios, with work from the 1960s to today, covering a wide range of styles and subject matter. Chapter 3 is a guide to the cameras, old and new, and Chapter 4 discusses film options. After that, the book is a guide to image making. Chapters 5 and 8 are specific to the Holga, while Chapters 6, 7, 9, 10, and 11 cover shooting, processing, printing, and presentation with any low-tech camera. Finally, the Resources section provides information to help you continue your creative journey in the world of plastic cameras. Enjoy, and happy shooting!

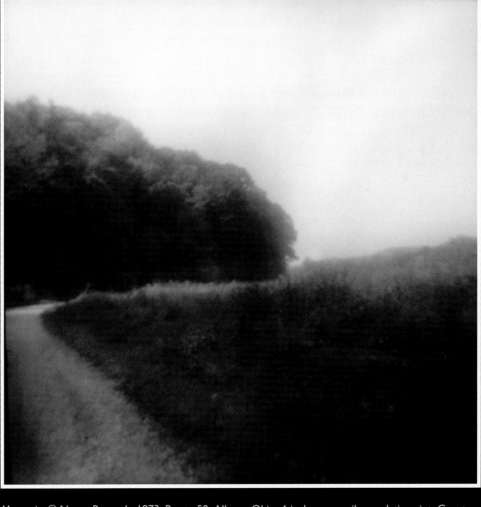

Mountain, © Nancy Rexroth, 1973, Route 50, Albany, Ohio, 4-inch-square silver-gelatin print. Courtesy of Robert Mann Gallery.

chapter one

What are Plastic Cameras?

Welcome to the exuberant world of plastic cameras! Beginning with the legendary Diana, to one of today's favorites, the Holga, these lightweight, simple-to-use, and inexpensive cameras conjure up an atmosphere of joy around image-making, create intriguing photographs, and make photographers as well as their subjects smile. Even better, the images you make can proudly take their place alongside photographs made with the most sophisticated cameras and lenses. Once you've mastered the art of photographing with a plastic camera, the possibilities of what to shoot and where to share, exhibit, or publish images are endless. Some might pick up one of the many varieties of plastic cameras for the first time and think "This can't be a real camera" or "How can this possibly produce good photographs?" And yet, images from these inspiring toys are being used in a wide range of commercial and noncommercial settings, from gallery exhibitions to magazines, newspapers, and advertising campaigns to fundraising for nonprofit causes. While we aficionados might still draw stares and exclamations of disbelief from digital camera users, for those of us who've been magically drawn into the world of these delightful image-making toys, there's often no going back.

Photographic technology has continually marched forward since its inception in the mid-1800s. While the advances made have been extraordinary, the basics of photography are still relevant, and even very old cameras can still function today. Like these relics, our plastic cameras totally ignore all the current camera features, but instead of this hurting their appeal, they are in fact gaining in popularity. Holga cameras, vintage Dianas, and new creations, such as the "Blackbird, Fly" and Diana+, lack meters, autofocus, auto film advance, adjustable shutters, and, of course, digital sensors. In an age when just about everyone has a digital camera and most people upgrade regularly to take advantage of the newest version's capabilities, it's astounding that anyone would choose a camera made of flimsy plastic, has a little spring for a shutter, and requires taping to keep the back from falling off. And yet, both experienced and novice photographers alike continue to adopt these toys as serious picture-making tools and as an important part of their collection of cameras.

The ways plastic cameras have managed to infiltrate the world of photography over the past 40 years have surprised even their champions. Since their discovery by American photographers in the late 1960s, they've been used by teachers at varied levels to simplify teaching the basics of photography. The ingenuity of their users has kept them from getting stuck in the realm of artist's toy though, and in the 21st century, professionals regularly use Holgas and other toys for serious photojournalism, commercial and editorial photography, portraiture, and weddings, often without even identifying their published images' humble origins.

Plastic cameras can be a surprisingly inexpensive way to get into photography. Although Holgas aren't the $17 they once were, they can still ring in at an affordable $30. Vintage Dianas are now collector's items, and newer creations tend to be priced at a premium. But with the most basic Holga 120N and some 120 film, you're ready to roll. The 120 Holgas and Dianas are a great introduction to medium-format photography, but 35 mm versions are also gaining in popularity, especially as processing options for 120 film become harder to find.

Another reason photographers love these cameras is the positive side of their flimsiness—they are lightweight. Medium-format cameras and film and digital SLRs will weigh you down far more than a 7-ounce Holga. With the proliferation of tiny digital point-n-shoot cameras, weight is less of a concern, but plastic cameras have other draws that set them apart.

Shooting with a Holga, Diana, plastic 35 mm, or even toy digital camera is a very different experience from using a "real" camera, for both photographers and their subjects. Giving a portrait subject my Holga to hold for a moment is a great way to break the ice and get them to smile, as they register with surprise that the camera weighs so little. Their experience of being photographed will always be different when the tool is a toy versus being accosted with an intimidating, complex piece of equipment. The cameras' affordability also makes them accessible for programs and classes that serve groups of youths, both in the United States and elsewhere.

Of course, the core reason for using any particular camera is the way the images will look in the end. Each camera and lens interprets the world in its own way, and the photographer needs to find the ones that complement his or her artistic vision. Negatives created with a Holga or Diana plastic lens are very distinctive; in fact, it's often possible to identify which camera made a particular image. The newer cameras and accessories are opening up even more avenues for photographers to explore their artistic vision and discover unique styles.

So-called reverse technology also has the power to bring people together, almost the opposite of the often competitive world of photography. Communities have sprung up among plastic camera aficionados, resulting in a multitude of projects, from group exhibitions, web sites, and forums to World Toy Camera Day, involving photographers from across the globe.

Since I first held a Holga in 1991, the demise of their popularity has been repeatedly predicted, but they have continued to grow in popularity to a degree that no one could have imagined. In recent years, the toy camera experience has attracted enormous numbers of people worldwide. These include both experienced photographers and novices, drawn in by the cameras' simplicity and cuteness, the perceived rebellion against more complex and expensive digital equipment, and the love of being part of a movement. The camera manufacturers have cultivated this movement and built on it. By releasing more types of cameras, colored and souped-up versions of old classics, and lots of accessories, they create choices for their widening demographic.

As long as these cameras and film are available, no one need ever be without an image-making device. In this era of more complexity, more megapixels, and more money—for some—all-manual plastic cameras provide a lifeline to pure photographic pleasure, a creative outlet for inspired artistic

Boarding School, 1965, © Michael Kenna. Taken with Kenna's first camera, a Diana, at age 13 while at St. Joseph's College, Upholland, Lancashire, England.

vision, and an antidote to the tyranny of technology.

WHERE DID THEY COME FROM?

How did such unassuming toys turn into invaluable tools for serious photographers? Diana cameras first appeared in the United States in the late 1960s. They were manufactured by the Great Wall Plastics Company in Hong Kong and sold for anywhere between 69¢ and $3.00. With three apertures, one shutter speed, a difficult-to-control bulb setting, and three pictographic focus settings, the Diana barely held together and only almost kept light out. Originally stumbled upon in drugstores by curious photographers, Dianas were also discovered by educators at university photography programs, including Jerry Burchard at the San Francisco Art Institute and Arnold Gassan at Ohio University. By adopting the Diana in their beginning photography classes, they immediately leveled the equipment field for their students. Using these simple cameras, students learned the same skills in composition and creative vision that they would have learned with more expensive cameras, without the distraction of having to make complex camera adjustments. Because both the cameras and the film were cheap,

students were encouraged to shoot with abandon. Dianas in hand, students and faculty alike loosened up.

This early history is discussed by those who were part of it in "$1 Toy Teaches Photography" by Elizabeth Truxell of Ohio University in the January 1971 issue of *Popular Photography* and in several issues of *SHOTS* Magazine during the 1990s (see Resources). Dianas appeared on the scene at a time when photography was expanding its reach, just beginning to be accepted in the academic and fine art worlds. The cameras fit in with the cultural explosion of the times, and photographers came at their imagery from a broad range of perspectives and experiences. The first work to be recognized by the fine art world was Nancy Rexroth's series *Iowa*, which was shown at the Corcoran Museum in 1971, excerpted in Aperture's 1974 publication *The Snapshot*, and published by Violet Press in 1977 as the first monograph of images made with a plastic camera.

In 1977, *Popular Photography* published two extensive articles devoted to the Diana camera written by Don Cyr. Included in special issues of the magazine, these must have opened up a whole new audience to the joys of the Diana. In 1979, the Friends of Photography put together *The Diana Show*, a juried exhibition that attracted more than 100 entrants. A catalog of the show, the first published collection of toy camera imagery, featured the essay, "Pictures through a Plastic Lens," by David Featherstone, which became the classic treatise on the subject. Diana cameras weren't manufactured for very long; Featherstone mentions that they had already stopped being made before *The Diana Show* catalog was published. The Arrow, Banner, Dories, and several dozen other Diana clones continued to be made, usually in a shade of blue similar to the Diana, but in varying degrees of quality. The last of the line, the Lina, ceased to be made in the late 1980s, but for the photographer willing to troll yard sales or eBay, there are still many Dianas and her kin floating around.

Without knowing about the legacy of the Diana, Mr. T. M. Lee ushered us into the Holga dynasty. Invented in 1982 for his Hong Kong company Tokina Corporation, part of Universal Electronics, Holgas were meant to feed the vast Chinese market for affordable medium-format cameras. The name Holga came from the Cantonese term hol-gon, meaning "very bright." Shifted a little, for easier English pronunciation, the word resulted in Holga. Within a few years, 35 mm film took over, and the Chinese demand for the larger format fizzled. The Holga's saving grace was the United States market, where

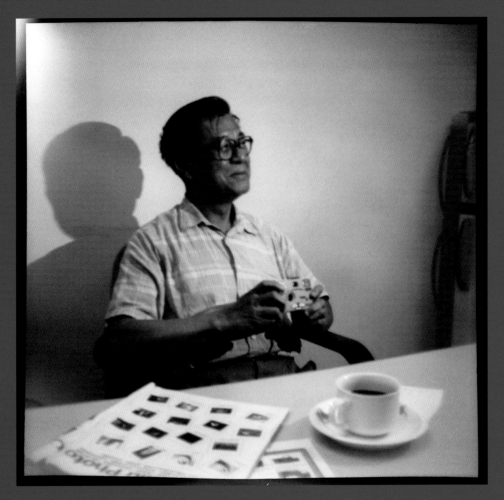

T. M. Lee, Inventor of the Holga, © Skorj. This portrait was taken with a Fujipet camera during a visit to the Universal Electronics factory by Tony Lim and Skorj in 2005 for an interview for *Lightleaks Magazine,* Issue 2.

Holga soon found a new realm of popularity with American photographers. In the early 1980s, Holgas were introduced at the Maine Photographic Workshops (MPW; now Maine Media Workshops), where they took the place of Diana and Dories cameras as low-tech educational tools for the workshops' students. Holga's availability at MPW and through their store, The Resource, made them accessible to photographers at large, and word spread quickly throughout the photographic community. As their popularity grew, imports increased, surprising even their manufacturers. Sales soon topped 10,000 per year in the United States and currently about 200,000 Holgas are sold per year worldwide. Well over 1,000,000 Holgas have made their way into the hands of adoring photographers.

In 1986, Dan Price launched *SHOTS* Magazine, and introduced an entire generation of fine art photographers to Diana and Holga imagery. In the 1980s and 1990s, some established professional photographers started using plastic cameras in their work. The breakthrough into the editorial realm came with the publication of

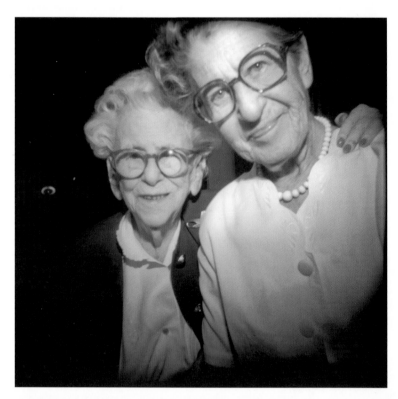

Leona Rostenberg and Madeleine Stern, 1995, © Sylvia Plachy, photographed for the *Village Voice*. Antiquarian book dealers and companions. "We still end each other's sentences. Together we look to the future—to our next find, to our next book, to our next adventure." Holga camera with Tri-X film and flash.

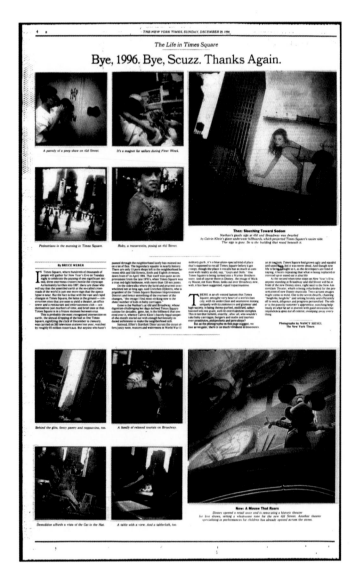

Sylvia Plachy's images in the *Village Voice*. In 1996, Nancy Siesel convinced editors at her employer, the *New York Times*, to take a chance, publishing a full-page article with 10 of her Diana camera images illustrating an article on the changing landscape of Times Square. Since then, acceptance of nontraditional images has spread into magazines, newspapers, advertising, and even videos worldwide.

21ST-CENTURY PLASTIC

These past few years are leading us into the true heyday of the Holga and plastic cameras in general. Their appeal has spread far outside beyond the

photographic community, and the demand has spurred new innovation and interest. It seems the more we are all overwhelmed by digital technology, the more popular throwbacks become, including plastic cameras, which are accepted both as serious photographic tools and as funky cultural objects. Their ever-burgeoning popularity has spawned the creation of more styles of plastic cameras, as well as other tools that create imagery reminiscent of their low-tech look, but within the digital realm.

In the early 1990s, Lomographic Society International began its bid to introduce the world to low-tech cameras with the Lomo LC-A. While neither plastic nor cheap, the simplicity and gaudy, contrasty color rendition of the LC-A endeared it to the Austrian students who stumbled upon it. They then decided that everyone should adopt their Golden Rules of Lomography, creating "Lomographers" who "shoot as many impossible pictures as possible in the most impossible of situations from the most impossible of positions." Their main tag line is "Don't think, just shoot," gifting photographers with a liberating manifesto. While the original LC-A is no more, now Lomographic makes the LC-A+, in addition to the Action Sampler, Super Sampler, and other multi-lens cameras. Lomographic's newest creation is the Diana+, along with its entire line of accessories. The huge success of this reinvented classic has converted many thousands of people worldwide into plastic camera enthusiasts.

To keep up the interest of those who buy their products, and to win new converts, the Lomographic Society has created a new angle on the natural congregating that tends to happen among toy users. Since 1994, the society, based in Europe, has thrown parties and events all over the world, including the LomOlymPics. LC-A, Holga, and Diana+-crazed photographers are sent out on missions of documentation, encouraged to not actually look through the lens when they shoot, and rewarded with exhibits made up of thousands of images, along with all-night parties.

The Lomographic Society regularly produces publications of images made with their stable of cameras, and their web site (www.lomography.com) provides an enormous number of opportunities to post images, chat online, and collect the latest in cameras or related gear. Lomographic showrooms in major cities around the world display the entire line of cameras and accessories, and they pioneered a relationship with Urban Outfitters, which now carries a wide selection of toy cameras in its stores throughout the United States, and has exposed a whole new generation of shoppers to the allure of brightly packaged, low-tech cameras.

In 2008, Tokina, which manufactured Holgas for over 25 years, but hadn't otherwise interacted with the photography world, broke out by bringing Christine So on board. With her passion and enthusiasm for photography, So reached beyond her original job description and connected the company with the enormous international community of photographers who had been enamored with their products for decades. I was contacted by So in the summer of 2008 and was absolutely thrilled to finally have a relationship with the company. I sent them a copy of the first edition of this book and was able to pay my respects and send suggestions to Mr. T. M. Lee himself.

Propelled in part by information So generated, a major decision was made to change the company name to Holga Limited to reduce confusion of the Tokina name with the Japanese lens company of the same name. Led by So's enthusiasm and connections, the company also created "Holga Inspire," an initiative that comprises a Web site and collection of top-notch Holga photographers, including several contributors to this book. The first "Holga Inspire" exhibition debuted in Bangkok, Thailand, in March 2009 and continues to tour in the United States. The company has also begun sponsoring educational programs, photo shows, and competitions, encouraging the adoration their cameras already induce. In addition, Holga Limited has expanded their line to include Holgas in a variety of shapes, versions, and colors, along with an ever-growing collection of accessories. The back and forth between the company and those who use their products has been fruitful and exciting and promises to continue as they generate new ways to respond to the community.

The newest entry into the manufacturer's field is Superheadz, a Japanese company, which has wowed the toy camera community with its original offerings, including the Golden Half, the "Blackbird, Fly," and the Digital Harinezumi. Their sister company, Powershovel, produces books and music, and together they are providing toy cameras and imagery for the enormous Japanese market, and worldwide. Learn about the history of Superheadz from an interview with its founder, Hideki Ohmori, on FourCornersDark.com and view more of their offerings at www.superheadz.com.

As the look of toy camera images has gained a widespread following, creative types who want to combine this low-tech aesthetic with their high-tech equipment have been busy. Craig Strong invented the Lensbaby, which has blossomed into a series of lenses for SLRs that, in

some ways, echo the look of a Holga, but have their own characteristics and can be used with digital as well as film bodies. Meanwhile, in the digital world, a wide variety of tools are now available to make standard image files look like they were made with a Holga, Diana, Lomo, or Polaroid; these include Photoshop actions and an ever-expanding array of iPhone applications.

Bringing all of these products together, Freestyle Photographic Supply has become a champion of traditional photographic methods and is the U.S. distributor of the Holga. Its mission is to keep students and photographic enthusiasts awash in Holgas, film, and darkroom gear and supplies, and its colorful, informative catalogs have increased the popularity of the entire family of plastic cameras.

Plastic camera history continues to evolve in its journey into the future.

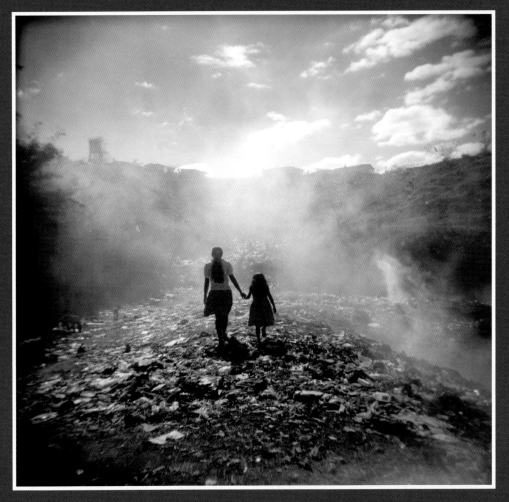

Jocotán, Guatemala, 2004, © Brigitte Grignet/Agence VU'. Holga camera with Fuji 400 color negative film.

chapter two

Plastic Portfolios

Introduction

This chapter presents a unique collection of plastic camera images gathered from dedicated photographers far and wide specifically for this book. You'll see here some of the earliest images made with the Diana, in the late 1960s, as well as contemporary work showing a wide range of approaches and sensibilities. Some of the photographers in this section shoot exclusively with their plastic camera of choice, while others keep them as just one tool in their array of camera equipment. Some are champions of low-tech photography, whereas others publish their images without calling attention to their source. Images here have been used for fine art, advertising, to communicate the news and humanitarian crises, and to spread joy through the magic of photographic imagery. What all the photographers have in common is a natural talent for creating beautiful photographs and a passion for their work. Many of the contributors have images elsewhere in the book. You can find out more about all of them through links listed in the Resources section.

Nancy Rexroth was part of the beginning wave of plastic camera photography, although she wasn't aware of it at the time. As a graduate student at Ohio University, she discovered the Diana camera, which was being used as a photographic teaching tool. Soon she had fashioned the style of imagery that would earn her national acclaim barely out of college. Unlike the highly conceptual photography then in vogue, Rexroth's Diana images arose from what she calls "an almost obsessive love of the classic face of beauty."

With the Diana she created "a melancholic landscape of dark and visceral longing," as she refers to it. She named this series *Iowa*. Taken primarily in southeastern Ohio, these images flowed from her memories of summer visits to her relatives in Iowa. "I began to see Iowa everywhere."

Luminous, emotionally charged, and poetic, Rexroth's *Iowa* photographs were included in Aperture's publication *The*

A Woman's Bed, © Nancy Rexroth, 1970, Logan, Ohio. The first Diana image that struck a chord with Rexroth; after this, images came "like a string of pearls" to create the *Iowa* series. 4"-square silver-gelatin print. Courtesy of Robert Mann Gallery.

Snapshot in 1974 and was published in 1977 by Violet Press as *Iowa*—the first published monograph of work done with a plastic camera. Rexroth was picked up by Light Gallery early on, and her work from *Iowa*, now highly collectible, continues to be widely shown, even today. This seminal series is recognized for revolutionizing the relationship between toy cameras and the fine-art world. Mary Ann Lynch writes: "Rexroth's stunning images introduced a new note into the photographic landscape. Blind focused, and with the sure fluidity of longing, the feeling in them is palpable."

More recently, Rexroth has been using a $30 low-resolution digital camera, the Digipix, which makes square color images. As with the Diana camera, Rexroth again creates in an expressively personal vein, photographing in the Victorian house of a neighbor who has painted the interior in "fantastic, luminous colors." Rexroth calls this new work *The House Series.* Currently turning to portraiture of all kinds, she lives in Ohio.

Folding House, © Nancy Rexroth, 1974, New Lexington, Ohio. From *Iowa,* 4″-square silver-gelatin print. Courtesy of Robert Mann Gallery.

Streaming Window, © Nancy Rexroth, 1973, Washington, D.C. Diana camera 4″-square silver-gelatin print toned first with sulfide (sepia) and then with gold. From *Iowa,* in Section III, which explores interiors. Courtesy of Robert Mann Gallery.

Library Ladder, © Nancy Rexroth, 2005. Digipix digital camera image made in Cincinnati, Ohio, from *The House Series.* 4″-square print.

Nancy Siesel

From Times Square to the far reaches of Asia, Pulitzer Prize-winning news photographer Nancy Siesel has made images concerned with the well-being of people wherever she goes. In her years as a staff photographer for the *New York Times*, she covered a wide range of topics, from wars to weddings to the arts, in her own backyard and in distant lands.

Siesel began using Diana cameras and Diana clones when photographing Times Square in the early 1990s. The area was dicey and gritty at the time, and the toy camera served both as protection and made sense aesthetically, imparting the feel of a lost era onto a neighborhood beginning a period of dramatic change. Her 1996 full-page 10 image portfolio of Times Square photographs broke ground as the first plastic camera images printed in the *New York Times*. Her black-and-white images illustrated an article by Bruce Weber, "Bye, 1996. Bye, Scuzz. Thanks Again," December 29, 1996, shown on page 10.

More recently, Siesel has turned her Diana to landscapes, creating her own personal view, one that "reflects the mystery and spirit of places both exotic and mundane."

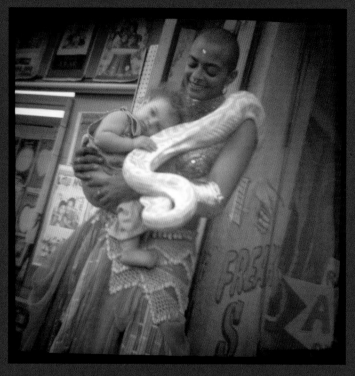

Snake Charmer, Coney Island, © Nancy Siesel, 2007. Mego camera (Diana clone) with Kodak Optima 400 film.

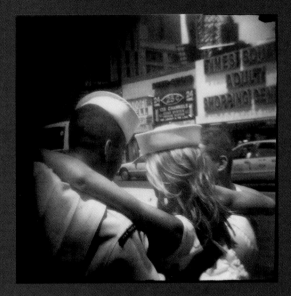

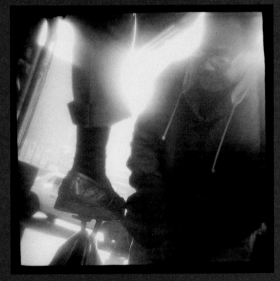

Sailors Posing, Times Square, © Nancy Siesel, 1994. During Fleet Week on West 42nd Street, sailors pose with a model. Diana camera, Tri-X film.

Shoe Shine, Times Square, © Nancy Siesel, 1995. Using a Diana camera gave Siesel unusual access to shoot in what was then a dicey neighborhood.

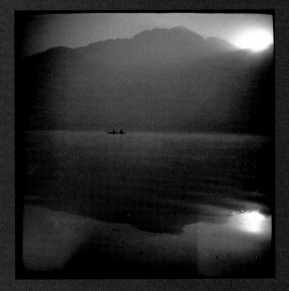

Dal Lake, Kashmir, India, © Nancy Siesel, 2008. A transcendent moment on her last day living on the lake, captured with a Diana camera on Fujicolor 400 film.

Thomas Michael Alleman—Sunshine and Noir

Thomas Michael Alleman wanders the streets of Los Angeles, New York, and other cities in search of metaphors. His mind awash in literary allusions and dreams, he and his Holga seek "a photograph whose lines and shapes are dreamy, allusive, and psychological."

Enjoying the interplay between the surprises that lurk not only in the world at night, but also in the shadows of the bright daylight, Alleman's "Sunshine and Noir" series seeks to illuminate its subtexts with light, shadow, and form. The images in this sprawling project often capture light as a subject in itself and give shadows and rich blacks the space and respect they deserve but rarely receive. The results are images that sing of the cities they depict with a tune unique to the voice of Alleman.

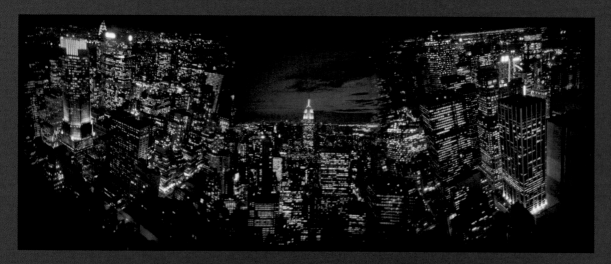

Midtown Manhattan, May 2008, © Thomas Michael Alleman. A triple image, exposed about 15 seconds for each exposure,

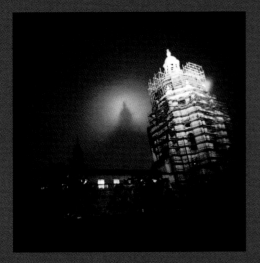

Pasadena, December 2005, © Thomas Michael Alleman. Approximately 30-second exposure on TMAX 400 film.

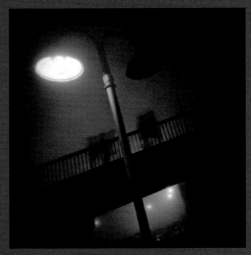

Santa Monica, January 2005, © Thomas Michael Alleman. Thirty-second exposure on Ilford Delta 3200 film.

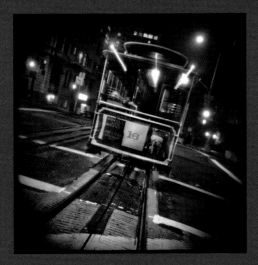

San Francisco, December 2007, © Thomas Michael Alleman. Ten-second exposure on Ilford Delta 3200 film.

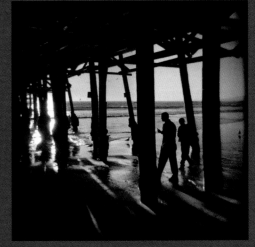

Santa Monica, August 2004, © Thomas Michael Alleman. TMAX 400 film.

Franco Salmoiraghi—Changing Worlds

Franco Salmoiraghi was one of the earliest users of the Diana, arriving at Ohio University's graduate school in 1966. His thesis work there eventually became a series of pinhole images, but the Diana was, he says, "one of the 'doors of perception' to break down the walls of that training that demanded a specific set of aesthetics, point of view, and belief in the truth of the photographic image." He has used the Diana and dozens of other toy cameras over the years, as photographic series have called for it or when it seemed time to bring out the simple camera.

Salmoiraghi's earliest Diana images, shown here, were made in 1967. When his first Diana's shutter broke after only a few rolls, he created a pinhole for it. With this modified Diana, he would subsequently make many evocative photographs.

Salmoiraghi has lived in Hawaii since the late 1960s, and while his plastic camera work often involves poetic natural subjects and impressionistic portraits, it may equally explore darker subject matter. Another series, *Dementia & Transience*, consists of images taken while the photographer cared for his aging mother. Salmoiraghi found that the fuzzy Diana photographs mirrored the sense of timelessness and altered space perception that distanced her from her previous reality. Salmoiraghi describes *Regarding Death*, another somber, though uplifting, series, as "an investigation of the visual manifestations of the death experience in society."

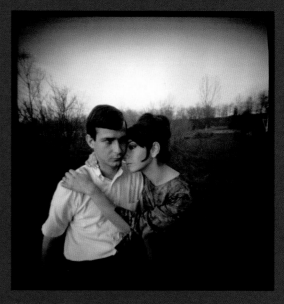

Bob & Sona, © Franco Salmoiraghi, 1967, Athens, Ohio. Pinhole-modified Diana, toned silver-gelatin print.

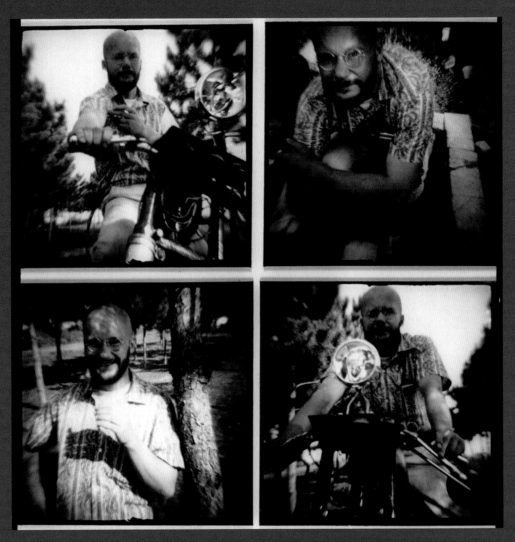

Motorcycle Guy, © Franco Salmoiraghi, 1967, Athens, Ohio. Diana camera (from one of his first Diana rolls); see the contact sheet on page 212.

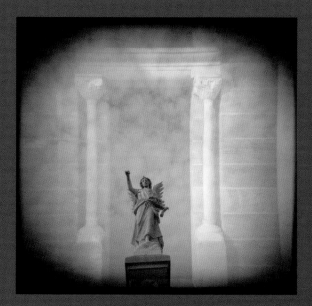

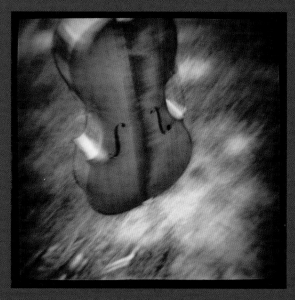

Guardian Angel, © Franco Salmoiraghi, 1998, Greenmount, Baltimore, Maryland. From *Regarding Death* portfolio. Holga camera double exposure, toned silver-gelatin print.

Swinging Cello, © Franco Salmoiraghi, 2002, St. Paul, Minnesota. Diana camera toned silver-gelatin print. From *Dementia & Transience: A Meditation on Aging and Memory Loss.*

Ted Orland—Parallel Careers

Ted Orland may well have been one of the first photographers to adopt the Holga, although he had not worked with the Diana. In the years when Diana was making waves, Orland was immersed in the opposite, super-sharp f/64 aesthetic while working with Ansel Adams as his student and assistant. While Orland appreciated the fuzzy look that Nancy Rexroth and others were creating, it took many years for him to disengage from the idea that "sharpness is good" and achieve the mental flexibility to appreciate the Holga's quirky qualities. Since discovering the Holga at the Maine Photographic Workshops in 1990, Orland has used it as his primary camera. In his ongoing quest for creative ways to make images, he uses both color and black-and-white film, often hand-colors his prints, and makes montages in Adobe Photoshop. Orland

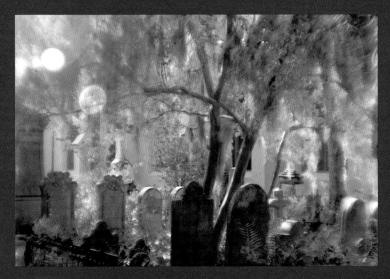

Cemetery, Charleston, SC, 2007, © Ted Orland. Digital image made with a Holga lens (altered by Holgamods) mounted on a Canon DSLR. Desaturated and slightly toned in Photoshop.

also uses a pinhole-modified Holga and occasionally takes a Holga for a swim sealed in a plastic baggie. He says "What the Holga's capable of doing with a vengeance is capturing ambiance," which is made clear by the atmospheric mood of his images.

Orland, whose home base is Santa Cruz, California, enjoys parallel careers as both a teacher of digital photography and a writer; he wrote *The View from the Studio Door* (Image Continuum Press, 2006) and coauthored *Art and Fear* (Image Continuum Press, 1993). Orland is prolific in his creation of images and generous in sharing his knowledge and insights with his students and readers alike.

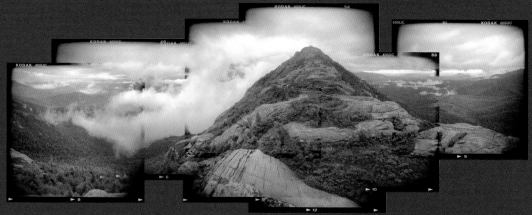

Mount Chocorua, NH, 2006, © Ted Orland. Several Kodak Portra UC Holga negatives, montaged in Photoshop, with liberal use of layers and blending modes. 20″ × 50″ digital print.

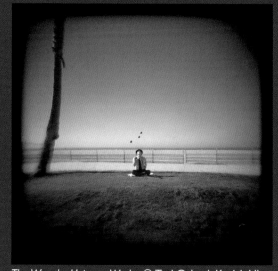

The Way the Universe Works, © Ted Orland. Kodak Ultra 400 film, scanned, minor manipulation in Photoshop.

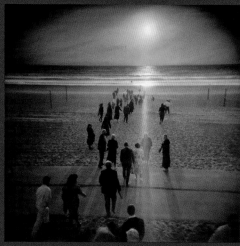

Yuppies Marching into the Sea, © Ted Orland, 1991. Holga camera with T-Max 400 black-and-white film; silver-gelatin print, hand-colored with oil paints.

Anne Arden McDonald

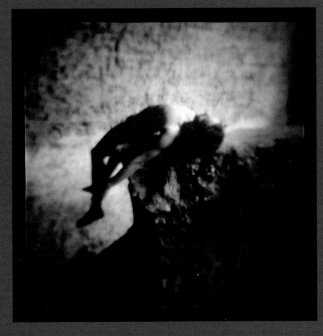

Fallen, Czech Republic, © Anne Arden McDonald, 1999. From the *Pillow Book* series, a collaboration with Radek Grosman. Diana camera on bulb setting.

When people who don't know better see Anne Arden McDonald's images, with titles such as *Diana #24* or *Diana #35*, they sometimes think they're about the mythological goddess Diana, not the camera. McDonald doesn't mind because Diana the Huntress is her favorite goddess. And it's easy to see the connection to ethereal realms and mythology in her photographs.

McDonald is well known internationally for a series of self-portraits (made with a Nikon 35 mm camera) in dilapidated spaces that have unique character. Her Diana work in the series *Pillow Book*, made with her collaborator Radek Grosman, are private performances created in places of a related abandoned feel. These series have taken her from her home in Brooklyn to several countries that have a much longer history, and buildings that reveal the character that comes with age.

McDonald describes her Diana series (the numbered images) as being about "vagueness and images half-remembered from the subconscious." She shoots with her Diana on the bulb setting to add a dreaminess and unpredictability to her images. With her fresh artistic visions and ideas, McDonald makes a series of unfocused frames come together as a focused body of work. Her creative work continues to evolve, adding life-size body shaped images made with household chemicals, installations, and hand-cast jewelry.

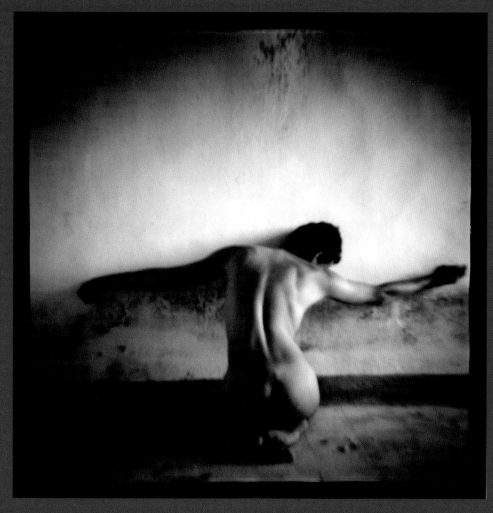

Hugging Wall, Italy, © Anne Arden McDonald 2000. From the *Pillow Book* series, a collaboration with Radek Grosman. Diana camera on bulb setting.

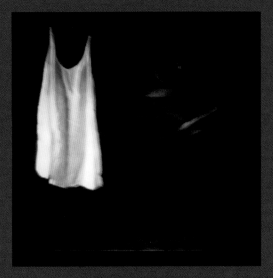

Diana #41, © Anne Arden McDonald, 1997.

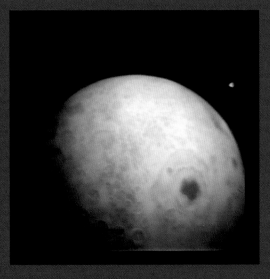

Diana #64, © Anne Arden McDonald, 1999. Diana camera image of a model of the moon in Italy.

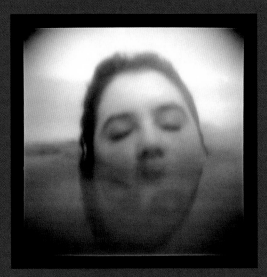

Diana #37, © Anne Arden McDonald, 1995. Diana camera self-portrait.

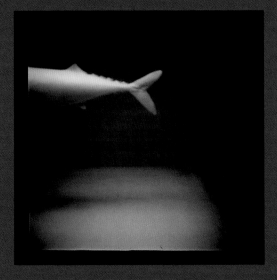

Diana #55, © Anne Arden McDonald, 2000. Diana camera image from the Museum of Natural History.

Sylvia Plachy

Sylvia Plachy carries a quiver of cameras with her when she's out photographing. Toting tools that include a Nikon, Hasselblad, Leica, and panoramic camera, clearly she doesn't use the Holga just because it's lightweight. To Plachy, each camera has a personality, each one sees a certain way, and she chooses the camera that's right for the feel and the conditions of each image.

For anyone who's seen Plachy's images over the many decades she's been shooting, what shines through is the emotion and the connection with her subjects, whether people, animals, or even objects. The natural softness of her images helps capture the feeling in the atmosphere.

A pioneer in publishing images outside of normal styles, Plachy's Holga and other toy camera images graced the page of the *Village Voice* long before the cameras became widely known or accepted. She continues to make images around the world, along with teaching, exhibiting, and publishing books.

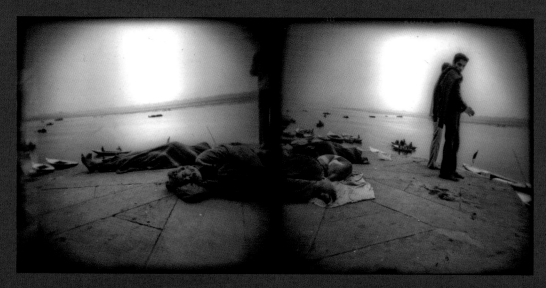

At the Bank of the Ganges, 2010, Varanasi, India. © Sylvia Plachy. Holga camera diptych on Tri-X film.

In the Mountains of Harghita, 1998, Eastern Transylvania, Romania, © Sylvia Plachy. Holga image on Tri-X film, made during a road trip in Romania and published in Plachy's book, *Self Portrait with Cows Going Home.*

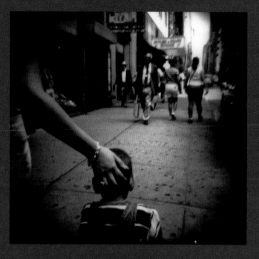

Confetti, 1993, © Sylvia Plachy. Made during the annual Broadway on Broadway Celebration.

Guiding Hand, 1997, © Sylvia Plachy. Taken on 47th Street in Manhattan with a Holga on Tri-X film.

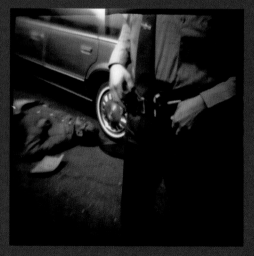

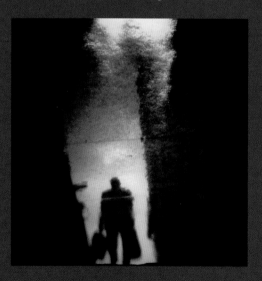

Seizure, 1992, © Sylvia Plachy. Dories camera image of Manhattan police awaiting an ambulance.

Man in Sidewalk, 1993, © Sylvia Plachy. Reflection in Avenue of the Americas, Holga camera on Tri-X film.

Pauline St. Denis

In the world of commercial photography, Pauline St. Denis may make the most sophisticated use of that most austere piece of equipment, the Holga. Over the past 25 years, St. Denis has perfected her system of doing multiple-exposure panoramas, using studio strobes and transparency film to create spectacular images for the music and fashion industries. Each of these techniques, materials, and pieces of equipment presents its own difficulties in working with a plastic camera; together they create a photographic setup that would boggle the minds of most Holga users.

St. Denis begins by loading the Holga with 200 ISO color transparency film (she also has used the now-unavailable Agfa Scala B&W). She connects strobe lights via a PC

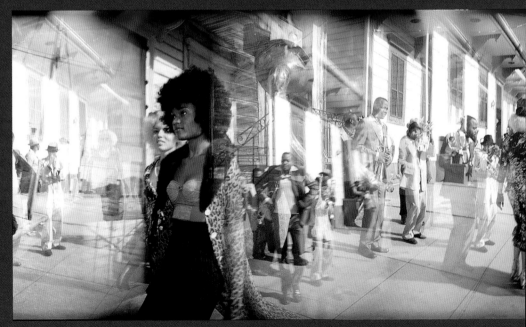

My N.O., L A, © Pauline St. Denis, 2000, for Dolce and Gabanna.

cord and adapter. Next she fine-tunes the exposure by adjusting the strobe output or adding neutral-density filters.

When shooting, St. Denis trusts her intuition and doesn't look through the Holga's viewfinder. This allows her to hide the moment of exposure from some of her subjects. Knowing each of her Holgas personally, she chooses them for the particular look they produce; one tends to be sharper, while another creates more flare. The panoramic format is achieved by winding the film only partway so that adjacent frames overlap and the resulting image is much longer than normal. While most photographers fight light leaks, St. Denis sometimes adds them deliberately by blasting light through the film counter window or along the edges of the film. Altogether, these techniques and St. Denis' methodical experimentation make for stunning, colorful compositions.

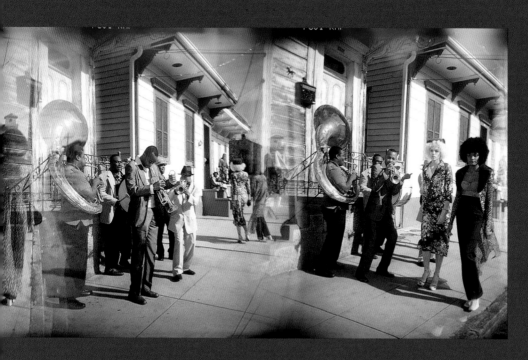

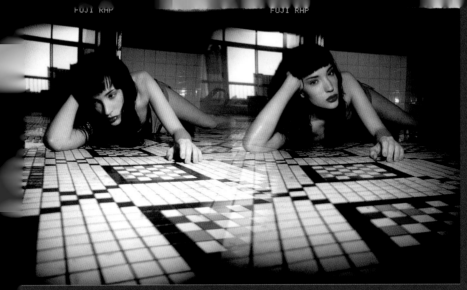

Mondrian's Reflection, © Pauline St. Denis, 2002. Holga camera diptych. Fuji RHP film and studio strobes.

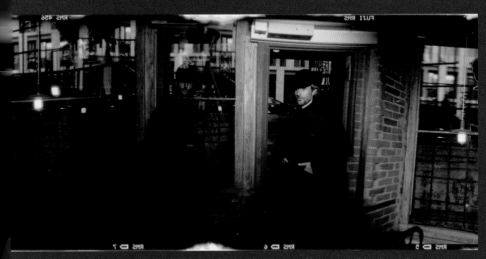

Sleuthhounds, © Pauline St. Denis, 2009. Fuji RMS transparency film, printed backward.

Nancy Burson—Compassionate Vision

Nancy Burson is one of the best-known fine-art photographers who counts the Diana and Holga among her collection of photo tools. She was also both an early pioneer in computer imaging and a devotee of the huge and technically complex 20″ × 24″ Polaroid camera, making her dedication to simple plastic tools all the more exceptional. In two series not done with plastic cameras, Burson is well known for her ground-breaking technique of "morphing," or manipulating faces via a computer to simulate the aging process. In her *Composites* series she merges images of several faces to create "averages." *The Human Race Machine* is an interactive exhibit that gives visitors the unique opportunity to see what they would look like as a different ethnicity.

Her Holga and Diana images are more straightforward. The subjects are calmly present, wrapped in the soft focus of the plastic lens. *Faces*, Burson's Diana series from the early 1990s, presents children living with genetic diseases, such as progeria, or injuries that affect the way they look, and hence interact with the world. Burson says it was her privilege to photograph these children, for "they are our teachers, as they are masters in the art of self acceptance." The *Faces* book was, for Burson, "about shifting people's vision, allowing the viewer time for their eyes to adjust."

For a later series, Burson took up the Holga, which she considers to be a step up from the Diana. Training her eye on healers, who use energy toward

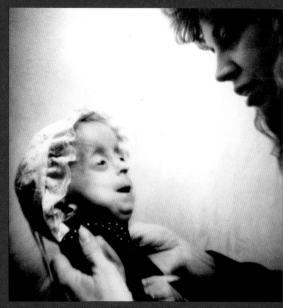

Untitled 1991, © Nancy Burson. Diana camera image from

Holga's single, uncoated plastic lens to record the frequencies they emit as part of the healing process. Several of these images are included in Burson's 2002 book, *Seeing and Believing*.

From her New York studio, Nancy Burson continually creates new work by exploring and expanding her artistic vision.

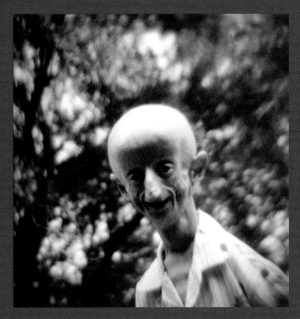

Untitled 1991, © Nancy Burson. Diana camera image from *Faces*.

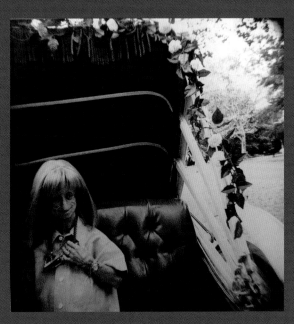

Untitled 1996–1997, © Nancy Burson. Holga camera, silver emulsion on anodized aluminum, 24″ × 24″, from *Seeing and Believing*.

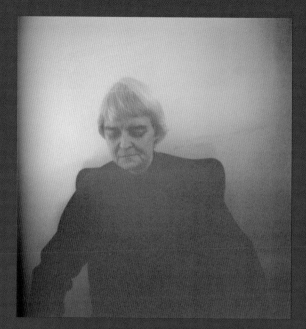

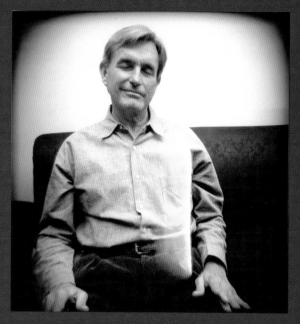

Nancy (Healing Series), © Nancy Burson, 2000. Holga camera chromogenic color print, 39″ × 39″.

Gary (Healing Series), © Nancy Burson, 2000. Holga camera, chromogenic color print, 39″ × 39″.

Michael Kenna—Night Watcher

In the 1960s when young Michael Kenna was at boarding school, his first camera was a Diana (see a photo from that time in Chapter 1). Its fogged, streaked negatives were the first rolls of film he developed himself. In the decades since, he has developed a signature style, making night images with Hasselblads, earning himself the stature of an international photo star. His long exposures take advantage of multiple light sources that come from an assortment of directions, exposing subjects in a way that is distinct from how they are illuminated by the sun. In the past, Kenna turned to the unpredictability of night photography as "a good antidote for previsualization." But after decades of mastering the conditions and equipment to make those images, he is rarely surprised by his standard

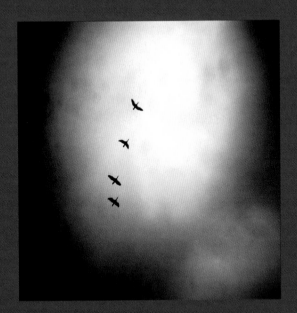

Four Birds Flying, Tbilisi, Georgia, 2008, © Michael Kenna.

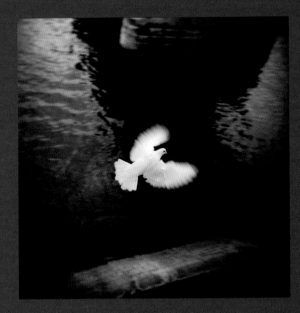

White Bird Flying, Paris, France, 2007, © Michael Kenna.

setup any more. For Kenna, one of the joys of the Holga is that he doesn't have a lot of control over the results. When not on specific photo shoots, Kenna often keeps a Holga in his pocket to capture interesting incidental moments, allowing himself to be more whimsical and playful. Kenna's desire is to create an individual interpretation of what he sees, guided by his aesthetic sense; when a Holga image "works," he adds it to his ongoing body of work. He travels the world making images and calls his Holga "the perfect traveling companion." Kenna lives in Seattle, where he enjoys a climate similar to his native England.

Window Seat, Study 7, Shanghai, China, 2006, © Michael Kenna.

Setting Sun, Beijing, China, 2008, © Michael Kenna.

Susan Bowen—Plastic Panoramas

Susan Bowens's panoramic images, made by overlapping several frames on her Holga camera, capture the vitality and intense pace of life in Las Vegas and her home town of New York City. Given that she has a day job as a computer programmer, her exhibition history is amazingly long, as are her

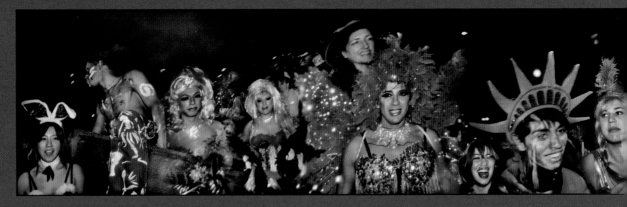

Blue Liberty and Feather People, © Susan Bowen, 2006. One of Susan's multiple-exposure panoramas, made at the New York City Halloween Parade, using flash. Portra 800 negative film, pushed two stops.

mural-sized prints, which can extend up to 8 feet. Expanding her images' reach even more, Bowen has installed images in porcelain enamel up to 48' long. Bowen's images take advantage of the Holga's wonderful ability to capture color, and her eye pulls an ordered beauty out of the chaos of the scenes she shoots. She says, "It delights me how well these mostly unplanned juxtapositions capture my experience of a particular time and place and at the same time have an identity all their own."

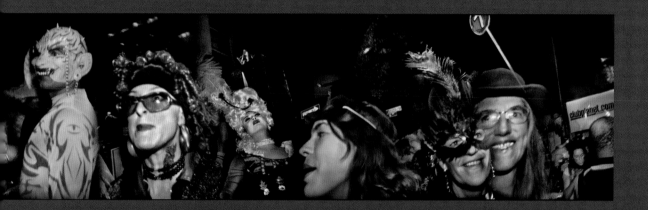

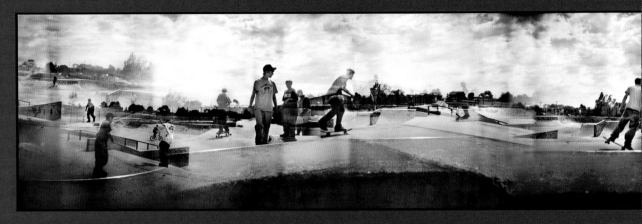

Skateboard Park, Arms Up, © Susan Bowen, 2003. Holga panorama using Ilford 400 film, shot in Santa Fe, New Mexico.

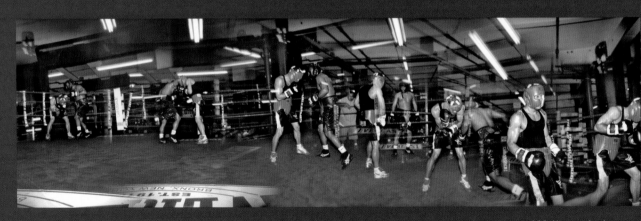

Jumping Jefe, Bare Back, © Susan Bowen, 2007. Shot with flash at Gleason's Gym, Brooklyn, New York, Portra 800 film, pushed two stops. All are printed 7″ × 30″ as digital C-prints.

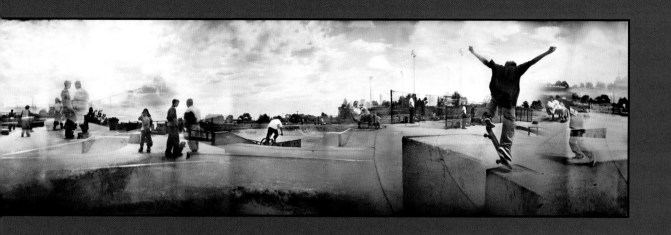

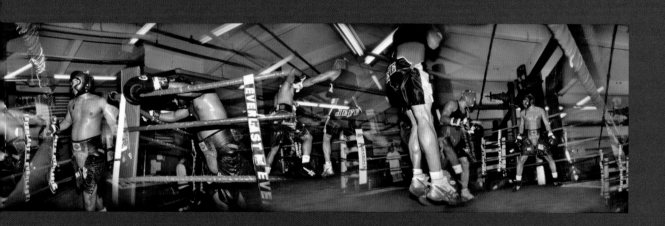

Michael Ackerman—Poetic Visionary

Michael Ackerman is a photographer who sees in ordinary surroundings what most would completely miss. Using not only Holgas but several other camera formats, Ackerman creates bodies of work held together by his particular vision and style. Instead of going for the "decisive moment," he shoots the in-between moments. This slightly awkward timing leads to edgy photos, with a dramatic power and poetic vision. He has collected his images into two volumes. *End Time City* is a series of photographs made in Benares, India. *Fiction* features images made all over the world, but doesn't identify or locate its subjects. It also mixes images by many cameras and includes three complete Holga contact sheets.

Katowice, 2005, © Michael Ackerman.

Ackerman, who was born in Israel and grew up in New York City, now wanders across borders, photographing ceaselessly, trying to capture the emotions he experiences in a place. He is represented by Galerie VU' in Paris, where his work has achieved much recognition.

Atlanta, 1997, © Michael Ackerman.

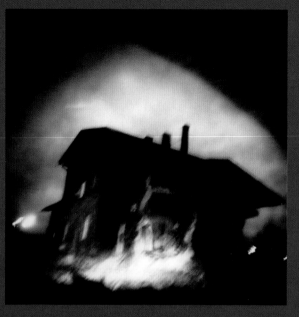

By Tom 1999, © Michael Ackerman. Published in *Fiction*.

David Burnett—Veteran Photojournalist

If anyone has taken advantage of all that photographic technology has to offer, it is David Burnett. In 40 years as a photojournalist, he has used every type of camera, from the simplest film camera to the most advanced digital. While Burnett appreciates what the highest of the high-tech can do, he also values the purity of the simple camera that forces you to really think about what you're doing.

After decades of documenting war, sports, and politics, including every president since John F. Kennedy, Burnett found shooting with the Holga to be a rekindling experience. It has allowed him to see as if picking up a camera for the first time, with nothing between his eye and his subject. A few years ago, Burnett realized that in the world of photojournalism, most shooters were using the same

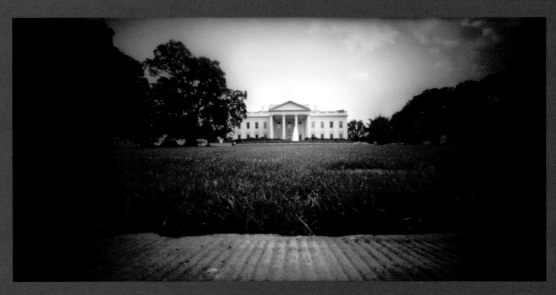

The White House, Washington, DC, © David Burnett/Contact Press Images, 2009. Taken with a Holga wide pinhole camera on Tri-X film.

handful of 35 mm cameras and lenses, creating images that had uniformity in their look. To challenge himself, and create images that would cause a reader to pause, he began using his 55-year-old 4″ × 5″ Speed Graphic, a couple of 2¼″ × 2¼″ cameras, and the light and simple Holga.

From his home base in Washington, D.C., Burnett continues to travel the world, offering his new, but old-style, look to his news and sports photography with his various cameras, including the Holga. His photographic vision has been recognized many times over the years with awards, including two of his Holga images, which garnered him White House News Photographers Association prizes. One of them, *Al Gore Campaigns*, can be seen on page 176.

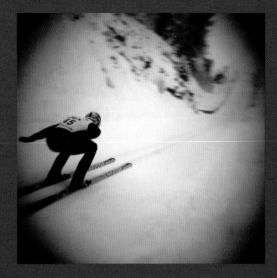

On the Big Hill, Steamboat Springs, Colorado, © David Burnett/Contact Press Images, 2005. Holga camera image.

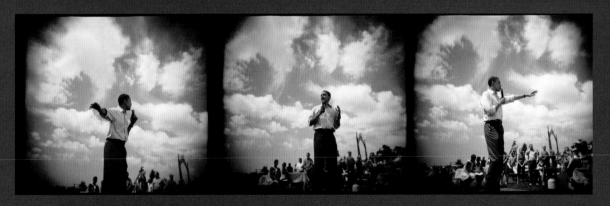

Barak Obama, July 4th, 2008, Butte, Montana, © David Burnett/Contact Press Images. Democratic presidential nominee Obama near the mining museum in Butte attending a picnic with his family.

Mary Ann Lynch

Mary Ann Lynch's journey with the Diana began in 1972 when she was living and teaching in Hawaii. Her first Diana, from a little photography shop in Honolulu's Chinatown, led the way for dozens more. Although Lynch also photographs in other formats, Diana and her clones would eventually become her primary choice for photographing energetic fields and places of power, "where one feels more than the eye can see."

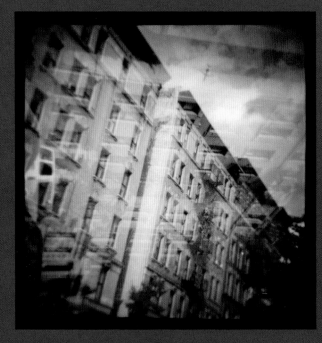

"Kerouac's last digs before taking to the road." © Mary Ann Lynch, 1998, New York City, from *Sweet Inspiration* series. Diana camera with color Kodak pro 120 film, chromogenic print. Lynch previsualized this in-camera double exposure "as a sort of visual jazz riff".

Lynch's plastic camera projects encompass a wide range. *Sweet Inspiration* subjectively glides the viewer into places that have nurtured creativity; for *Entering Egypt*, Lynch found that only her Diana images "held the heightened sense of reality transformed" that she felt in the ancient temples and sacred sites, many off the beaten path.

Working in a new direction, Lynch now "scans her black and white Diana negatives of Hawaiian land and water that hot lava has touched" and then "digitally adjusts tonalities in the metaphysical landscapes that reveal themselves when the visual spectrum is shifted to color." Lynch's connection with the lava in part stems from her work creating a documentary of Kalapana, an ancient Hawaiian

fishing village, in the 1970s. That work continues to garner worldwide attention, but sadly, the village was buried beneath lava in the 1990s.

Throughout her long, inspiring career as photographer, writer, filmmaker, and educator/curator, Lynch has worked with words and images to much acclaim. After many years traveling between her New York City studio and her home upstate, in 2009 she returned to full-time residence in Greenfield Center, where she was born, raised, and lives with her husband Jack.

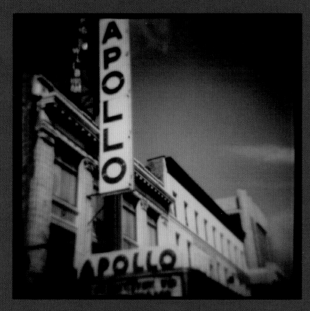

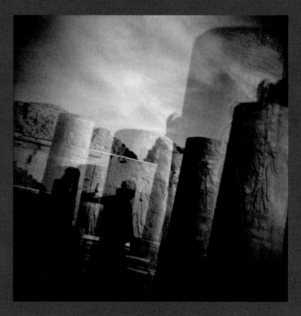

Apollo Theater, Harlem, NY, © 1997 Mary Ann Lynch, from *Sweet Inspiration*. Diana camera with black-and-white Ilford 400 film.

Kom Ombo, 2001, © Mary Ann Lynch, from *Entering Egypt*. Diana camera with Tri-X black-and-white 400 film. In-camera double exposure.

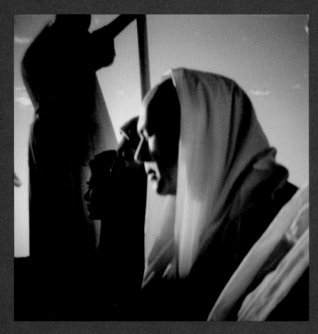

Dawn Sail to Philae, 2000, © Mary Ann Lynch, from *Entering Egypt*. Diana-F camera with Tri-X black-and-white 400 film. Traveling with a group of healers on pilgrimage often meant dressing all in white.

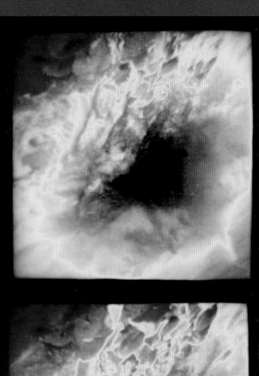

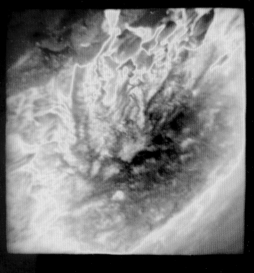

Pele, © Mary Ann Lynch, 2009. Two frames made on black-and-white negative film in a vintage Diana camera. Scans from the contact sheet are converted from grayscale to RGB and then manipulated in Photoshop.

Brigitte Grignet

Belgian photographer Brigitte Grignet brings a humanitarian eye to her imagery. She has photographed projects in Chile, Colombia, the West Bank, Gaza, and Guatemala, documenting communities for herself and for Action Against Hunger. Along with developing her eye for making caring, thoughtful portraits of places and people, she developed a love for the way a Holga captures the world. When Grignet lives with communities, working on her projects "Chiloé-La Cruz del Sur" or "Palestine—Unfortunately it was Paradise," her Holga is her main image maker, with only the occasional shot made with a backup Mamiya 6. The stories she tells are about life, seen through the eyes of a photographer with a stunning eye for images and a compassionate heart.

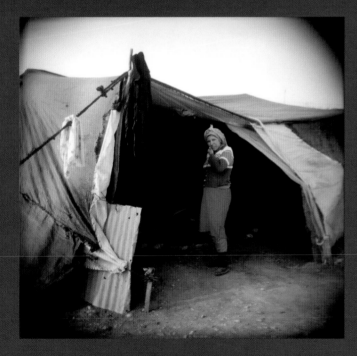

Aysha Naji Ahmad, Bedouin, Al Maleh, Jordan Valley, West Bank, December 2005, © Brigitte Grignet.

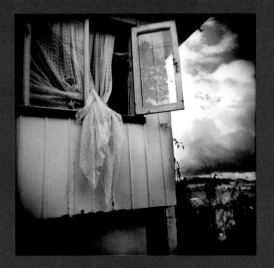

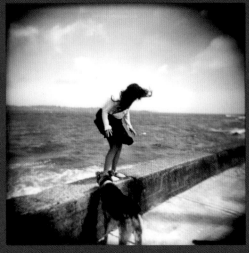

Castro, Chiloé, Chile 2003, © Brigitte Grignet/
Agence VU', from "Chiloé-La Cruz del Sur."

Ancud, Chiloé, Chile 2006, © Brigitte Grignet/
Agence VU', from "Chiloé-La Cruz del Sur."

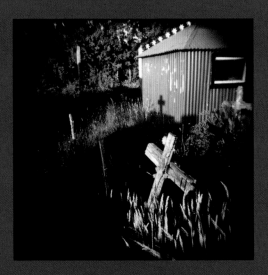

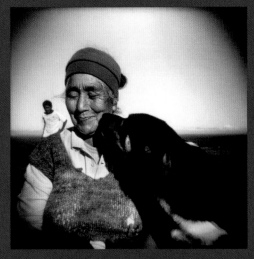

Teupa, Chiloé, Chile 2003, © Brigitte Grignet/Agence
VU', from "Chiloé-La Cruz del Sur."

Tia Carmen, Isla Meulin, Chiloé, Chile 2007, ©
Brigitte Grignet/Agence VU', from "Chiloé-La
Cruz del Sur."

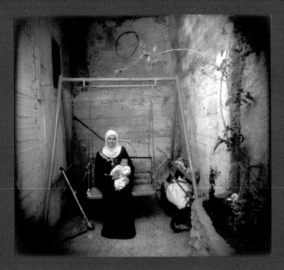

Jehad Ayad and her newborn, Nablus, Palestine 2005,
© Brigitte Grignet/Agence VU', from "Palestine—
Unfortunately it was Paradise."

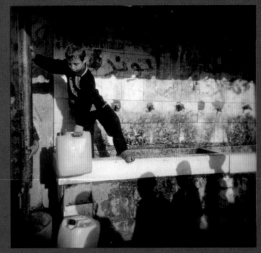

Khan Younis, Gaza, Palestine 2005, © Brigitte
Grignet/Agence VU', from "Palestine—
Unfortunately it was Paradise."

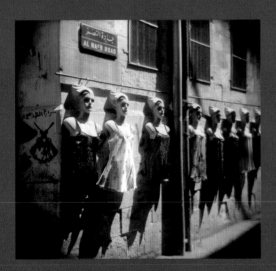

Nablus, West Bank, Palestine 2005, © Brigitte
Grignet/Agence VU', from "Palestine—
Unfortunately it was Paradise."

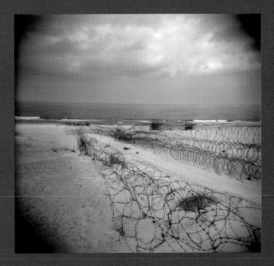

Dougit, Gaza, Palestine 2005, © Brigitte Grignet/
Agence VU', from "Palestine—Unfortunately it was
Paradise."

Sandy Sorlien—Armchair Antarctica

Sandy Sorlien's series *Imagining Antarctica* takes her and the viewer on an imaginary tour of a place she's never been. Frustrated in her attempt to get to the last continent, Sorlien instead photographed scenes in a particularly harsh Northeast winter, evoking the place where her brother coincidentally was stationed. The images and correspondence with her brother are combined in a catalog of the same name.

Sorlien has left teaching and is now involved in the rebuilding of the Mississippi Gulf Coast using Smart Code urban planning software.

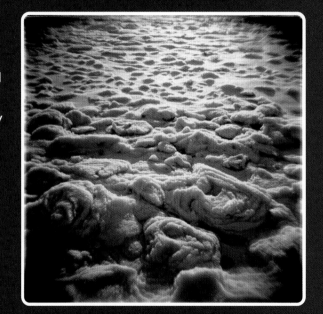

Snow, New Jersey, © Sandy Sorlien, 1996, from *Imagining Antarctica*. Holga camera.

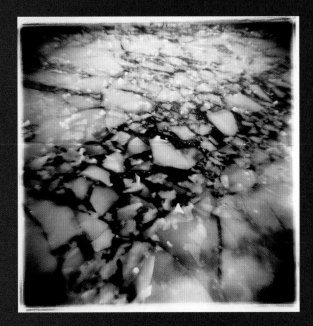

Ice, Philadelphia, © Sandy Sorlien, 1996, from *Imagining Antarctica*. Holga camera.

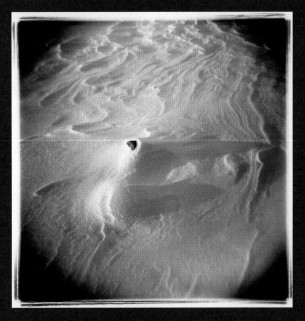

Snow, New York, © Sandy Sorlien, 1996, from *Imagining Antarctica*. Holga camera.

Harvey Stein

Harvey Stein is a professional photographer, educator, lecturer, and author based in New York City. He teaches at the International Center of Photography and the New School University and travels internationally lecturing on photography. Stein has shown his work in almost 200 solo and group shows, has several books of his images, and is represented in dozens of collections. His work has also been published in every photography magazine you can think of and in many other well-known periodicals.

With this kind of a resume, you might picture Stein with a Leica, and some of the time you'd be right. But it is just as easy to catch him wandering New York City capturing the continuous energy and clamor of its street life with a Holga.

Stein has several series done with the Holga. He aims to make "visually complex images that belie the simplicity with which they are made," as seen by this selection of street scenes. He manages to capture, with the most basic of instruments, the "rhythmic, spontaneous, ever-moving scenarios that constantly unfold, change, and disappear before (his) eyes."

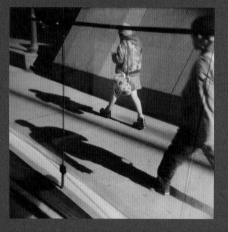

Two People, Two Shadows, © Harvey Stein, 2001. Holga camera split-toned 9″ × 9″ silver-gelatin print.

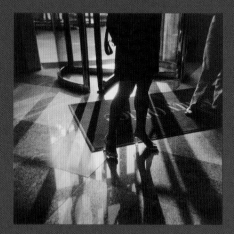

Legs, Austin, Texas, © Harvey Stein, 2002. Holga camera split-toned 9″ × 9″ silver-gelatin print.

Fire Escape, Madison, NJ, © Harvey Stein 2003. Holga image, made with Tri-X film, split-toned silver gelatin print.

Eric Havelock-Bailie

Eric Havelock-Bailie is an active member of the Denver photography community. He used nothing but Diana cameras from 1981 to 1993 and created a close-focusing portrait Diana by extending the lens barrel. His image making is, like his friend Wesley Kennedy's, very concept-oriented. These portraits were made just days before Kennedy passed away.

Wes Kennedy Number 2, © Eric Havelock-Bailie, 1993. Diana camera, modified for close focus, 15″ × 15″ silver-gelatin print.

Wes Kennedy Number 5, © Eric Havelock-Bailie, 1993. Diana camera, modified for close focus, 15″ × 15″ silver-gelatin print.

Wesley Kennedy—Photographic Light

Wesley Kennedy was a shining star of the Denver photography scene in the 1980s and early 1990s until his death in 1993. He was an energetic explorer, creating staged work with complex concepts and capturing the images with a Diana camera. His personal and unique voice was an inspiration to photographers in his community. In a catalog accompanying a retrospective of Kennedy's work in 1993, critic Jane Fudge comments on *The Overman Series*: "This powerful group of photographs confronts primal fears and social problems at the same time. Kennedy sets the modernity of his sentiments about the unthinkable future against nostalgia for a misunderstood past."

Cheating Death, © Wesley Kennedy, 1986, from *The Overman Series*. Diana camera image. Courtesy of Michael Murray.

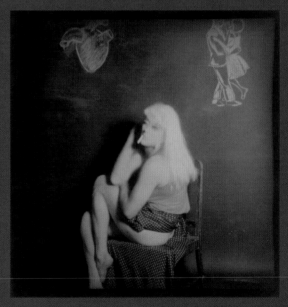

The Prostitute, © Wesley Kennedy, 1986, from *The Overman Series*. Diana camera image. Courtesy of Michael Murray.

fotovitamina: Rosanna Salonia and Matthew Yates

Partners in their photography and life, Rosanna Salonia and Matthew Yates each use Holga cameras in their personal work and for their work together as fotovitamina. Commercial and fine-art photographers based in Tucson, they use a wide variety of techniques for making their images and their final prints.

Yates collects vintage frames and presents his prints salon-style, with the mix-and-match style of the frames and layout complementing his timeless, moody images.

Salonia creates her prints as objects, coating them in wax and distressing them so each one is a unique object. They are hung on the wall or presented in collected wooden boxes, with print sizes ranging from 2¼″ contact prints to 8″ × 8″. See photos of their installations in Chapter 11.

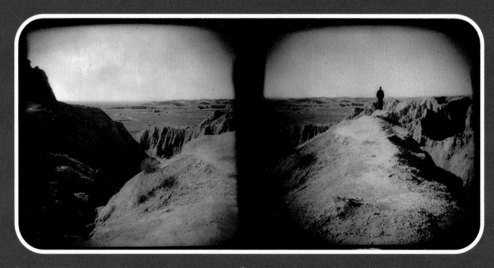

Badlands, South Dakota, from the *Universi* series, © Rosanna Salonia, 2004–2006. Tea-toned, beeswax-coated, and hand-shaped 2.5″ × 5″ silver-gelatin contact print diptych. Image made with a Holga on a coast-to-coast road trip.

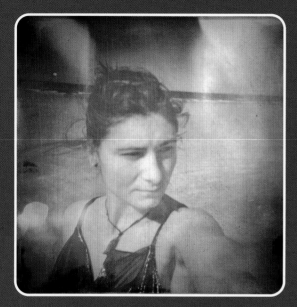

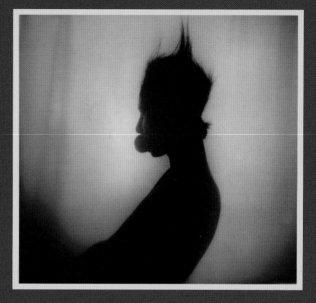

Rosanna, Sea of Cortez, Sonora, Mexico, from the *Universi
Series*, © Rosanna Salonia, 2000–2004. A 10″ × 10″
silver-gelatin print, bleached and copper-toned, beeswax-
coated, and hand-shaped. Handheld Holga image using
Ilford FP4 Plus film.

Fin, © Matthew Gordon Yates, 2005, from the *Beautiful
Nightmare* series. Holga tea-toned silver-gelatin print, made
with Fuji NP 400PR film.

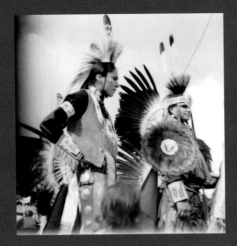

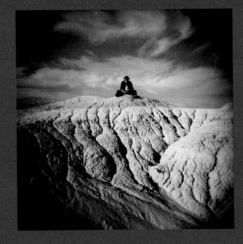

Powow, © fotovitamina [Rosanna Salonia + Matthew Yates] 2009, San Xavier Mission, Tucson, Arizona. Shot using the Holga's bulb setting on expired Fuji RDP III transparency film and cross-processed.

In Clambodia, © fotovitamina [Rosanna Salonia + Matthew Yates], 2008, Petrified Forest National Park. Cross-processed expired Fuji RDP III film.

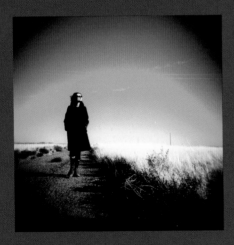

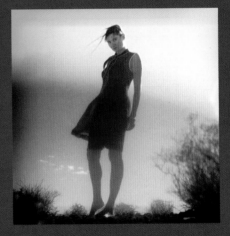

Green Coated Turista, © fotovitamina [Rosanna Salonia + Matthew Yates], 2008, Petrified Forest National Park, Arizona.

Siren, © fotovitamina [Rosanna Salonia + Matthew Yates], 2008, Petrified Forest National Park. Shot with orange sunglasses lens held halfway over the Holga's lens, cross-processed expired RDP III film.

Teru Kuwayama—Humanitarian Photographer

Teru Kuwayama totes his Holgas as part of his collection of cameras all around the world documenting humanitarian crises. Working independently, he has witnessed wars and disasters in Iraq, Afghanistan, Pakistan, New Orleans, and elsewhere. His dramatic, award-winning photographs have wound up in the pages of publications, including *Time* and *Newsweek*. Not content with just seeing his work published, Kuwayama volunteers for Central Asia Institute, which builds schools in remote areas of Afghanistan and Pakistan. He dreams of having a "ruggedized" Holga that can withstand the rigors of his constant world travel. When he takes a break, he makes his home in New York City, where he helps run the Lightstalkers web site, which provides an online home for those who wander the world for work and art.

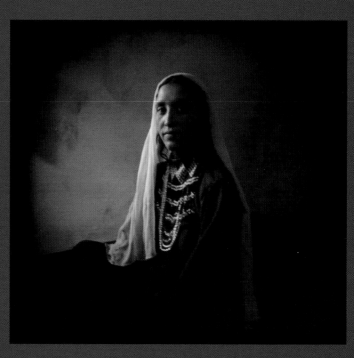

Wakhan Corridor, Afghanistan 2009, © Teru Kuwayama, 2009.

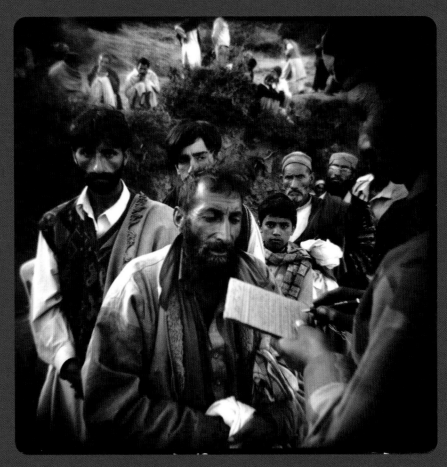

Relief Supplies, Nosari, Pakistan-Occupied Kashmir, © Teru Kuwayama, November, 2005.
Holga camera on Tri-X film. Pakistan Army soldiers check ration cards as survivors line
up for relief supplies. A massive earthquake killed some 80,000 people and displaced
millions in the region.

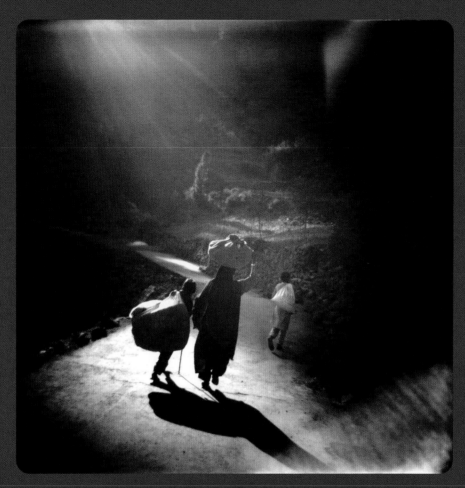

Relief Supplies, Nosari, Pakistan-Occupied Kashmir, © Teru Kuwayama, November, 2005. Holga camera on Tri-X film. A family carries away relief supplies from a distribution point in the mountains after the earthquake.

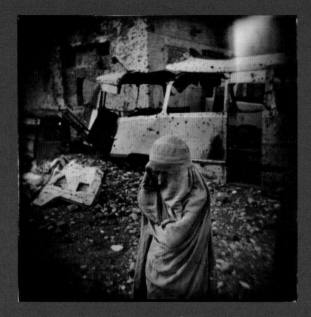

Aftermath—Rebuilding Afghanistan, © Teru Kuwayama, 2002, Kabul, Afghanistan.

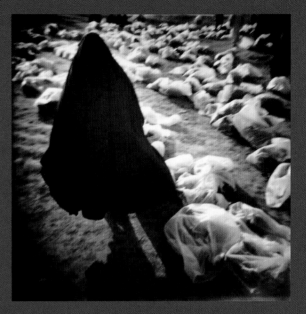

Exhumed Bodies at Mass Grave in Hilla, Iraq, © Teru Kuwayama, 2003. A Shia woman searching for family members' bodies at Hila, near Baghdad.

Mark Sink—The Diana King

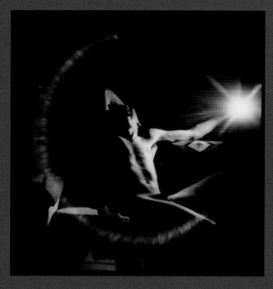

Self Portrait, © Mark Sink, 1979–1980. One of Sink's first Diana images on Tri-X film.

Mark Sink and the Diana have had a long and fruitful relationship. It began in the late 1970s when he discovered a Diana he had used as a child with undeveloped photos of his mother still inside. Seeing these images taken from his short vantage point, he realized the art potential, thinking he was breaking new ground. After winning a Kodak Images in Silver Award with photographs from his first Diana, his bubble was burst when he learned that Dianas had made the rounds and, in fact, *The Diana Show* had already been published. Luckily, he trudged on with his little blue love and continued to make art, having his first solo show in New York in 1986 with the Diana series *Twelve Nudes and a Gargoyle*.

Sink had Dianas in hand, right next to his trusty Polaroids, while living in New York City and hanging around Andy Warhol at the Factory throughout the 1980s. Starting with self-portraits shot with flash and moving on to elaborate studio setups, Sink produced memorable photographs in the fine-art and commercial realms. He has captured the images of many celebrities, including Warhol, Jean Michel Basquiat, and Rene Ricard.

A relentless community organizer, Sink has coordinated various plastic camera projects over the years, in addition to opening Gallery Sink in Denver, cofounding the Denver Museum of Contemporary Art, and curating the Denver Salon. Sink teaches workshops and continues to pursue his own art and commercial work. He has written extensively about Dianas and other toys and has been a juror for the Krappy Kamera show at Soho Photo Gallery in New York City.

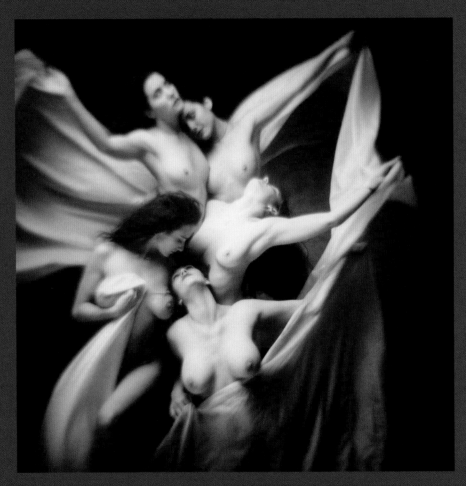

Nymphs #1, © Mark Sink, 1997. Plus-X film.

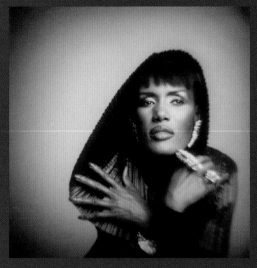

Grace Jones, © Mark Sink, 1989. Taken with studio strobe light on Plus-X film.

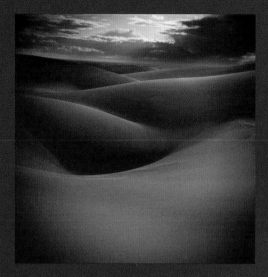

Dunes, Great Sand Dunes National Monument, Colorado, © Mark Sink, 1998.

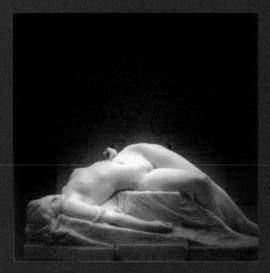

Nude 2 Canova Nude, © Mark Sink, 1987.

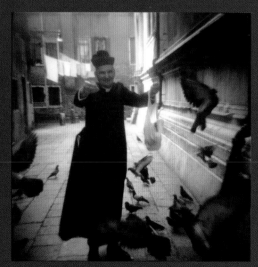

Italy Priest, © Mark Sink, 1998, Venice.

Gyorgy Beck—Multimedia Visionary

Hungarian photographer Gyorgy Beck has dipped into many realms of art, in many parts of the world. A cinematographer, painter, and photographer who also works in set and exhibition design and creates video installations, he combines forms to create unique works.

Beck's Holga photos of Auschwitz are presented within glass blocks, giving them both an ethereal glow and a grounding in structure that brings home the reality of the place (see page 239). His Holga image of a massive stone Buddha statue is printed on a filmy fabric that sways in the slightest breeze. Other stark images are printed on sheets of aluminum, with the imperfections of hand-coating and distressing of the medium adding depth to the scene.

Beck's metaphysical landscapes, made with a Holga and whatever expired film the photographer happens to have on hand, transport the viewer into realms that are both timeless and meditative.

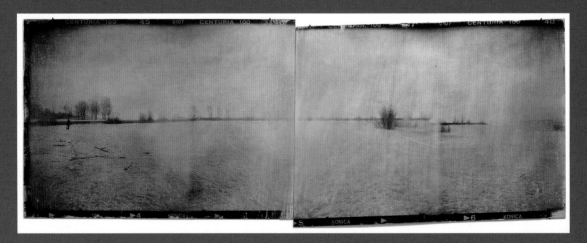

Sylvia, © Gyorgy Beck, 2001. Holga camera photograph (with a far-off view of Sylvia Plachy) printed with liquid emulsion on aluminum.

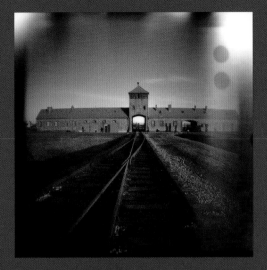

Auschwitz 11, © Gyorgy Beck, 2002.

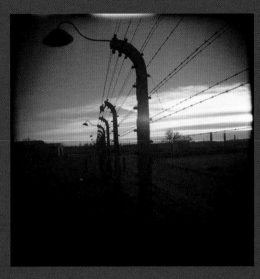

Auschwitz 16, © Gyorgy Beck, 2002.

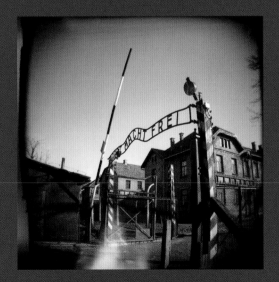

Auschwitz 40, © Gyorgy Beck, 2002.

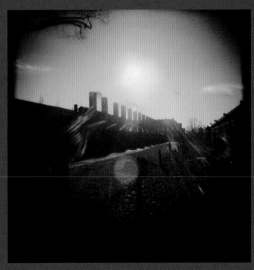

Auschwitz 85, © Gyorgy Beck, 2002.

Richard Ross

Richard Ross has an extensive 30-year catalog of exhibitions and publications to his name. A teacher at the University of California, Santa Barbara, since 1977, he also does commercial photography and creates highly conceptualized and designed exhibitions. The *Fovea* series consists of collections of dozens of images made with his Diana camera, from 1979 to the present, taken using the bulb setting. The collections are presented with the 30″ × 30″ images stacked edge to edge, floor to ceiling, allowing the viewer to swim in a sea of slightly blurry color images.

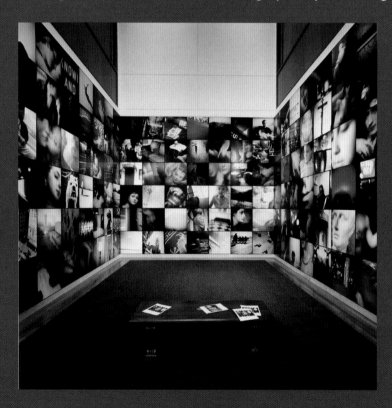

Fovea, © Richard Ross. 180″ high × 210″ across each of three walls. Opened September 11, 2001 at the Speed Museum of Art, Louisville, Kentucky.

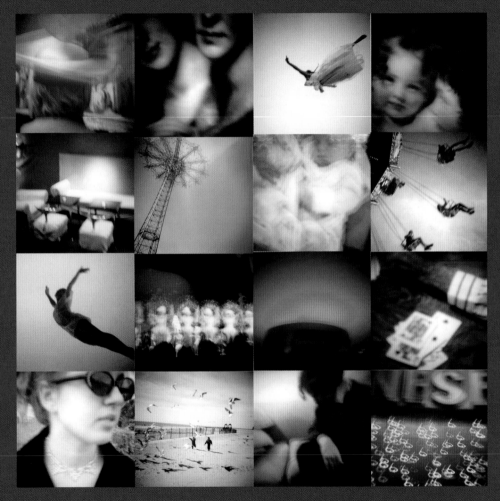

Fovea, © Richard Ross, 2006.

Annette Fournet—Plastic Perception

Annette Fournet appreciates the beauty of things imperfect, impermanent, and incomplete. This description could refer to a Diana camera, but to Fournet it describes the Japanese aesthetic of wabi-sabi, which she brings to her images. Among other ideas, wabi-sabi is based on tenets of intrinsic simplicity, intuition rather than logic, acceptance of the inevitable, and beauty of the inconspicuous or overlooked detail. In such series as *Sticks, Stones, & Bones*, Fournet photographs the changing

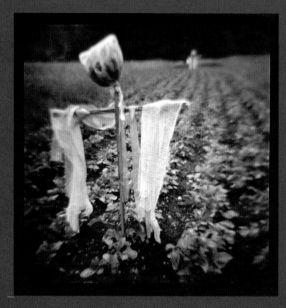

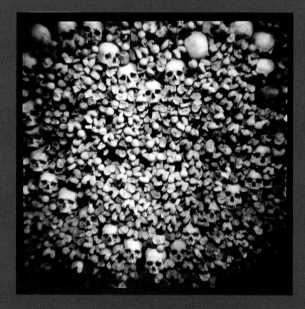

Kalimbina, Poland, © Annette Fournet, 2004, from the *Sticks, Stones, & Bones* series. Diana camera image made amidst the confused stares and questions of the Polish locals.

Melnik, Czech Republic, © Annette Fournet, 1999, from the *Sticks, Stones, & Bones* series. Diana camera with bulb setting; image made in an ossuary of sculptures made of plague victim bones.

landscapes of central Europe and the American south, both places with a strong cultural heritage giving way to the inevitable forces of change.

As a long-time photographer and educator, Fournet has been able to create images of lasting beauty with her Diana, which she first discovered in the late 1980s and which she continues to treasure for its unique qualities. Documenting places such as the Czech Republic, where she founded and spent 8 years running the Prague Summer Program, Fournet has captured scenes from lonely scarecrows in disappearing villages to a sad longing in ossuaries. Wabi-sabi may be how Fournet describes her images, but the idea also describes the simplicity, inevitable flaws, and unknowing angst of photographing with our beloved plastic toys.

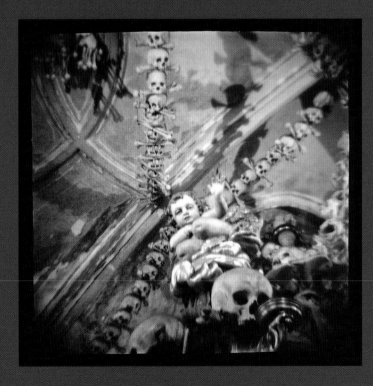

Sedlec, Czech Republic, © Annette Fournet, 2005, from the *Sticks, Stones, and Bones* series. Rand camera (Diana clone), taken in an ossuary.

James Balog—Naturalist Photographer

James Balog expands the bounds of how nature is represented in photography. Of his 25-year career, he says, "I consider myself a photographic artist who looks for fresh ways for humans to look at nature and to understand themselves in relationship to it." In his world-famous series of images of endangered species, Balog brought them out of the idealized backgrounds they are usually pictured in and framed them instead on stark white backdrops, creating stylized images that highlight their endangered status. In another, Balog took on documenting the oldest and most spectacular trees in North America. Some of these images were massive technical projects, but to visually embrace a small gnarled bristlecone pine, over 4000 years old, he pulled out a Holga. For *Audubon* magazine, Balog used his Holgas to document orangutans in Borneo. There, he created a compassionate portrait of these apes within their threatened environment, the Tanjung Puting National Park. Colorado-based Balog has also taken Holgas to Nepal, Africa, and the Arctic.

Balog's latest project, *The Extreme Ice Project*, uses time-lapse digital photography to document the disappearance of glaciers as a tangible example of the effects of climate change.

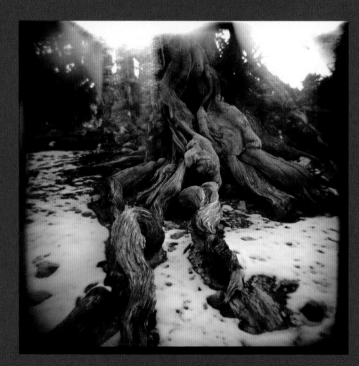

Intermountain Bristlecone Pine, © James Balog, 1998, Inyo National Forest, California. This is one of the oldest trees in the world.

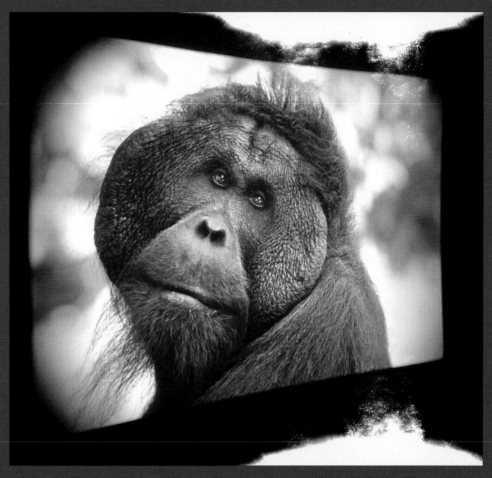

Borneo Orangutan "Kusasi," © James Balog, 1999, alpha male, Tanjung Puting National Park, Indonesia.

Susan Burnstine—Ethereal Imagery

Susan Burnstine doesn't use a Holga, a Diana, or any other manufactured camera for her fine-art work. Her tools are entirely homemade; the creation of the camera is intimately intertwined with the creation of the images, and the results are distinctively hers. Her many years of refining cameras and imagery have led to photographs that are stunning in their beauty and uniqueness and have earned Burnstine worldwide recognition.

Sporting hand-crafted plastic lenses, bits of rubber, and household odds and ends, Burnstine's cameras' unique views provide a conduit for her to represent intangible themes, including dreams and the unconscious. Her compelling artistic vision allows her to create ethereal images that embody her own emotions, while also allowing viewers to project and interpret their own. No matter what the camera, therein lies the magic of photography.

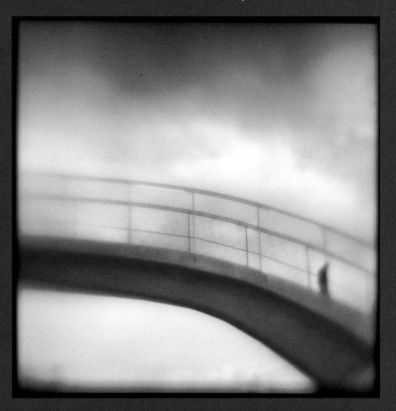

Bridge to Nowhere, © Susan Burnstine, 2006.

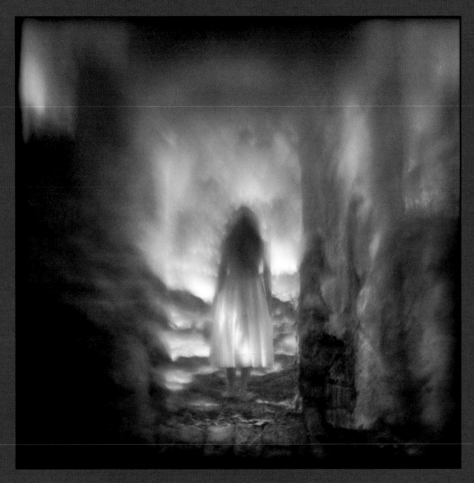

Threshhold, © Susan Burnstine, 2008.

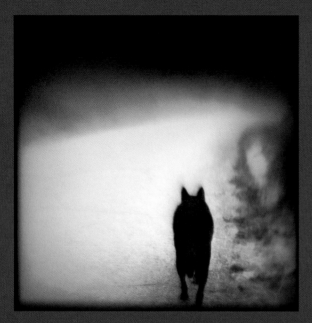

The Road Most Travelled, © Susan Burnstine, 2006.

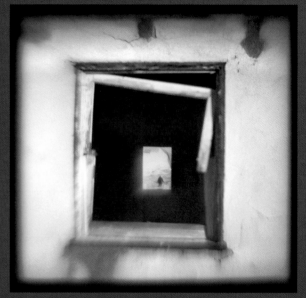

Unending, © Susan Burnstine, 2006.

Perry Dilbeck

Commercial photographer and instructor at the Art Institute of Atlanta, Perry Dilbeck is another accomplished shooter who counts the Holga among his cameras of choice. Dilbeck spent more than 8 years on a series of images called *The Last Harvest: Truck Farmers in the Deep South*, documenting a fading way of life. Images from this series have been published in a number of magazines, and Dilbeck received a sponsorship from the Blue Earth Alliance for the project. The 2006 book of the series is available from University of Georgia Press.

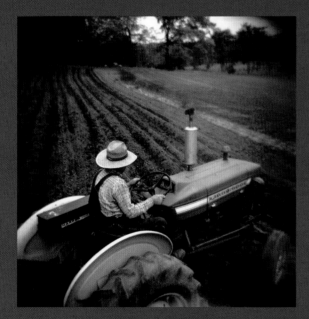

Spring Plowing, © Perry Dilbeck, 2004, from *The Last Harvest: Truck Farmers in the Deep South*. Holga camera image; 14″ × 14″ silver-gelatin print.

Pecans, © Perry Dilbeck, 1998, from *The Last Harvest: Truck Farmers in the Deep South*. Holga camera with old movie projector lens attached; 14″ × 14″ silver-gelatin print.

Leavell Smith, © Perry Dilbeck, 2003, from *The Last Harvest: Truck Farmers in the Deep South*. Holga camera image; 14″ × 14″ silver-gelatin print.

Jennifer Shaw

Jennifer Shaw adopted her current home of New Orleans in 1994. Her visual fascination with the city has led her to create many series of images, representing both the city's more beautiful sides and its grittier ones.

Many of her projects were made before the transformation of the city by Hurricane Katrina and the subsequent flooding, but, like many others, Shaw created art out of the disaster, with her own personal twist. Jen and her husband evacuated the day before the hurricane, while she was pregnant with her first child. On the road with their two dogs and two cats, Shaw delivered her son the day Katrina hit, in a strange town far from home. The family spent 2 months traveling the country, watching the fate of their hometown on TV. Only after returning was Shaw able to create a document of their ordeal, using toy models and a magnifying glass to create scenes from her memory; these grew into a narrative series of self-portraits illustrating her experiences and emotional state during her family's time in exile.

Since her homecoming to the city, there has been a renaissance in the photography world there, spurring the creation of the New Orleans Photo Alliance; Shaw is a founding member. She continues to enjoy New Orleans in all its complexity, along with her growing family.

Felicity Street with Rain, © Jennifer Shaw 2002. Holga with Tri-X film, split-toned silver-gelatin print.

We left in the dark of night. 2006.

At the hotel in Andalusia we tried not to watch the news. 2007.

At 3:47 a boy was born. 2006.

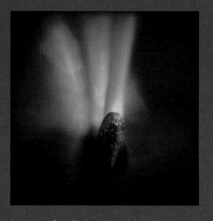

In the morning we turned on the T.V. 2007.

It was months till the phone was restored. 2007.

In spite of it all, there's no place like home. 2007.

From the series *Hurricane Story* (graphic novel with 46 images), © Jennifer Shaw, 2007. Series was created using a Holga camera with a magnifying lens held in front. Portra 160NC film.

Louviere + Vanessa

Jeff Louviere and Vanessa Brown are an infinitely creative team living and making art in New Orleans. After bringing together their individual artistic talents and experience, they have gone off in innovative directions with their photography that are hard to grasp, even when viewing the images and hearing their explanations. Mixing photography with elements of filmmaking, painting, and printmaking and mingling media and elements ranging from resin, gold leaf, and hand-made papers to wax, blood, and New Orleans tap water, they question and experiment with every aspect of the final piece. Combining play with scientific experimentation, Louviere + Vanessa use craft and concept to explore themes of duality from a variety of perspectives.

Their video, *Repetition/Compulsion*, was created with 1944 individual Holga frames. It caught the interest of Rosanne Cash, who hired them to create a Holga video for her. Their cineagraphs are created by taking Super-8 films of a single photograph and then making an image from the cut-up motion-picture film (see page 230).

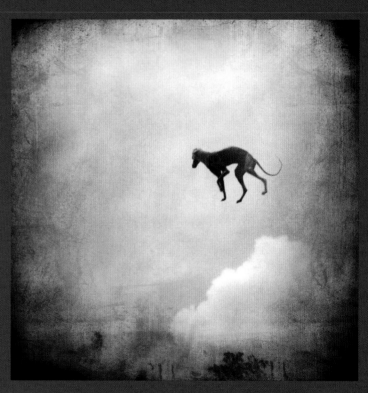

945 (flying), © Louviere + Vanessa, 2005, from the *Creature* series.

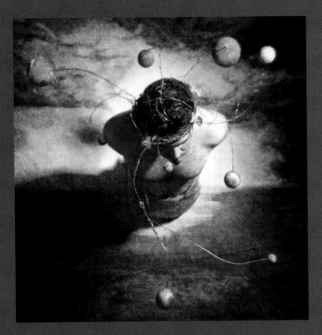

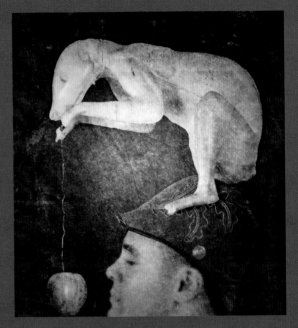

Equilibrium, © Louviere + Vanessa, 2004, from the *Slumberland* series.

Mr. Giggles Plays God, © Louviere + Vanessa, 2005, from the *Creature* series.

Theory of Chaos, © Louviere + Vanessa, 2004, from the *Slumberland* series.

Fridge, © Louviere + Vanessa, 2005, from the *Overawe* series, New Orleans. Archival pigment print on handmade kozo paper, stained with tea and New Orleans tap water.

The Rain Will Breathe Life in Wiltshire, © Phil Bebbington, 2006. A Holga camera image using Fuji NPZ800

chapter three

That's So Cute!

For the early adopters of toy cameras as serious photographic tools, there were few other choices in the 1960s and 1970s—Dianas and their clones were it. In the 1980s, the main options were the Holga 120S and 120SF, both introduced in 1982. In the 1990s the Lomographic Society began producing other plastic wonders and breaking out into new markets, which increased the awareness and use of these low-tech cameras greatly.

The new millennium, all the way to now, has ushered in new players, including Freestyle Photographic Supplies and Superheadz. Their cameras, accessories, and other products continue to expand the offerings even more, while analog photography in general has been in a precipitous decline. Not all the new additions adhere to being "cheap," a feature once integral to the definition of these cameras; new versions routinely cost in the three digits.

Because the Holga opened up the world of photography for me and has been the most popular plastic camera for the past several decades, I'll begin talking about the world of plastic cameras with her and then move backward into the world of Diana before getting to today's ever-expanding low-tech camera culture. For continually up-to-date information about the latest cameras, along with reviews

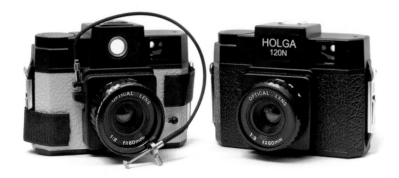

The Holga 120N, with a Holgamods version. It has a custom bulb modification that's accessible even when mounted on a tripod, cable release, waist-level viewfinder, and a step-up ring screwed into the lens for attaching filters.

and images, keep an eye on the magazines and blogs listed in the Resources section. It's an exciting, rapidly changing time in the world of plastic cameras!

THE HOLGA

All Holgas have the same basic features. The original Holga, the 120S, and the current flagship, the 120N (introduced in 2005), take 120 film and can shoot it in two formats: 6 × 6 cm squares (also called 2¼, for inches) and 6 × 4.5 cm rectangles. The spring shutter delivers a shutter speed of approximately 1/100 of a second. The aperture is somewhere about f/11 and, contrary to what you would expect, has in the past changed by moving the aperture switch. This is changing in newer versions, which have added a functional smaller aperture to the arm. The Holga's self-declared "OPTICAL LENS" is a single-element, uncoated plastic lens, with a focus setting ranging from around 4 feet to infinity. Much more information specific to Holgas is presented in Chapter 5, and Holga modifications are covered in Chapter 8.

Medium Format (120) Holgas
Holga 120S and 120SF

In production from 1982 to 2005, the original Holgas came with a hot shoe (120S) or built-in flash (120SF). This basic design was produced for more than 20 years and vaulted the Holga to worldwide fame.

Holga 120N

The current flagship model retains the classic spring-shutter mechanism and hot shoe and adds a tripod socket and a bulb setting that allows for long exposures. Some newer versions have two functional aperture settings—at last.

Holga 120FN and CFN

These versions have built-in flash, with the CFN model also sporting a rotating series of colored filters: blue, red, and yellow, in front of the flash.

Holga 120GN, 120GFN, and 120GCFN (Previously Called Woca)

These versions of the Holga feature glass, instead of plastic, lenses. They may look and feel like Holgas, but aren't really part of the plastic-camera club.

Colorful Holgas

Dubbed by Freestyle Photographic, which is based in West Hollywood, as the Holgawood Collection, many Holga models are also now available in a variety of colors. If basic black doesn't do it for you, try white, purple, hot pink, silver, camouflage, or any of the other options. Other accessories, including vinyl "skins," are available to further customize your Holga.

35 mm Holgas

These Holgas have become more popular as professional film-processing facilities that work with 120 film have disappeared. They combine the simplicity of the 120 Holgas with the convenience of 35 mm.

Holga 135, 135 BC, and Pinhole

These are 35 mm versions of the Holga. Because the original doesn't have the "Holganess" of the 120 version, the BC model adds a mask that creates vignetting on the images. Holga 35 AFX is a discontinued 35 mm model.

Holga K-Series

This series includes versions with color flash, multiple-exposure button, and fish-eye lens. The K-200NM is a fish-eye version.

Holga TIM

This is a half-frame 35mm, two-lensed version with a big smile and lots of personality, released in 2010.

Twin-Lens Holgas
Holga TLRs

In 2009, the line of twin-lens Holgas was introduced. While the lens and

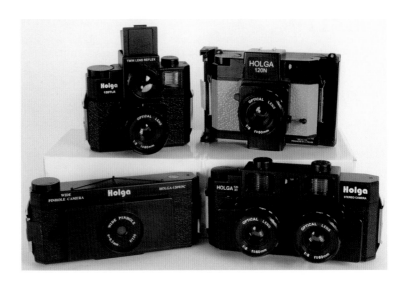

As if Holgas weren't weird enough to start with, some new versions go even farther out on a limb. Now we have the Holga TLR (twin lens reflex), Holga with instant film back, Wide Pinhole Holga, and Stereo Holga.

shooting mechanisms are unchanged, viewing is through a waist-level viewfinder used by looking down at the camera through a supplementary lens. The series includes the 120 TLR, 120 GTLR, 135 TLR, and 135 TLR BC.

PinHolgas
120PC, 120WPC, and 135PC

These hybrids make transitioning to a pinhole camera a snap. The 120PC and 135PC are like the standard versions, with just a pinhole instead of lens. The Holga Wide Pinhole Camera is a new beast altogether and is my favorite of the new generation. Its wide-format body shoots up to 6×12 cm panoramic images, with or without an insert, and 6×9 cm with an insert.

Stereo Holgas

Another bizarre-looking camera, the Stereo Holga 120-3D has a wide-format body with two lenses, two flashes, a coupled shutter, and a viewfinder right in the middle. A stereo pinhole version (Holga 120PC-3D) is also available, along with mounts for the images and a bulbous stereo viewer.

Holgamods

Since starting his Holgamods business in 2000, Randy Smith has been customizing Holgas to expand their capabilities. His basic modifications include flocking (painting the interior flat black to decrease light bouncing around in the camera) and adding two true apertures, a higher quality bulb setting, tripod port, and closer focusing capabilities. Randy pioneered the bulb setting, coloring the body, cable release attachment, and twin-lens and stereo Holgas, all of which have since been added to Holga models or accessories by Holga Limited, and he continues to innovate. For more information, along with tips and images, go to www.holgamods.com.

THE DIANA

The reverse technology movement truly began with the Diana in the late 1960s. Dianas were made in two versions: the Diana and the Diana-F, which came with a dedicated external flash unit that used disposable flash bulbs. In the 1970s, many different brands of almost identical cameras were produced, with a multitude of names and of varying quality. Some of the best known are the Arrow, Banner, and Dories. See Allan Detrich's collection, which includes over 100 versions; it is now owned by the

Part of the charm of these cameras is their whimsical, colorful packaging.

Lomographic Society and viewable on their web site and occasionally in shows at their stores worldwide. Although highly collectible Dianas and clones are still used actively, these days they go for a lot more than $3 on eBay. But once in a while they still crop up at yard sales and thrift stores, so happy hunting. Here's the good news: as of 2007, the reborn Diana+ allows entry into the Diana realm for a whole new generation of photographers.

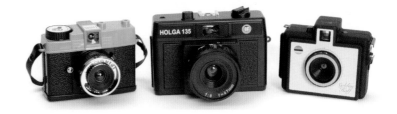

35 mm plastic cameras are extremely popular now, especially in areas where 120 film processing isn't available. The most popular of these smaller cameras are the Diana Mini, the Holga 135, and the Golden Half, representing the three major players in the toy camera world.

Vintage Dianas, like Holgas, have many quirks that either endear them to photographers or drive them crazy. Dianas are by far the leakier of the two, so more taping around the body seams is necessary to keep images from getting streaked. Most versions had bulb settings, but no tripod outlet, so other ways had to be devised to keep the body still during long exposures. Some photographers incorporated the blur into their images instead.

Dianas create sixteen 4 × 4cm images per roll of 120 film. This leaves a considerable amount of unused film on each roll, but can reduce the amount of light leaks that infiltrate the image area. Dianas have three true apertures, pictured on the front of the lens as cloudy, partly cloudy, and sunny. These measure out to around f/11, f/13, and f/19, which help ensure reasonably sharp images, but make low-light shooting a challenge. Diana images are softer, and the cameras are more delicate than Holgas, but each photographer has his or her own visions, and many treasure their aging Dianas.

Diana+, Diana F+, and Diana Mini

In 2007, the Lomographic Society took history into its own hands and resurrected the Diana in a new version called the Diana+. After reverse-engineering a body that is almost identical looking to

an original Diana, they added several new features: two formats (4.2 × 4.2 cm and 5.2 × 5.2 cm), a removable lens, built-in pinhole, and Endless Panorama mode. Later, they added a Diana F+ version and a removable electronic flash, which comes with an adapter that allows its use on any camera with a hot shoe. The newest addition to the line is the Diana Mini, an adorable 35 mm version that shoots square and half-frame images.

Lomographic also produces numerous versions of the Diana+, featuring different colors, with some cobranded with popular bands (such as the White Stripes). Various kits are available that include a camera, flash, add-on lenses, film, and other accessories. The price point and allure of the new Dianas and their accessories can burn a large hole in your wallet if you're not careful.

ACCESSORIES

Holga Limited and the Lomographic Society have been busy producing a multitude of accessories for Holgas and the Diana+, giving photographers a sometimes overwhelming assortment of ways to shoot with their toys. This may be a boon to photographers who love to experiment, but may also take away from the inherent simplicity of using cameras with few-to-no adjustments.

Holga Accessories

Cable Release Adapter

This is my favorite accessory, which slips over the Holga lens and allows attachment of the locking cable release, which is included, for making long bulb exposures.

Instant Film Back (Holgaroid/Polga, etc.)

There have been several versions over the years, using different versions of film and produced by a few entities. See details in Chapter 8.

Filter Sets

Holga originally produced three filter sets, usable on Holgas with a custom adapter. These are a solid-color filter set, another with clear centers and mottled colors that create blur in the rest of the frames, and three beveled filters that create multiple images. These have been joined by close-up (500, 250, and 125 mm) and macro (60 and 30 mm) filter sets, which slide satisfyingly onto Holga lenses; no adapter necessary (see Chapter 8).

Accessory Lenses

The Holga Tele Lens 2.5× and Holga Wide Lens 0.5× allow different angles of view using your standard Holga; of course the viewfinder doesn't change, leading to even more guesstimating of composition. Two fish-eye lenses are available—one from Holga Ltd. and one made by the Lomographic Society. Both come with external viewfinders that give some sense of what you'll get.

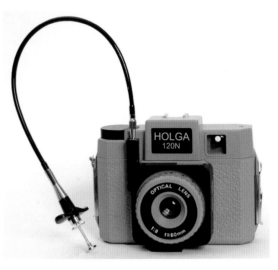

Holgas and Diana+s have dedicated cable release adapters for easy long-exposure shooting.

Diana+ Accessories

The Lomographic Society also continues to add accessories to its Diana+ line.

Cable Release Adapter

Yes, now there's one for the Diana+ too.

Lenses

Because the Diana+'s standard 75 mm lens is removable, other lenses can be swapped in easily. These include 55 mm and 38 mm wide-angle lenses; the latter including a close-up add-on; 20 mm fish-eye; and

a 110mm telephoto, which also includes a soft-focus add-on. There's even an adapter available that lets you use any of these lenses on Nikon and Canon bodies.

The Diana Instant Back+

uses Fuji Instax Mini film—for instant gratification with super-cute little prints.

SUPERHEADZ

This newcomer in the world of plastic cameras has burst onto the scene, thrilling toy cam aficionados with their original creations. Their film cameras are detailed here, and their digital video offering is given later in the chapter. All of their cameras come in a variety of colors and designs. See www.superheadz. com for more information.

Blackbird, Fly

Designing from the ground up, Superheadz created this 35mm twin-lens plastic camera in 2009. It also allows shooting in three formats: 24mm square, 24 × 36mm rectangle, and full-frame, which includes the sprocket holes of the 35mm film. Its one shutter speed is 1/125 of a second, with apertures of f/7 and f/11.

Golden Half

Adding an element of adorable to this teeny plastic camera, Superheadz extended the number of photos per roll of 35mm film; by shooting half-frame, one can get 72 images on each roll and either use the images as diptychs or individual frames.

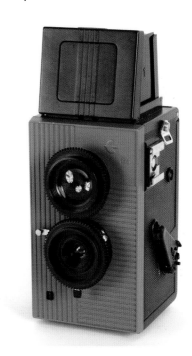

The Blackbird, Fly, is available in a variety of yummy colors: red, yellow, blue, black, white, and orange, with the occasional special limited-edition color appearing as well.

Slim Series

When the popular 35 mm Vivitar Ultra Wide & Slim went out of production, Superheadz came to the rescue; it was reborn in several new colors under different names—White Slim Angel, Black Slim Devil, and more. They have a 22 mm, self-proclaimed "Super Fat Lens" that creates a natural vignette.

FUJIPET

This rare beast is a stunning example of great design and beautiful image making. The Fujipet was manufactured in Tokyo, Japan, by the Fuji Photo Film Company from 1957 to 1963 and came in a variety of body colors and styles. Although hard to find today, they are sturdily built and have held up well over time. These plastic-lensed toys use 120 film and make 6 × 6 cm square images, which look like a cross between a Holga and a Diana photo. See the portrait of the Holga's inventor in Chapter 1, taken with a Fujipet.

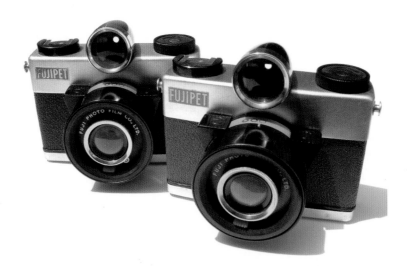

A pair of Fujipets. Image courtesy of Skorj, © 2006.

MULTILENS CAMERAS

Another category that continues to be popular is multilens cameras. These create negatives that combine multiple images (2, 3, 4, 8, or 9) onto one 35 mm frame. The negatives can be processed and printed by standard labs or uploaded to the Lomographic web site to create animated MiniMovies.

Split Cam

This very simple camera has only one lens and little blinders that slide in and out to cover half the lens, allowing the photographer to expose half of the frame at a time. The two halves merge in a fuzzy border down the length of the 35 mm image.

Nickelodeon Photo Blaster

Two lenses, each triggered individually, create a series of four images on a 35 mm frame. If you can keep track of which frame you're on, it's possible to choreograph interesting composites. These were produced only until 1999.

Action Sampler and Action Sampler Flash

Four lenses fire in rapid sequence. The flash version sports four flashes, which fire in synch with each of the lenses. These are produced by the Lomographic Society.

Quad Cam

The queen of the quads, this gem gives you the choice of shooting each lens individually, making two or four identical images, or shooting all four sequentially at three different speeds. All result in four images per 35 mm frame.

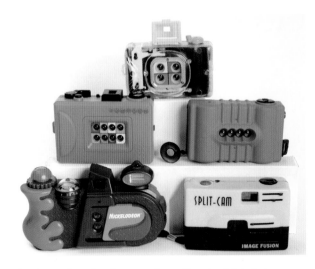

The Action Sampler, Octomat, Super Sampler, Nickelodeon Photo Blaster, and Split Cam provide just a few of the many ways to make multilens images.

Super Sampler

Four wide-angle 20 mm lenses fire sequentially, producing four vertical panoramic strips within one 35 mm frame. These are also made by the Lomographic Society, available in several funky colors and finishes.

Oktomat

Eight lenses fire sequentially over 2.5 seconds, forming a 2 × 4 grid of images. These are another Lomographic creation.

Pop 9

Nine 24 mm lenses fire at the same time, creating a 3 × 3 grid of identical images per 35 mm frame. Lomographic, once again.

35 MM PLASTIC PANORAMICS

These cameras don't necessarily stretch the width of negatives to a true panorama; they simply cut off the top and bottom to produce the panoramic format. The Ansco Panoramic has an unusually wide-angle 20mm lens, and some photographers are making disposable panoramics into reusable cameras, to great effect.

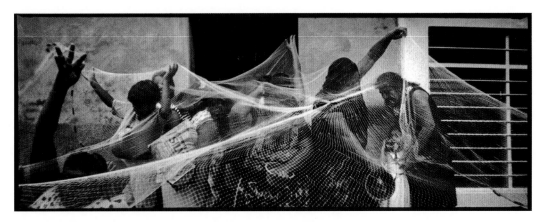

La Net, © Francisco Mata Rosas, 1998. From the *Litorales* series, made with a Pix Panorama ANSCO on Tri-X film in Juchitan, Oaxaca, Mexico.

Pinhole Cameras

A book that focuses on low-tech photography could hardly omit a reference to pinhole photography, the oldest and most basic type of image capturing. Pinhole cameras, of course, have no lens at all. Images are transmitted from the outside world into a light-tight box through a tiny hole and feature an infinite depth of field. These cameras can be, and have been, made from any size container, from a matchbox to the quintessential oatmeal box, all the way up to an airplane hangar.

The world of pinhole photography is very much alive, with books, online communities, especially Eric Renner's PinholeResource.com, and exhibitions regularly spurring its practitioners on. The level of creativity and skill these photographers put into their photographs is remarkable. Many pinholers

make their own cameras, and numerous versions are available for sale as well. Jo Babcock's "Invented Camera: Low Tech Photography & Sculpture" has many examples of his unique creations. Currently, the toy and pinhole worlds have melded, with the Diana+ sporting a built-in pinhole, and several Holga pinhole versions available (detailed earlier in the chapter).

HYBRID CAMERAS

There's nothing sacred about a Holga or Diana that means all its parts have to stay together; in fact, armed with a teeny screwdriver, you can add a new meaning of "play" to your interactions with your camera. Holga and Diana lenses have been mounted onto other medium-format cameras and even view cameras. You can hack a lens onto a digital SLR and create a bizarre hybrid; Holgamods adapts Holga lenses; and the Lomographic Society sells adapters to use Diana+ lenses on Nikons or Canons. Christopher James modified a Diana camera to work with a Graflex shutter, making it more sophisticated and allowing a whole new world of exposure adjustments; while Susan Burnstine builds her cameras from the ground up, creating her own unique look.

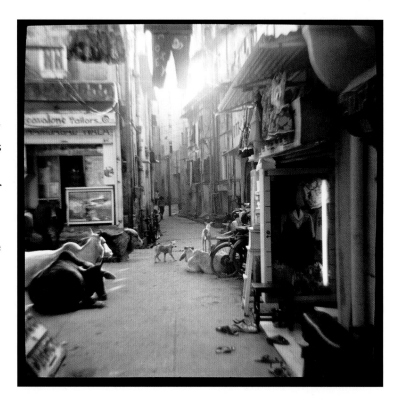

Moxey, Jaipur, India 1994, © Christopher James. A Diana camera with GB-Kershaw 450 shutter inserted to provide a range of shutter speeds with the original Diana plastic lens. Gold-toned Kallitype print from a digitally scanned Tri-X negative.

Calm Before the Storm, © Ted Orland, 2006. Digital image made with a Holga lens (adapted by Holgamods) mounted on a Canon DSLR.

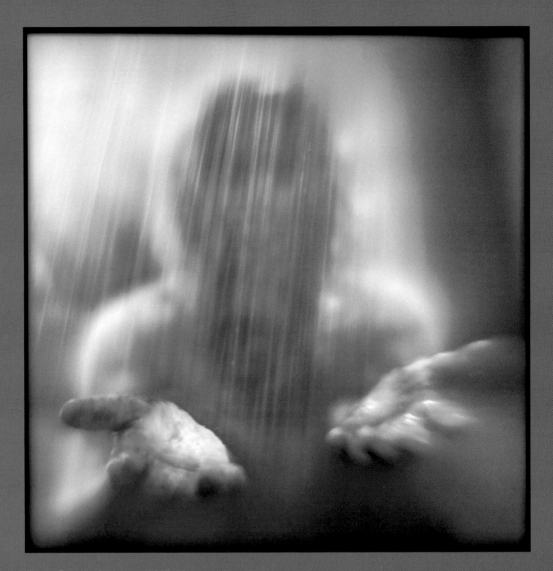

Grasp, © Susan Burnstine, 2007. Homemade camera.

NOT QUITE PLASTIC

While most plastic cameras qualify as toys, not all toy cameras are made of plastic. Part of the charm of these cameras is their look and feel, both to the photographer and to the subject, and the qualities of the images that come out of them. So while the main focus of this book is on plastic cameras, there are other cameras out there that break through the traditional barriers that cameras can create between the wielder and the subject. These, too, often evoke a smile and exclamation: That's *so* cute!

Lensbaby

The Lensbaby is a strange hybrid animal. A Lensbaby on a Nikon, Canon, or other 35 mm or digital SLR creates a contraption that could be the offspring of a Holga and a view camera and produces high-quality images with an offbeat flair. Most Lensbaby lenses are made of glass, but their form and function offer the photographer an entirely new way to interact with the camera. This combination is an easy way to get plastic camera-style images from a digital camera.

So what is this Lensbaby? The original Lensbaby is a lens mounted on a flexible free wheeling mini-bellows, adjustable by pulling, pushing, and tweaking back and forth with extended fingertips. This gives the photographer control over "the sweet spot," that is, the area of the image that's in focus, while the rest of the frame blurs out toward the edges. The size of the sweet spot versus the surrounding blur can be changed by swapping out aperture rings; at maximum aperture, you get maximum blur.

The original Lensbaby's lens is a simple, uncoated glass optic, with aperture rings that sit in front of the lens and are changed by fishing them out clumsily with a plastic stick on a chain. The Lensbaby 2.0 and its newer version, the Muse, are a bit higher quality, with a more sophisticated glass doublet lens, a faster 2.0 maximum aperture, and a relatively high-tech magnetic aperture ring setup. The Lensbaby 3G, now called the Control Freak, adds arms that allow fixing the lens in position and fine-tuning the lens angle and focus, while keeping the lens's quick-response flexibility. The newest Lensbaby is the Composer. It has a ball-and-socket design that is not quite so funny looking and is slower to adjust, and is more stable. All the newest Lensbaby incarnations allow swapping of the lens optics, which are

available in single-lens glass, glass doublet, pinhole/zone plate, fish-eye, soft focus, and, near and dear to our hearts, plastic. Lensbaby versions are made to fit on all the major 35 mm and digital bodies. A variety of accessories, including tele and wide-angle adapters and macro filters, add to a Lensbaby's capabilities.

Much of the Lensbaby's charm lies in the reaction of your photographic subjects to its weirdness. But, like anything else, truly great images come from the vision of the photographer, not from the equipment or what others may think of it. See Corey Hilz's book, *Lensbaby: Bending Your Perspective* (Focal Press, 2010) for a complete guide to the Lensbaby phenomenon.

The Lensbaby's lineup includes the Muse, Composer, and Control Freak, with swappable optics, for the different looks plastic, glass, and pinholes create.

Rollei MiniDigi

The world of digital photography is finally also discovering the joy of the cute factor. With the MiniDigi (released in 2004), Rolleiflex proves that somewhere in its hallowed halls, someone has an excellent sense of humor. The MiniDigi, a teensy (2¾″ high) replica of Rolleiflex's flagship twin-lens reflex camera, also happens to be a working digital camera. It may not have as many features as most digital cameras on the market—in fact, it may have fewer than any other—but it just might be the only one that can be worn as a very stylish fashion statement. I wear mine to lots of photo events, and it always draws attention. While the lens is glass, I appreciate that it gets more smiles than any other camera I've ever used and inspires everyone to fondle it, gaze down at the miniature LCD screen, and try making a photograph with it. Who wouldn't be charmed to see the word "Welcome" scrolling across the teeny screen when you turn the camera on?

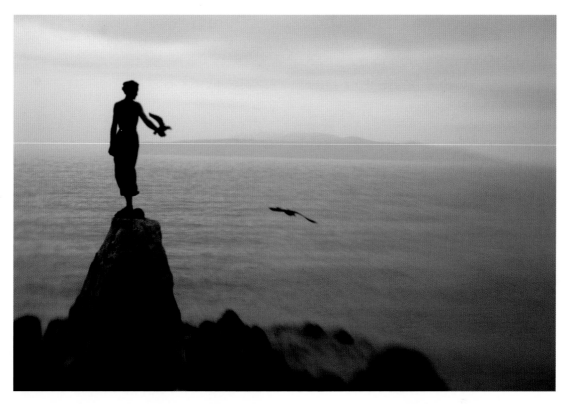

Opatija, Croatia, © Jill Enfield 2005. Shot with a Lensbaby lens on a Nikon D70s digital SLR.

If you can live with few megapixels, no exposure adjustments, and having to remember to crank the wee handle between exposures, this toy will be the star of your camera collection, as well as your jewelry box. However, making great images with this cutie-pie can be tricky. While the Holga has one predictable exposure that you can learn to work around, the MiniDigi's meter makes all the adjustments for you and doesn't allow any manual fine-tuning. Building on the popularity of its first version, in 2008 the MiniDigi 5.0 was released. The 5.0 stands for 5 MP, but the camera really only

creates three megapixel files. The extra 2 MP are invented by interpolation to make 5 MP files. This update does, however, allow shooting in much lower light, adding to its party caché. Another element the darling Rollei doesn't share with the plastic cameras is price; this replica sells for around $300.

Other digital toy cameras include the Jamcam and Digipix and many other small, truly cheap options.

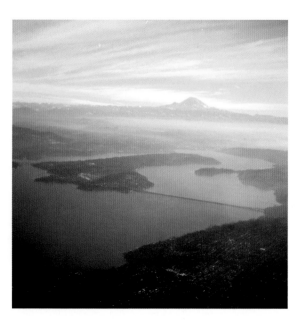

The Rollei MiniDigi flies in over Seattle, capturing Lake Washington, Mercer Island, and Mt. Rainier, © Michelle Bates, 2005.

The Rollei MiniDigi 5.0—adorable and functional.

Toy Video—From Cassettes to Digital

PixelVision and Digital Harinezumi

Sometimes it's necessary for grownups to raid kids' stores to discover new tools for artistic innovation. Such is the case with the Fisher Price PixelVision PXL-2000 video camera, the film and video world's answer to the Diana. This toy records super low-quality video onto audio cassette tapes. Made only from 1987 to 1989, these are collector's items to some, working tools to others. Each year, films made on a PixelVision are shown at the PXL THIS Film Festival. Watch some at www.pxlthis.ning.com.

To fill the appetite created by the PixelVision, Superheadz introduced the Digital Harinezumi in 2009, updating it to version 2 before the end of the year. Reminiscent of a 110 film cartridge, the Harinezumi makes 3 MP digital video (in addition to larger stills) and has already spawned a film festival of its own, "Imperfect As They Are," at New York's New Museum in March 2010.

Cell Phone Cameras and Applications

Who doesn't have a cell phone with a camera these days? This feature makes everyone a potential photographer. These minuscule cameras are used to capture images of our friends when they call or to snap a picture of something interesting or important when there are no other cameras on hand. But they can also be used as fun and serious photographic tools, both older, lower-quality ones and newer, more sophisticated versions. Books are starting to appear that feature nothing but cell phone photography, like Chase Jarvis' "The Best Camera is the One That's With You."

The real revolution in recent years is the boom in cell phone applications that allow tweaking of these photos to mimic the looks of our favorite plastic cameras. Applications such as CameraBag for the iPhone allow transformation of an image with its "Helga" and "Lolo" settings, among others. Hipstamatic, Plastic Bullet, Toy Camera, and others offer image manipulations as well for those feeling creative—even if their files are teeny compared with what you can get scanning a Holga negative.

While we've covered a few special cameras here, don't feel limited to just these. Any camera can be made to produce fabulous images because, as we can never say enough, it's the photographer who creates the images, not the camera.

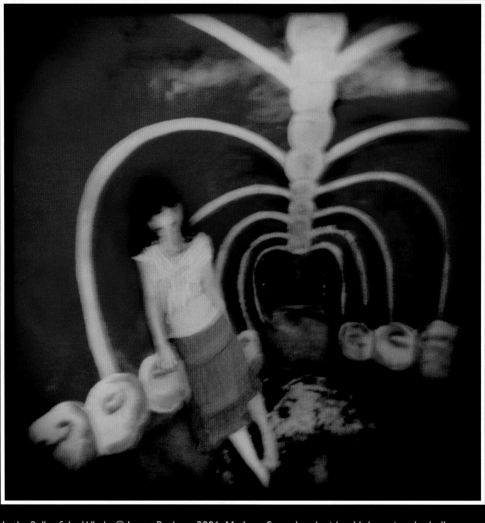

In the Belly of the Whale, © Laura Burlton, 2006. Made at Story Land with a Holga using the bulb setting, on Agfa RSX II transparency film, cross-processed in C-41 chemistry.

chapter four

Film Options

FEEDING YOUR PLASTIC CAMERA
Film Choice: What Flavor of Film?

The medium-format versions of Holgas and Dianas use 120 film, which comes wrapped around plastic reels about 2¼" tall and has a paper backing along the whole length of the film, with extra paper at each end. Roll film comes wrapped in foil, leading my non-photographer friends to think I always have candy in my pockets, which may also be the case. You can use black-and-white (B&W), color negative, or transparency film in low-tech cameras, but the limitations of each may affect your film choice.

Be careful not to confuse 120 film with 220 film, which looks the same, but has twice the length of film, with paper only at the ends. It is more difficult to use with the Holga or the Diana because it doesn't have the numbers on the paper backing to help orient you while advancing the film. However, 220 film offers the advantage of twice the number of images per roll as 120 film does. When using 220 film, follow the same technique and precautions as shooting with 35mm film, which are covered in Chapter 8. Some photographers actually court light leaks when shooting 220 film by leaving the red window uncovered.

For most plastic camera shooting, I recommend 400 speed negative film, color or black-and-white. Because negative film provides lots of latitude and can capture a wide range of tones, you can compensate for the camera's lack of controls later on, tweaking your images in the printing or scanning process. Negatives that are over- or underexposed can often still create good final images. See Chapter 9 for more on film handling and processing.

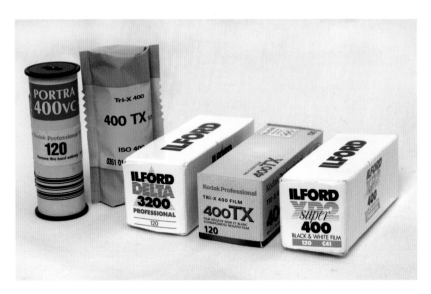

A selection of 120 film.

When considering which film speed to use, remember that most plastic cameras have only one to three apertures and shutter speeds, which limits your ability to adjust the camera's settings to the lighting circumstances. Holgas have a single-setting spring shutter, ~1/100 second, and one or two apertures, ~f/11. The bulb setting some plastic cameras sport, which allows for long exposures, is not easily controllable or repeatable. Using it usually results in too long an exposure for daylight shots, but for very low-light situations, it can be quite useful. Always choose a fast enough film so that you can get the exposure needed to make good images—ISO 400 is a great general shooting speed. You can also use faster films; speeds of up to ISO 3200 are available. By increasing the processing times with some of these, you can get the equivalent of film speeds that go through the roof, although with this come changes in other areas, such as grain.

With transparency film, the film itself is the final product, so correct exposure is critical. Transparency film, as well as slower speed negative films, can be used in situations where you can

adjust your light input. This is possible when using the bulb setting on your Holga or Diana or on- or off-camera flash or studio strobes. Handheld light meters can be helpful in determining the level of available light. There will be more on these options later in Chapters 6 and 7.

Many people are surprised that Holgas and Dianas shoot color. In fact, they make wonderful color images, and the final prints you produce can be gorgeous if you continue the chain of control by doing your own color printing, whether darkroom or digital. There are a few different types of color film available that can create a range of moods and feelings in your images. Portrait films reproduce slightly muted colors and good skin tones. Super-saturated films make colors pop to create heightened effects and even surreal images. Results can be even more personalized using techniques such as cross-processing and hand-coloring. Experiment with your preferences and subject matter to get results you love. Even with the limitations of Holgas, Dianas, and other plastic cameras, don't be afraid of shooting when the light isn't perfect or when you don't have the right type of film in the camera. Poor negatives may be a challenge, but a lost moment is lost forever.

FILM TYPES
Black-and-White Film

Traditional B&W films can be processed at home in any sink or developed by a lab. Not all B&W films are available in 120 size, but there is still quite a variety. Kodak Tri-X Pan 400 is an ideal choice for plastic cameras, but also consider Kodak Tmax 400, Fujifilm's Neopan, Ilford's HP5, Delta 400, and Freestyle's new Holga film, along with some of the less well-known 400 speed choices, including Arista, Foma, and Rollei. These can all be pushed to achieve more speed, but for the greatest light sensitivity, use the one-of-a-kind, Ilford Delta Pro 3200, the only B&W film faster than 400 that comes in 120 size. It can be rated from 400 to 6400 and even higher with special developers. For slower B&W films, there are many choices. Freestyle Photographic and B&H Photo carry wide selections of hard-to-find films and offer some new and off-beat options. Check the Resources section at the end for information on suppliers and more.

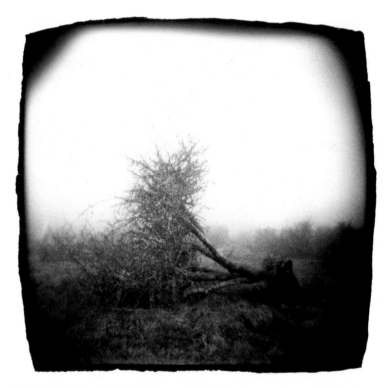

Wax Orchard Tree, © Michelle Bates, 2005. Holga image taken with Ilford
Delta 3200 film on a very foggy morning.

Infrared Film

For those wanting to combine a plastic camera's signature style with an alternative look in film, there
are three types of available 120 film that give infrared (IR) effects: Efke IR820 (formerly Macophot
IR820c 820nm) for true infrared shooting and Ilford SFX and Rollei Infrared for near-IR. See Chapter 7
for more information on these films and how to use them.

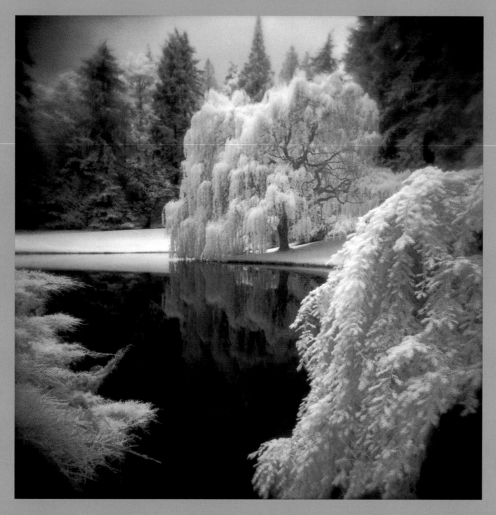

Ethereal 2-14, © Ryan Synovec, 2008. A classic infrared image, highlighting IR film's effects on trees and water. A Holga camera on a tripod, using Efke IR820 film and a Hoya R72 filter to block visible light.

Black-and-White C-41 Film

Ilford XP2 and Kodak BW400CN are specialty films that produce monochromatic negatives, but are processed in color negative (or C-41) chemistry. The magic of these films is that you get beautiful black-and-white negatives, but they can be taken in for processing to any color lab that can do 120 film. If you don't process your own film, don't have access to a professional lab that runs black-and-white, and don't want to send precious images in the mail, these films are a great option. Labs processing B&W film are less and less common these days, so if you've kept your darkroom equipment stored away, you may want to hold onto it or even set it up again.

Both Kodak and Ilford black-and-white C-41 films are ISO 400 and, like the same speed color films, have wide latitude and capture a generous range of tones. Negatives from either film can be used to make prints in a color lab or a home black-and-white darkroom. According to the companies' specifications, the Kodak BW400CN is optimized for printing on color paper, while Ilford XP2 is meant for printing on standard black-and-white paper. Even so, experimentation can be a gateway to discovery that you may want to boldly explore. These wonderful films richly enhance your shooting options and processing possibilities.

Color Negative Film

As film sales plummet with the rise in the use of digital cameras, the selection of color 120 films is dwindling. Kodak's selection is the widest, while Fujifilm has at least one option, Fujifilm Pro 400H. Kodak's options are Portra 160NC, 160VC, 400NC, 400VC, and 800—the only high-speed 120 color film still being made. NC, which stands for natural color, produces a tonal range good for portraiture. The VC, or vivid color, versions make images with higher contrast and color saturation. Rollei's offering, Digibase CN200 Pro, has a clear base that makes for easier negative scanning. Experiment to see which color balance and intensity suit your shooting style. As with all film, brands and versions are coming and going quickly, so if you find one you cherish, you may want to stock up.

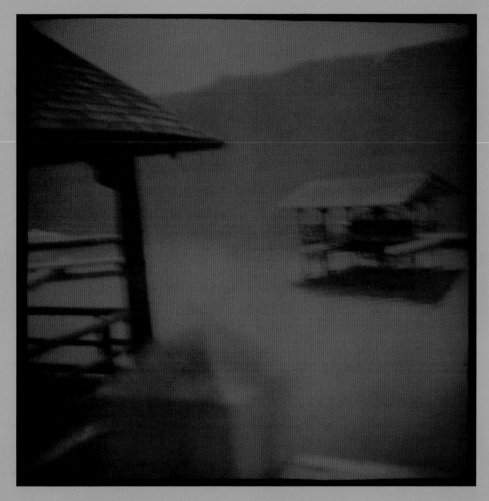

Silver Bay Boathouse, from *The Adirondacks*, © Mary Ann Lynch, 2001. A Diana camera handheld,
extended bulb exposure on Fujicolor NPH 400 pro color negative film. The muted tonalities and
soft focus created by the long exposure imbue the scene with a timeless quality.

Transparency Film

Transparency film, also called slide film, is tricky to use in a camera that has very little in the way of exposure control. But it is suitable to a Holga if you're up for a challenge. These films offer bright, saturated colors, and the ease of viewing your images without an intermediate printing step. Chapter 7 offers several tips to increase control over your exposures, vital for getting well-exposed transparencies. Kodak and Fujifilm offer several choices from ISO 50 to 400, while Rollei makes Digibase CR200 Pro.

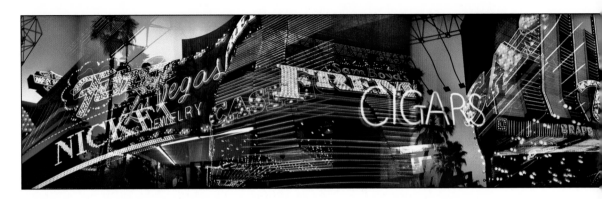

Lights of Fremont, Golden Nugget, © Susan Bowen, 2007, A multi-image Holga panorama shot on Kodak Portra 800 color-negative film, pushed two stops.

Cross-Processing

Another way to add unpredictability and a special look to your toy camera experience is to cross-process color film. To do this, transparency film, normally developed in E-6 processing, instead is run through color negative C-41 chemistry, yielding a variety of fascinating color results. Similarly, color negative film that is cross-processed goes through the E-6 processing usually associated with transparency film. Few labs are willing to cross-process, so ask around or check online forums to find a lab near you or use a mail-order lab.

35 mm Film

Even though the Holga 120N and Diana+ are made to use 120 film, you can also load up either one with 35 mm film, as detailed in Chapter 8. With this smaller film, the images are wide panoramic shots that bleed right out to the edge of the film, including the sprocket holes in the image. There are many classic and new plastic 35 mm cameras that allow you to take advantage of the far greater selection of 35 mm films still available.

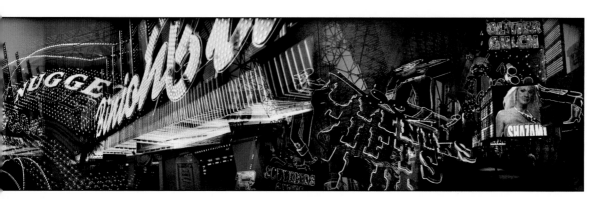

Instant Films

Polaroid's instant film cameras have been popular since their inception. With the advent of digital photography, however, a different way of achieving instant gratification has overtaken the prominence of this format. As a result, Polaroid ceased producing film in 2009. Fortunately for those who still appreciate the thrill of making instant prints, Fujifilm still produces several versions. Instant film backs are currently made for the Holga, which can use these Fujifilm peel-apart films: FP-100C (100 ISO color), FP-100B (100 ISO black-and-white), and FP-3000B (3000 ISO black-and-white). The very first generation of Holgaroid backs used Polaroid's 80 series films, which are gone, along with the 660 series

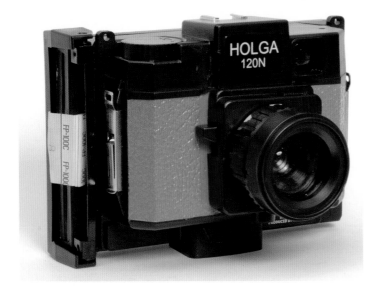

A Holga with a Polaroid instant film back may look like a cloning attempt gone wrong, but don't be misled—it's your passport to instant satisfaction. A diopter lens and (very approximate) external viewfinder are included.

films that the later versions accepted. In 2009, The Impossible Project was created to resurrect some formats of Polaroid film, but it is not working on peel-apart versions that would work with any of the Holga backs. The Lomographic Society makes instant backs for its Diana+ and LC-A+; both use the ISO 800 Fujifilm Instax Mini film. See details on using instant backs in Chapter 7.

Expired Film

As film ages, its characteristics change. Usually photographers try to avoid using degraded film, but in our plastic realm, where the cameras themselves are agents of unpredictability, expired film can add another appealing element of chance to image making. And sometimes, as with Polaroid, expired film is all we have left to shoot with.

Round Barn, Ojo Caliente, New Mexico, © Michelle Bates, 2003. A Holga Polaroid image made with a first-generation Hoglaroid back on 80 series square film.

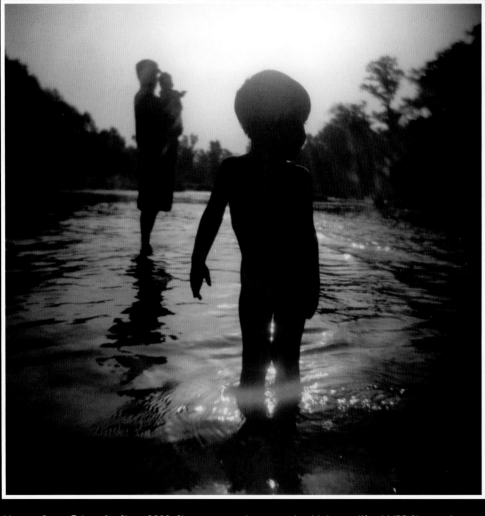

Morning Swim, © Jennifer Shaw 2008. Shooting into the sun with a Holga on Ilford HP5 film on the Bogue Chitto River in Enon, Louisiana.

chapter five

Prepping and Shooting Your Holga

At this point you may be wondering why do I need help using this camera if it is so low-tech? Holgas are quite simple, but they have many quirks that affect their use and the look of the images. As with any camera, the more you know about how your Holga functions, the better you'll be able to make images that match your personal artistic vision. This chapter guides you through the main issues you'll need to know to gain control over the Holga's peculiarities. Once you know what they are, you can choose how you'd like to proceed; some photographers want to banish any unpredictability from their shooting experience, while others welcome it.

After that, you'll learn how to load and unload a Holga and how to use the few controls it offers. While most of this information is specific to Holga 120 cameras, there is information of interest to other plastic cameras users or you can skip ahead to Chapter 6, which covers shooting with plastic cameras in general.

Holgas don't have many of the adjustable elements we've come to expect of cameras. There are no expensive interchangeable lenses or controls that allow the photographer to fine-tune almost every aspect of how light enters the camera. Also, there are no sophisticated meters and electronics to make adjustments for you. However, the amount of light that the Holga captures with its minimalist spring shutter is consistent frame to frame, so the onus is on the photographer to understand how to work with that limitation to his or her advantage. Certain modifications will allow photographers to expand the Holga's range and the types of images it can produce. These are discussed in Chapter 8.

You'll want to discover, and experiment freely with, the different effects Holgas can produce. The variety of their visual "vocabulary" is a major part of the joy of shooting with them.

GETTING YOUR HOLGA READY TO PLAY
Chuck the Lens Cap

Unless you have experience shooting with a rangefinder camera, you will want to get rid of the Holga's lens cap. Like rangefinders, the Holga's viewfinder is separate from the lens; even when the lens is covered, you can still see through the finder, compose and shoot, and only later realize that no light was able to reach the film because you left the lens cap on. The one use I've found for the lens cap is to keep the lens barrel covered while skiing. I learned this after once tumbling down a ski slope with no lens cap on my Holga and having the lens barrel become packed with snow, which was pretty

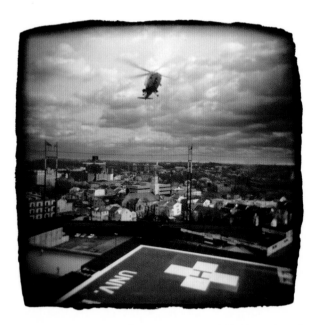

Aid Helicopter Arriving 1, © Michelle Bates, 1992. Using the full Holga negative gives a wide-angle view of the world.

hard to clean out and dry off wearing ski gloves. Yes, without the lens cap, your lens will get dusty over time, so wipe it with a soft cloth once in a while. The lens is set so deeply in the lens barrel that scratches aren't really a problem. And hey, if something happens to the lens, the whole camera costs less than a protective filter for a real camera.

Image Formats

Classic Holgas, which use the versatile 120 (also called medium-format) film, can be used to produce images in two different formats: 6 × 6 cm squares or 6 × 4.5 cm rectangles. Most photographers shoot the larger size, which creates the Holga's special look, a square image with a sharp center and symmetrical corners that fade into darkness and fuzziness. This shape can be obtained either by using the square-format plastic insert in the camera, which crops the image slightly, or by not using any insert. The smaller framing is created by using a different insert that masks the film to the rectangular shape. This format has the advantage of allowing 16 frames per roll of 120 film, compared to 12 in the square format, but the rectangular shape loses the fuzzy corners that make the images recognizable as plastic camera shots. The inserts are distinguished by the faint "12" and "16" embossed on the front upper left corner.

35 mm versions of the Holga are also now available; they are simpler to use and don't need most of the following tweaks necessary with 120 Holgas.

To set the Holga 120N series cameras up to shoot in either square or rectangular format, you need to set the film counter window, on the camera back, to the appropriate setting. When shooting square, make sure that the pointer is facing the number 12; to shoot rectangles, move it to point to 16. On original Holga 120S models, this window could be very difficult to move, but with the introduction of the Holga N series, it has been loosened up.

The plastic inserts do more than just change the format of Holga's images. They block some light leaks and press the film against the back of the camera, which makes the images a bit sharper and tightens the film on the spools. In Holgas with built-in flash, they also hold the batteries in place. It's not necessary to use any of these inserts in your Holga at all; I never do. Going insert-less creates some problems, but we can fix those up with a few little tweaks.

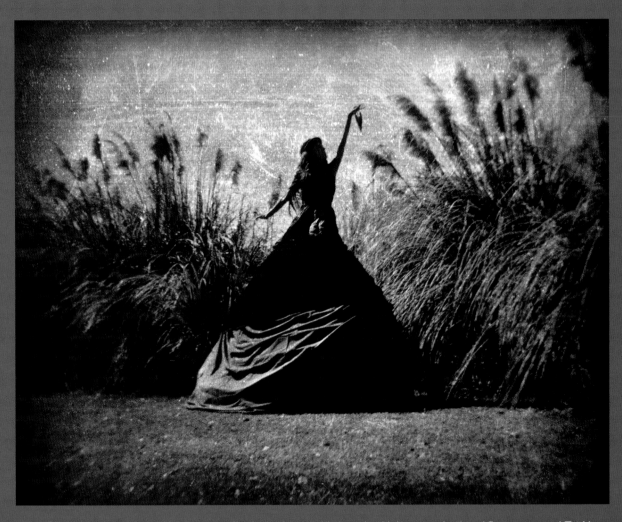

Muse, © Louviere & Vanessa, 2004. From the *Slumberland* series. Made with a Holga using the 6 × 4.5 cm insert and Tri-X film, scanned and printed digitally.

A variety of inserts are now made for the Holga or you can file one out yourself.

Light Leaks

The first thing many photographers think of when you talk about plastic cameras is light leaks. Ah, light leaks. Some shooters love them, some hate them. Dianas tend to make images full of streaks from leaks all over the camera. To get clean images with a Diana, it is necessary to tape all the seams

and other parts that don't fit together well enough to keep out the light. Because Holgas are made to a relatively higher standard, they don't have as many problems with light coming in where it's not wanted. There are a few areas that will leak, though, if not taken care of.

Before you begin, get yourself a roll of black gaffer's tape. This tape is strong, opaque, easy to tear by hand, and can be peeled back and restuck many times without getting goo all over your camera. It is the king of tapes, and while it is pricey, one roll will banish light leaks from many Holgas.

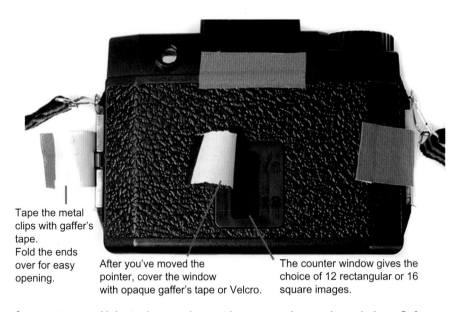

Tape the metal clips with gaffer's tape.
Fold the ends over for easy opening.

After you've moved the pointer, cover the window with opaque gaffer's tape or Velcro.

The counter window gives the choice of 12 rectangular or 16 square images.

Start getting your Holga in shape to shoot with some tape here and a push there. Refer back to this figure throughout the chapter to see how to tweak your Holga.

When you use a Holga 120S or a 120N produced before Holga Ltd. started fixing the problem in 2010, there are two holes that will spill light onto the top of your frame if you shoot without an insert in the camera. These holes provide a conduit for the flash wiring on built-in flash models, so they aren't a problem if you have a 120FN, 120CFN, or 120SF. Using the diagram to help find them, cover the holes with opaque tape; once that's done, you can forget all about them.

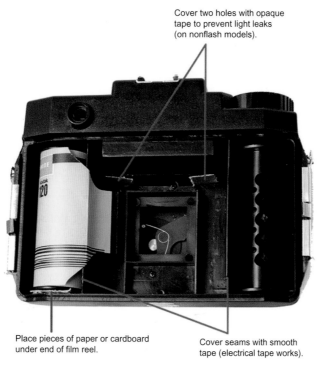

Cover two holes with opaque tape to prevent light leaks (on nonflash models).

Place pieces of paper or cardboard under end of film reel.

Cover seams with smooth tape (electrical tape works).

Follow this guide to fixing up the inside of your Holga.

Cover that Window

Another area that may leak light is the red counter window on the camera back. While the red filter and the paper backing block most ambient light from reaching the film, very bright light can blast through these barriers. This can create patterns on your images, including those of the text printed on the film's paper backing. To prevent such leaks, keep this window covered with gaffer's tape, with one edge folded over for easy lifting (see figure on page 130). Only uncover the window when you are advancing the film, preferably in subdued light; if it is bright and sunny out, turn so the camera is in your shadow. Other ways to keep this window light-tight, while still allowing easy access, include Velcro flaps and sliding covers, if you want to get elaborate.

Keeping the Back On

Another quirk of the Holga that can lead to not just light leaks, but ruined frames, is, believe it or not, the tendency of the camera back to fall off. The metal clips that hold the Holga back on are very weak and are pulled on continually by the camera strap, which connects to holes at the top of each clip. I once experienced this catastrophic failure as I ran full speed through a parade I was photographing, hearing plastic bits bouncing behind me on the pavement. Several frames were ruined, and I had to stop to pick up the pieces of my camera in front of several thousand people.

Fortunately, such a calamity can easily be prevented. First, the clips themselves can be strengthened somewhat. Remove the clips from the camera by pulling out on the little tab so it releases from the groove, then sliding upward. Bend the loose center part inward (not too far—don't break it) to increase its tension against the camera. Slide the clip back on, and you'll feel the tighter grip as it snaps into place. I would still add gaffer's tape for good measure. Tear off 4-inch-long pieces of tape—1-inch wide gaff tape works great for this—or tear 2-inch-wide tape in half lengthwise. Wrap them around the sides of the camera, folding a little bit over at each end for easy grabbing of the tape (see figure on page 130). Some photographers create Velcro closures or go simple with rubber bands.

Don't Scratch My Film

If you're not using an insert inside your Holga, there is one more thing to consider. On the surface of the interior dividers that the film passes over are seams that can damage your film—they may create scratches that extend horizontally across the whole or part of a roll. Cover these divider edges with a smooth tape, such as black electrical tape (not gaffer's tape) or thin foam, to make a nice resting surface for your film (see figure on page 131).

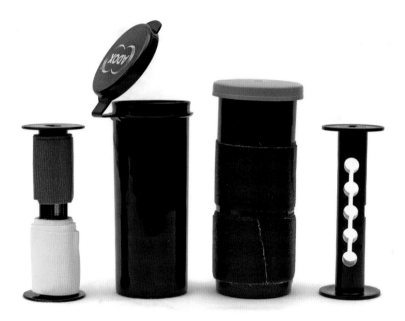

Keep gaffer's tape handy in your bag by wrapping it around a 120 film reel. Make your own 120 film canisters by cutting the bottom off a 35 mm canister and taping it onto a second one with opaque tape, or buy specially made canisters from Freestyle, included in our Resources section.

Roll it on Tight

The Holga doesn't always do a great job of what should be a simple task—rolling the film from one reel to another. As frames are shot, film is wound from its original spool onto the empty take-up spool, located on the right side of the camera. Often though, there isn't enough tension to keep the film and paper backing rolled tight, and this loose winding allows light to leak into the edges of the roll after it's removed from the camera. These light leaks create streaks coming in from the edges of the film at the end part of the roll.

There are a few ways to help prevent these loosely wound "fat" rolls. Newer Holgas come with foam pads that press against the new roll and take-up reels to increase the tension. Unfortunately, these pads are not always attached securely to the camera, so pull them out and reglue them before using the camera or they may end up wound into your roll of film. The plastic inserts help increase the tension as well and can keep the film from rolling on at an angle and then rolling up over the edge of the reel. The best way to prevent fat rolls is to add tension under the new roll of film by jamming bits of paper or cardboard between the bottom of the reel and the wall of the camera. Pieces of film boxes or the paper tape that comes wrapped around the film both work well. Experiment with the amount of material you stuff into the gap; too much will jam the reel and make it impossible to advance the film. More elaborate and permanent shims can be made with folded pieces of plastic or thin metal. No method is perfect, but these tips will help decrease the frequency of your precious film rolling poorly.

Even with precautions, the film will roll on off-kilter occasionally. The key to saving your irreplaceable images is being able to detect a problem while you're advancing the film, before opening the camera back. When the film does roll on loosely, or up onto the edge of the reel, it will often become difficult to turn the advance knob. When you feel this, either take your Holga to a light-tight room or put it into a changing bag. This is a zippered opaque bag with elastic armholes that allows you to manipulate the camera and film in darkness and is small enough to throw in your camera bag.

Once the camera is in a dark environment, take off the back and remove the film. If you find the film is wound on loosely, take hold of the paper end and pull the film tight while turning the spool until

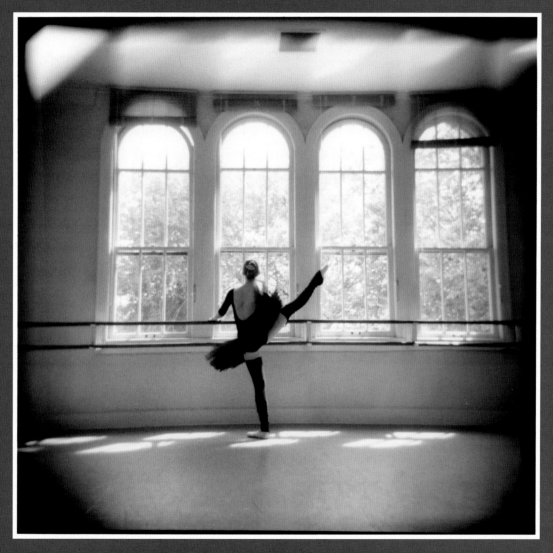

Dancer in Studio at Barre, © Kurt Smith, 1998. Light leaks and vignetting are classic Holga effects.

it is as compact as possible. Then you can remove it from the bag, fold the end tab of the film under, lick the white strip, and seal it shut tightly.

If there's no time to pull your film taut, you'll want to put your vulnerable film into a light-tight container for the time being. After taking the film out of the camera in darkness, place it into a 120 film canister, shown on page 133. Alternatively, you can wrap it in foil. When you have access to a light-tight space at a later time, pull the film tight and seal it or, if developing the film yourself, load it directly onto processing reels.

If the occasion arises, and it will, when you think the film has rolled on okay, but open the back to find that it has not, slam the camera back shut right away. If you don't have a changing bag, under your coat or in a dark closet can do for a quick transfer to a light-tight container. Many photographers try to avoid light leaks by always unloading film in a changing bag.

LET'S GET SHOOTING!

Now that your Holga is taped up and ready to roll, it's time to get shooting. Loading and unloading a Holga take a little getting used to. Once you get the hang of it, it's still slow and clumsy, but hey, so is loading a Leica. When opening the back, always keep the camera in subdued light, such as your shadow. The following instructions are your guide to getting film into, through, and out of your Holga successfully.

Loading the Film

A new roll of film gets loaded in the left side of your Holga, with the paper rolling off the spool clockwise. The empty spool, placed on the right side, serves to take up the film. After you finish shooting and remove each roll of film, move the empty reel from the left to the right side. If you're missing an empty spool or are using a brand-new Holga, load one from a stash of spools that you should keep just for this purpose. The spools included with Holga cameras allow a little bit of light to

leak at the top and bottom of the film; this is not tragic, but worth avoiding if possible. Keep some spools after home processing or ask a lab for a few.

Now, how to load your film. Insert the reel into the top left lug with the paper rolling off toward the right. You may need to rotate it until it catches. Then press the lower part of the reel down into the camera. Insert the previously mentioned cardboard or plastic pieces under the bottom of the reel to keep things tight. Keeping your thumb on the lower part of the new reel so that it stays in place, pull the paper backing to the right, unfold the narrow paper tab, and insert it into the slot in the center of the empty spool, which you may need to rotate until the slot faces up. Lightly holding the paper against the right-hand spool, with the crease catching on the edge of the slot, wind the advance knob until the paper is taut and it seems like it will stay on the reel. If you have trouble getting it to catch, tape the end of the paper tab to the empty spool, making sure the tab is centered, or remove the reel from the camera and wrap the paper around it before reinserting. Once the film has caught, keep a little pressure on the lower part of the left reel and wind the advance knob a couple of times. Replace the camera back, close the clips, and restick the tape flaps to keep the clips secure.

Now the film can be advanced to the first frame—sounds simple, right? Sort of. Pull back the tape covering the red counter window and start winding the film advance knob while watching the window for the number "1" that will eventually appear. First you'll see arrows and various other markings slide by. Different brands of film have different printing on the backing paper, but the general idea is to keep turning until you see the number, which may be upside down or sometimes be just a line. This takes a while.

Go slowly when you're learning to advance the film until you know what you're looking for; all films have markings on the paper backing designed to warn you when the next number is coming up so you don't go flying past it, but each brand is different. Once you start shooting, you'll figure out the system of your film. Kodak has text leading up to the numbers; Ilford prints a series of dots that increase in size before the number appears. These dots are very faint through the red window, making Ilford films a challenge to use, especially at night. Once you see the "1," your Holga is ready to go. Many people miss the "1" the first time around and land on the "2." Consider that first frame a sacrifice to the photo fairies and forge ahead.

Shoot!

To make an exposure, release the shutter by pressing the lever next to the lens downward. Hold the camera steady; it takes a little effort to click and it's possible to blur an image or change your composition by moving the camera.

Shutter Options

Holgas have two ways of using the shutter. On any S series Holga or the "N" (which may stand for normal) setting of an N series Holga, the spring shutter fires at about 1/100 of a second. This varies a bit camera to camera and may slow down as the camera ages. Firing the shutter multiple times without advancing the film allows the exposure to be increased in a controlled, predictable way. With the "B" setting, for bulb, Holgas can be used to make long exposures. On bulb, the camera's shutter will stay open as long as you hold the shutter button down, closing only when you release it. This is useful for very low-light situations. Try shooting handheld to achieve blurry results or mount your Holga onto a tripod for clearer images. Attach a cable release to further increase image sharpness by enabling the shutter to be held open with minimal camera movement. Cable releases are available with adapters for the Holga or they can be rigged.

An important thing to remember is as follows: because the N–B switch is on the bottom of the camera, be sure to switch it back to N after using the bulb (B) setting; I recommend taping it on "N" when not using the bulb setting to prevent accidental movement of the switch. In time, you can even learn to hear the difference between N and B shutter sounds.

Focus

The Holga's lens may be simple, but it does in fact rotate and have focus settings. The settings are vague in a primitive sort of way, representing distances with a solo character, a supposed nuclear

family, a fun-filled group, and a scenic mountain. It turns out that the simplicity of the lens's design has at least one advantage: because the lens isn't corrected in a way that guides all wavelengths of light to focus on the same plane, as higher-end, multi-element lenses are, Holga images tend to be generally in focus, if not tack sharp, no matter where the focus ring is set. This applies beginning about 4 feet from the camera. See Chapter 7 for details on close-up focusing.

Viewfinder

The Holga's viewfinder isn't particularly accurate, in a couple of ways. It's designed to show the approximate frame when shooting with the 6 × 4.5 cm insert, so when shooting the full square, you only see just 60 to 70% of what you're going to get in your negative. In practical terms, this means you should compose and frame your image and then take one or more steps forward so things start disappearing past the edges of the viewfinder. Doing this is counterintuitive, and definitely weird at first, but you'll get used to it, especially when you realize with relief that you *can* actually control what your images look like. The amount of your image left outside the viewfinder varies a bit depending on whether you shoot your 6 × 6 cm images with or without the square insert in the camera and on how you make your prints. Do some tests, write down what you see through the viewfinder for several frames, with subjects at different distances, and compare the results. This is by far the fastest way to learn.

Another strange Holga quirk you may notice is an occasional double exposure in the lower right-hand corner of your image. This occurs on completion of the shutter mechanism's circle. I like to think of these echoes as special gifts, once again from the photo fairies.

Viewfinders for all plastic cameras are also a bit off when shooting close-up. This is because the viewfinders and lenses have slightly different views of things. There is more information on close-up shooting in several later chapters.

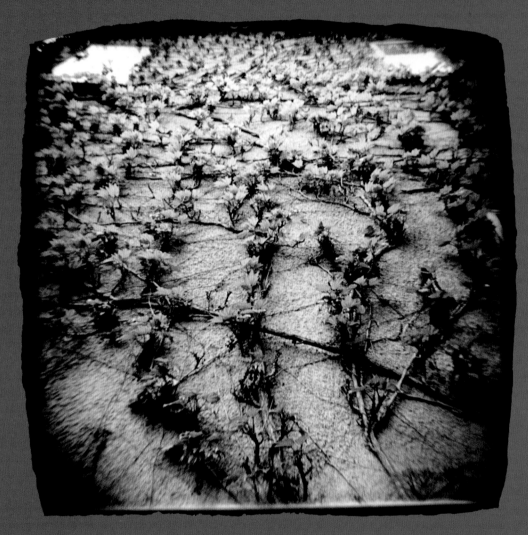

Ivy Wall 1, © Michelle Bates, 2005. With the Holga, it's not possible to see exactly what will end up in the corners of your frame, so shoot several frames to get it the way you envision.

Vignetting

Holgas have a fairly sharp lens, for plastic, anyway, but only in the center. Because the image circle that the lens creates isn't quite big enough to cover the full 6 × 6 cm, images get dark and blurry toward the corners, an effect called *vignetting*. Using an insert or cropping the negative reduces this effect, but many photographers find it to be one of the Holga's most endearing qualities. Pay attention to how vignetting works with your images, for it can definitely be used to your advantage if you learn to love it.

Advancing the Film

To get ready for your next shot, pull back the tape covering the back window, and wind the film advance knob until the next number appears in the window. I find it takes about five turns of the knob—not all the way around, just how I happen to grip it—to advance one frame in the square format. Remember, the Holga is not a smart camera. It will let you keep shooting even if you never advance the film, making double, triple, and quintuple exposures. It's up to you to remember to advance the film after every shot, unless you're using multiple exposures for effect. Also, do not forget that if you're shooting the rectangular format, you'll have 16 exposures to a roll; with squares, you'll have just 12.

Unloading

After shooting the last frame on a roll, it's time to wind the film and paper all the way onto the take-up reel—there is no rewinding with 120 film. Watching the counter window, wind the film-advance knob until you see the paper backing slide off to the right and out of sight. Then open the camera back, remembering everything about light leaks as you do this, and remove the film, holding the paper so that it doesn't unravel. To secure the film, peel the white tape off the roll and then fold the paper tab under, creasing the edge. Holding the top and bottom of the spool, rotate until the paper is taut and then lick and seal the tape tightly (some films have self-stick tabs—don't lick those, ouch!). Move the empty spool to the right side of your Holga and you're ready to load your next roll.

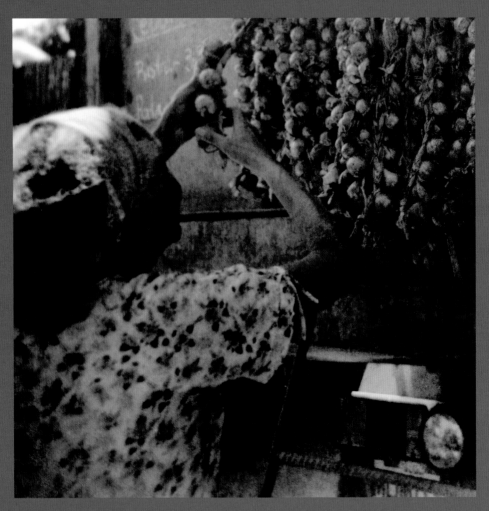

Woman with Garlic, © Shannon Welles, 2007, Havana, Cuba, from the series *A Forbidden Place*. A Holga image with Agfa APX 400 film, lith print. Creating well-framed compositions is a challenge with Holgas until you get familiar with the viewfinder's limitations.

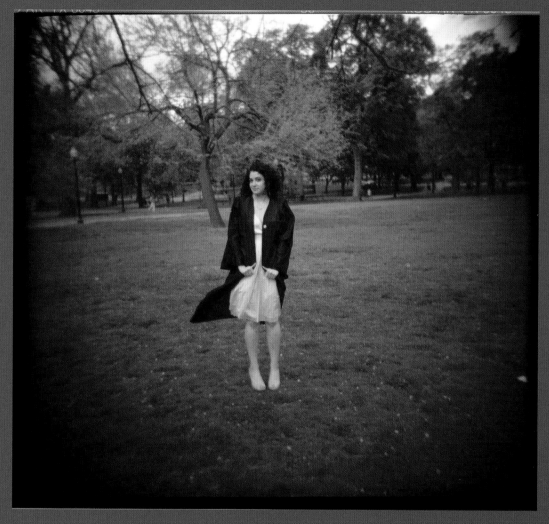

Jordan at Her College Graduation, © David Burnett/Contact Press Images, 2008. Holgas can also be used to make images of daily life or special occasions.

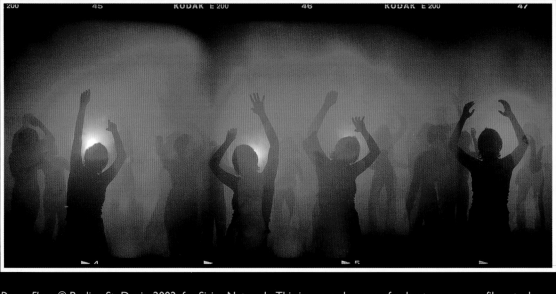

Dance Floor, © Pauline St. Denis, 2002, for Sirius Network. This image makes use of color transparency film, strobe lighting, multiple exposures, and panoramic format, all with a simple Holga.

chapter six

Let's Get Shooting!

TAKING YOUR TOY OUT TO PLAY

It might sound paradoxical in a book about a particular type of camera, but the camera is just part of what goes into photography when it comes to making images with staying power. This is especially true for those who take their photography seriously, whether as art, their profession, or for personal use. Creating images that resonate with you and that have something of interest to other people takes *seeing* in your own personal way and getting your idea on film. This kind of vision is mostly unrelated to the equipment you're using and takes practice to develop.

Look, see, shoot, review your images, edit, and repeat often. I also find it useful to look through my random images and start to pick out ones that resonate with me, combine them stylistically or thematically, and then pursue those subjects or styles further. Concentrating on both what and how you are photographing in relation to the photographs that result can move you beyond the predictable into making images you love.

I hope that the images in this book and referenced in the resources will serve as inspiration for you to photograph subjects and themes outside of what's considered "normal" for what we call toy cameras. I also hope that once you've figured out the basics of shooting with a Holga or your other low-tech tool, it will become something you see *through* on the way to making images, not something you depend on to make them for you.

Having said that, the better you know your camera and its idiosyncrasies and the more you learn from your "mistakes," the more freedom you'll have in your image making, so here are some things to think about as you head out with film and camera in hand!

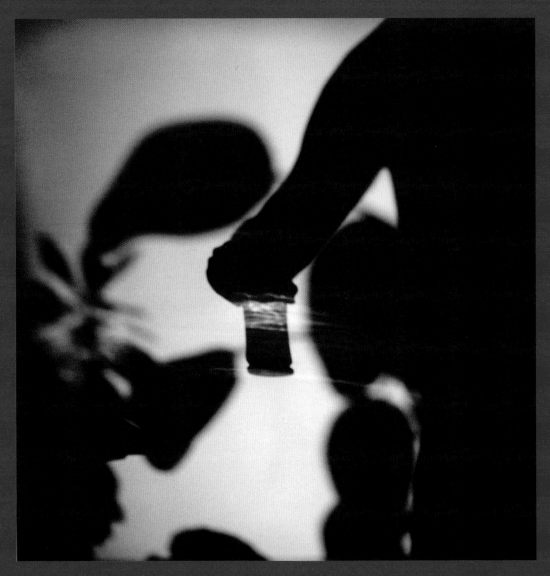

Self Portrait with Glass, © Harvey Stein, 1993. This Holga image doesn't have a tangible subject; a shadow has all the detail to make an intricate image.

Viewfinder

All the plastic cameras discussed in this book have an inherent disconnect between what their lenses view and what the photographer sees through the viewfinder. Their relative relationship to one another and what each presents—such as the amount of coverage of the viewfinder—differ camera to camera. To have a better sense of what your Diana or Holga will put on the negative, compare what you see and, hopefully, recorded in your notes, with what you get. If necessary, learn to compensate

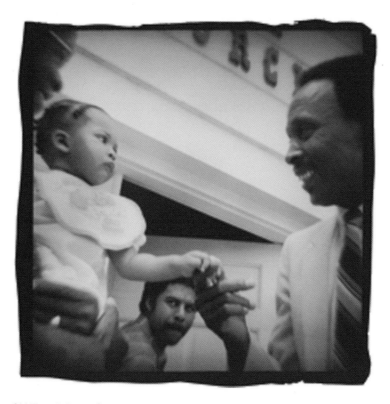

Old Time Religion, © Dan Price, 1985, Kentucky. Diana camera image.

for the difference between what the camera will photograph and what can be seen. This is called *parallax correction*. Parallax error is more pronounced when shooting close-up. We'll talk more about this shortly.

Framing and Vignetting

Each plastic camera puts a different image on film, even when the subject is photographed from the exact same position. The 120 Holga, as described in Chapter 5, has pronounced vignetting that makes its images easily identifiable. The Holga 135 doesn't have any inherent vignetting, but because Holga lovers have come to expect it, the Holga 135BC version introduces it artificially with a "black corners" mask. Original Diana images tend to be a bit soft, with a slightly irregular interior framing. These effects vary among the many clones. In the realm of the Diana+, the framing and the amount of vignetting vary widely, depending on the combination of format, lens, and accessories used.

Multiple Exposures

All the film cameras in this book require you to wind the film manually. Autowinding is absent, as is any system to prevent you from shooting continually on the same frame. And for photographers new to film cameras, the concept of winding will be entirely unfamiliar. This can sometimes cause problems. I find the biggest cause of double exposures is giving my Holga to someone else to photograph me and then forgetting to wind the film when I get it back. However, advancing the film manually allows for creative shooting as well. When subjects are photographed in only one exposure of a multiple exposure, they will appear ghostly, with the background in the other exposures showing through. In low-light situations, you can add exposure in a controlled way by clicking the shutter repeatedly.

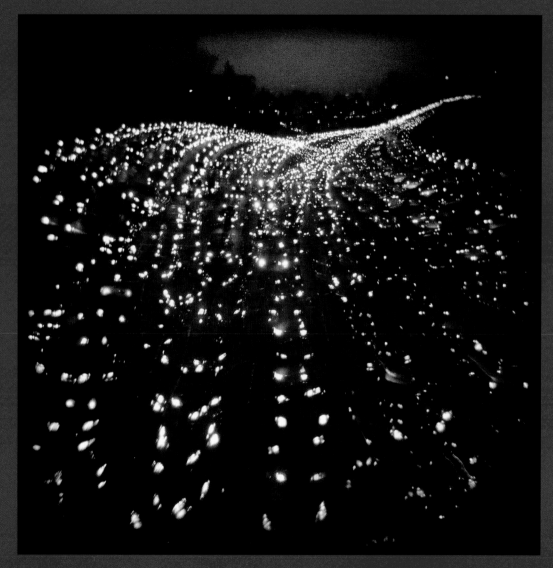

Harbor Freeway, Los Angeles, October 2004, © Thomas Michael Alleman. Clicking his Holga's shutter multiple times, Alleman creates a sea of cars and headlights. Ilford Delta 3200 film.

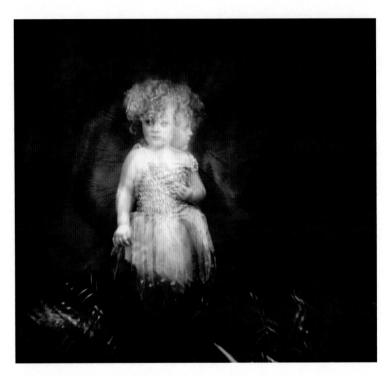

Ori, the Amazing Two-Headed Girl, © Laura Burlton, 2005, from the series
Fairytales and Nightmares. Double exposure with Holga 120S camera,
13″ × 13″ toned silver-gelatin print.

Panoramas

Panoramic images are easy to create with Holgas and with both generations of the Diana. Simply advance the film partway so that adjacent frames overlap and create images that are two frames

wide, or a few, or squish together the entire roll. With Holgas and Dianas, it takes some practice to determine the right amount of winding to achieve the overlap that you like. The Diana+ offers a setting that positions adjacent frames for perfect panoramas.

One way to shoot panoramas consistently with the Holga is to use frame numbers for 6 × 4.5 cm shooting (keep the pointer on the back at 16) without the 6 × 4.5 cm insert. The overlapping portions of the images blend together the most smoothly if you shoot without any insert, whereas using the square insert creates distinct vertical lines within the image.

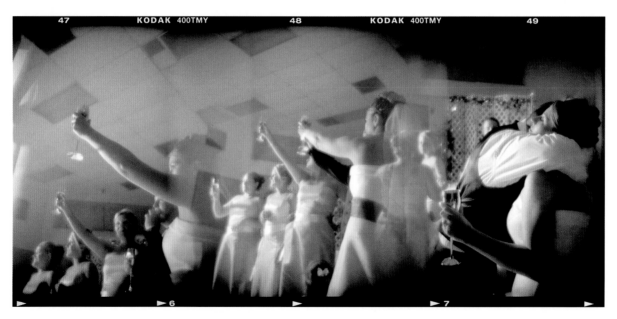

Toast, © Erin Antognoli, 2007. Shot on a Holga, wound partway between frames, during the best man and maid of honor's toasts. Using Holgas to photograph weddings has become increasingly popular.

To create a true panoramic representation of a scene, start shooting on the left and continue by moving the camera to the right. Don't think that's the only way to make panoramas though; feel free to combine images from different scenes to create a world of your own. If you're a fan of panoramic images, try the Wide Pinhole Holga: it makes images up to 6 × 12cm with a truly unique look.

You'll need to be creative in the printing of these negatives. In the darkroom, large-format enlargers can print negatives up to 5 or 10 inches long, but the real freedom comes in scanning and digital printing (see Chapter 10).

Capturing Movement

Holgas and Dianas have fairly fast shutter speeds (~1/100s and 1/125s). They can stop action, but sometimes still show blur in a very fast-moving subject. With the cameras' spring shutters, you can freeze a moment or, while on the bulb setting, use long exposures to let motion become part of your image. Keep your camera still to turn moving objects into blurred lines, or track an object with your camera to keep your subject sharp against a streaked background; this camera move is called *panning*. Making extended exposures of water causes the detail to disappear and a certain softness to alter the feel of the scene. If your exposures are long enough, moving objects will disappear completely, which can result in surreal scenes, such as normally busy streets pictured devoid of any cars.

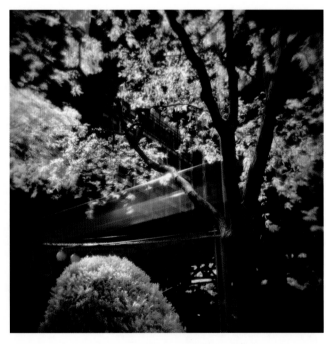

Wells-Monroe L Train, © Ryan Synovec, 2009. Create "ghosts" in your image by securing the camera on a tripod and holding the shutter open while moving objects across the scene. This infrared image was made with a Holga using a Hoya R72 filter on Efke IR 820 film.

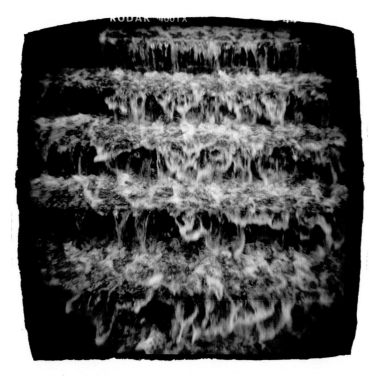

Water Steps, © Michelle Bates, 2004. The Holga's single shutter speed can freeze some fast-moving subjects, while still showing movement.

Low Light

Shooting with cameras that have limited apertures can be tricky in low light. This applies to interiors, night shooting, and any situation where the available light isn't enough to make a good exposure. The first way to compensate is to use the right film speed; fast films are ISO 400 to 3200. If the film you have with you isn't fast enough for the scene at hand, you can wring more information out of your

film in the processing stage by pushing it (see Chapter 9). To increase exposure with the shutter, use multiple clicks of the shutter or the bulb setting. Doing either while hand-holding your camera will result in unsharp images, which may or may not be the effect you're after. To make sharp images, plant your camera on a tripod; for best results, use a cable release—both Holgas and Diana+s now have custom-made adapters for attaching them.

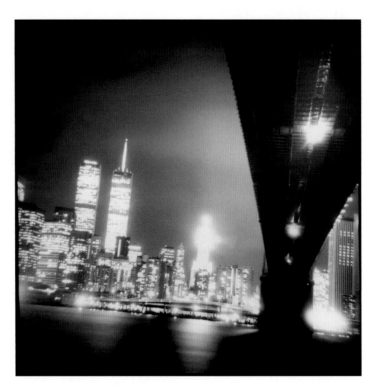

NYC Under Brooklyn Bridge, © Mark Sink, 1997. Diana camera on bulb setting, Tri-X film at f/16 printed on Fortezo paper.

The last way to add light is by, in fact, adding light with on- or off-camera flash, studio strobes, or even flashlights. For details, see Chapter 7. Combining a long exposure with flash will allow you to capture a flash-lit subject in the foreground and still have some detail in the background. When shooting in low-light situations, bring along a small flashlight to illuminate the frame numbers when advancing the film.

Night 382, © Becky Ramotowski, April 2, 2005. Holga camera with a modified bulb setting, 2-hour exposure on Agfa RSX II 100 transparency film. Cable releases can lock to keep the shutter open for long periods without wearing out your thumb.

Steers at Dusk, The Pastures of Ruhengeri, Rwanda, © Sylvia Plachy, 2005. A Holga with on-camera flash using Fujicolor NH5 film.

Flare

One of the reasons people buy expensive lenses for their fancy cameras is that the lenses are coated in a way to reduce flare, that is, light streaks that result from shooting into a light source. The Holga, with its self-declared "optical lens," or any of the other plastic cameras don't have these coatings and so are highly susceptible to flare. You can try to minimize flare by not shooting into the sun or bright lights, or by taping a lens hood onto your lens, or you can learn to embrace it. Flare is one of those effects that can add greatly to the look of an image. Because you don't look through the Holga's or Diana's lens

Midtown Manhattan, July 2005, © Thomas Michael Alleman. Tmax 400 film in a Holga, catching the last rays of sun in the big city.

Holy Cow, © Michelle Bates, 1996. Holga image made on Tri-X film, shooting straight into the sun while on a road trip in eastern Washington.

when composing, you can't see what it will end up looking like, so shoot with abandon and see what you get. You may just learn to love flare and the ever-unpredictable images it creates.

Color

Any plastic cameras can use color film to create images that range from muted to explosively gaudy; negative film is easier to control than transparency. Experiment with film types, color, and light; shoot

at different times of day, in all weather conditions, and from varying directions in relation to your light source. Light can be spectacular and colors intense on overcast days, when the sun is low in the sky, or when it illuminates leaves and flowers from behind.

Light leaks take on different characters in color film and black-and-white film. In color, they are usually somewhere between yellow and bright red, making it much harder to get rid of them in the final image than with black-and-white film. You have more opportunity now to tweak your lights leaks in the digital darkroom than in the old days of the color darkroom, where the best you could do was hope they fit into your image!

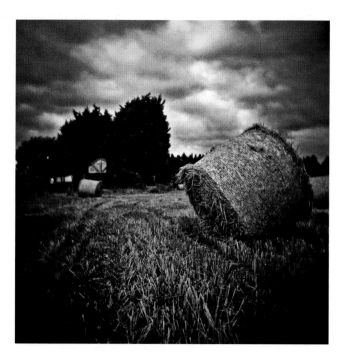

Harvest Mishap at Marshfield, Gloustershire, © Phil Bebbington, 2006. Shot with a Holga on Fuji NPZ800 film.

Hydrant, © Michelle Bates, 1999. Overcast days make colors pop.

Perspective

Photographers often limit themselves to shooting from the obvious perspective: straight ahead from about 5 feet off the ground. Start thinking outside that box and try bending your knees—it's also great exercise. Shoot up, squat down, hold the camera over your head, shoot from the hip, or spin around while clicking the shutter. Looking through the viewfinder is not required. You never know what you'll end up with!

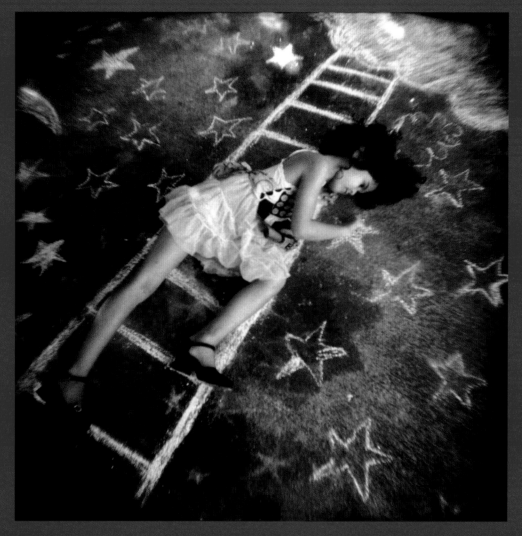

Maker of Dreams, © Laura Burlton, 2008, from the series *Dreams in the Key of Chalk.* Taken on World Toy Camera Day with a modified Holga. When creating a two-dimensional image of three-dimensional reality, you can take advantage of the shift in perspective.

Bondage A Go-Go, © Gordon Stettinius, 1992. Shot with a Holga camera with external flash on Kodak TMY 400 film. Sepia-toned silver-gelatin print.

Close-Ups

Most plastic cameras can't focus on subjects that are very close to the lens. You can use the blurriness that results when shooting close up as part of your image or you may want to try to make your images sharper. One way to do this is to use close-up filters in front of the lens. See the section on filters in Chapter 7 for details on using these filters to do macro photography and Chapter 8 for an easy camera modification for Holgas. The Holga's and Diana's viewfinders, already fairly inaccurate, lose even more relationship to what will be captured on the film when you shoot close up. This is called *parallax error* and represents the difference between what the lens, at the center of the camera, sees and what you see through the viewfinder. Be aware of this and move the camera slightly so that the lens seems more directed at your subject. Make several exposures to make sure you get the framing right. Another way to extend a Holga's focusing range is to remove your lens and use a pinhole instead—shooting through a pinhole gives infinite focus (see Chapter 8).

Get Extreme!

Holgas are not precious objects; they are relatively cheap, don't have complex parts that can be damaged by exposure to the elements, and they actually float, but you'll want to protect them a bit. Go out in the rain, wade in the ocean, and even go snorkeling; tote your Holga along to places you'd never dare bring a Hasselblad. For a little protection, drop your Holga into a Ziploc bag; they're clear enough to shoot through and flexible enough to allow you to turn the film-advance knob.

 Holgas and other plastic cameras, which may be more expensive or not easily replaceable (such as vintage Dianas), are still great for other unfriendly environments, such as the hot dusty desert, which can easily destroy a complex camera, or the frigid regions of the north, where batteries become ineffectual, leaving most cameras useless. One problem to keep in mind though—your plastic partner can melt. After all, it is plastic.

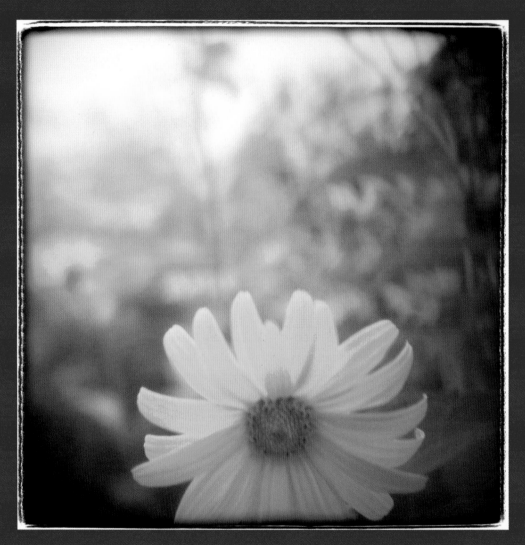

Curtsy, © Rebecca Tolk, 2009. A Holga 120N with a hand held, close-up filter on Kodak Portra 800 film.

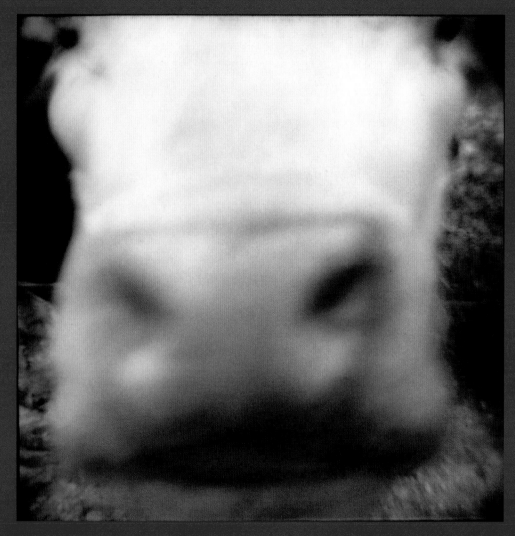

Cow's Face, © Nancy Rexroth, McArthur, Ohio, 1975. A Diana camera vintage silver print, 4″ × 4″.
Sometimes compensating for being too close just isn't necessary. Courtesy of Robert Mann Gallery.

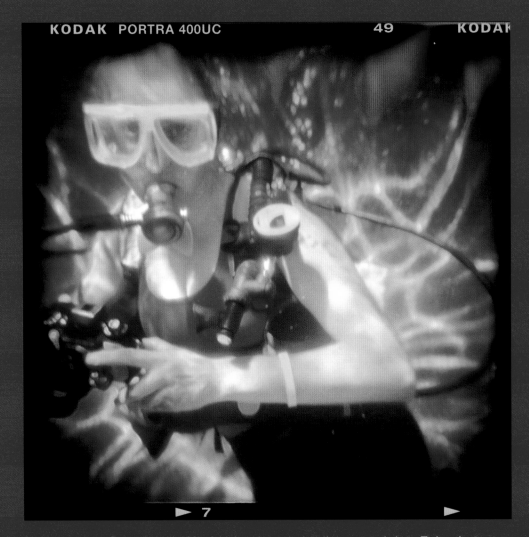

Robin Underwater, © Ted Orland, 2004. A Holga takes a dunk underwater sealed in a Ziploc plastic bag, photographed with Kodak Portra UC 400 color negative film. Condensation in the bag softens the image further.

HAVE FUN!

The real joy of toy cameras is the freedom they give the photographer to play. Complicated instructions for custom functions go out the window, people are more curious than freaked out when you point a Holga at them, and you're more likely to carry around a light, expendable camera than a heavy one. Plus, when you know that your negatives are most likely going to be terrible, there is freedom to shoot with abandon. Experiment, experiment, experiment. Find your vision, create your unmistakable personal style, and have fun!

Holga Stars 258, © Becky Ramotowski, 2005. Holga camera, modified with bulb setting, attached to an astronomical mount that tracks the stars. Twenty-minute exposure on Fuji Provia 100 color-negative film.

chapter seven

Techy Tips

You've gotten film in your Holga, taken your Diana+ out to play, and some images have even shown up on the film—what's next? Here are some techniques to experiment with that will expand the range of what your toy camera is able to create. All of these are widely used on standard cameras as well, but plastic cameras have some special needs.

FLASH

Many plastic cameras are able to be used with flash; some have them built in, while others sport hot shoes for connecting external units.

Some early Diana cameras and clones had specially made flash units that fit into holes on the F models. These units required old-style, one-time-use flashbulbs, which are not only obsolete but almost impossible to find. The new Diana F+ flash mimics these older versions in look, but uses an electronic element and comes with an adapter, allowing it to be used on any hot shoe. The Holga was the first 120 camera made with a built-in flash.

Built-in Flash

Many in the Holga line have built-in flashes. The original version is the 120SF, and currently there are the 120FN, 120CFN, 120GFN, 120GCFN, the 120TLR, and the Stereo 120 3-D, which has two flashes, synchronized to each other and to the two lenses. Lomographic's Action Sampler Flash has four little

Larry, © Gordon Stettinius, 1994. A Holga camera with external flash, Kodak 400 TMY film.

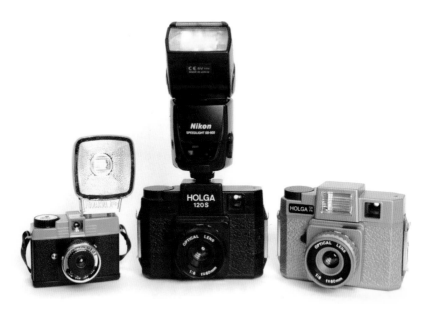

Several options are available for shooting with flash, especially for cameras that have a hot shoe.

flashes that go off in sequence with each of its four lenses. Built-ins are convenient, as they're always with you, but several issues make them problematic. The small flashes aren't very powerful, don't have a sensor or output controls, and, due to their close proximity to the lens, are more likely to produce red-eye in color images.

With the Holga, there are additional issues. The batteries that power the flash are behind the film, so if they run out mid-roll, it's nearly impossible to change them. The batteries are intended to be held in place by the inserts; if you shoot without one, as I do, it's difficult to get the batteries to stay put. Try taping them in with gaffer's tape or cut some of the plastic out of one of the provided inserts to make a version that won't affect the image frame.

Flash doesn't always have to be pure white. The Holga 120CFN version includes red, yellow, and blue filters for the flash, but you can tint any flash easily by holding or taping gels in front of it. A slight warming

filter can be useful when combining flash with long exposures to balance the color of the light. Gel-filter sample packs, available from theater lighting and sometimes photo stores, are just the right size.

Flash on a Shoe

External flashes offer much more in the way of power and flexibility than built-ins. However, the main disadvantage, after their cost and weight, is that you have to remember to bring them along. Plastic cameras that come with hot shoes for external flashes include the Holga 120N, Lomographic's Diana F+ (when used with the included adapter), and Superheadz's Golden Half and Blackbird, Fly. Hot shoes are wired to set off the flash when the shutter is triggered. In sophisticated cameras, information is transmitted through the hot shoe, which allows the camera and flash to adjust settings automatically to make perfect exposures in through-the-lens (TTL) mode. No such luck with plastic cameras. While most flashes will work with them, any information has to be entered manually.

In the world of flashes, bigger means more light, and usually more control. I have a range of flashes, from the small and simple to my high-tech Nikon flash, with an adjustable head, multiple controls, and a sensor that monitors output. What equipment I use with my Holga depends on what I'm shooting and how much I'm willing to carry. Before you decide what to buy, you'll also want to consider both your technical needs and your endurance.

The smallest flashes, including special Holga versions and the Diana Flash+, tend to be ones that look most at home on a Holga or a Diana. These flashes are somewhat more powerful than built-ins and, being farther away from the lens, usually give more pleasing results, but still suffer from limitations. Professional flashes on plastic cameras may look a bit ridiculous and have a tendency to flop over and fall off with a crash, but their added controls can help compensate for some of the limitations of these cameras. Units that have integral sensors adjust their output depending on the light that bounces back to them. If you have one that allows manual entry of information, set it to auto mode; enter your camera's aperture, the focal length of the lens, and the speed of film you've loaded; and you'll get surprisingly well-exposed images.

Some pro flashes also have extra features, such as a head that can be swiveled or pointed up to the ceiling, bouncing the light to provide broader and more diffuse coverage. A variety of modifiers can be attached to these to alter the quality of the light output. To give directionality to the light, most flashes can also be used on an extension cord that attaches via the hot shoe. Some have other built-in tricks, such as multiple flashing to create a stroboscopic effect during long exposures. You can expand your camera's reach greatly once you get to know the versatility of flash.

One additional thing to note: Holgas eat flash batteries very quickly because the flash is fired twice for each frame—once when the shutter button is pressed down to click the exposure and a second time when the button is released, which doesn't affect the image. Make sure to bring extra batteries along.

Strobes

For full lighting control, most of our plastic cameras can be used with studio strobe lights. These lights are, in fact, ideally suited to shooting with a non-adjustable camera, since in the studio, most of the adjustments are made with the strobes.

With hot-shoe models, use a small device called a hot-shoe to PC cord adapter. The PC outlet lets you plug in a standard cord that triggers strobe lights. You can also try using wireless strobe triggers, although some of their features may not work. One thing to be careful about when using this type of setup with the Holga is its "double click." As mentioned in the section on flash, when taking a picture, the Holga's shutter clicks once on the way down, when the exposure is made, and again on the way back up. The double click can cause technical problems when working with strobes, which will be triggered by both clicks. Because studio strobes take a few seconds to recycle, the second click may set them off again before they're ready. This can damage them and "blow the packs," possibly causing permanent damage. To avoid wrecking your lights, hold the shutter button down until all the strobes recycle, which is usually signaled by re-illumination of the modeling lights. Then release the shutter button. With on-camera flashes, it's actually better to release the shutter quickly. This will cause less

Beauty Zoya, © Pauline St. Denis, 2002. Holga camera image made with a ring strobe around the lens on transparency film.

drain on the batteries, as the second flash will use up less power if the flash hasn't had time to recycle. Flashes aren't damaged by successsive triggering.

A Holga's built-in flash, or a flash sitting in the hot shoe, can also be used to trigger strobes remotely. Yes, wireless technology even works with plastic cameras! Most strobe lights have a built-in "slave" unit that responds instantaneously to a flash, setting the strobes off in time to light your exposure. However, be careful—the double click issue still occurs with this setup.

The addition of flash greatly extends the range of conditions in which a simple camera can be used. Simply set your light output so that your meter reads the correct aperture for your camera and you're ready to go. Those serious about exploring further may want to take a class in on-camera flash or studio lighting; the possibilities of artificial light are limitless.

FILTERS

Filters, long a mainstay of traditional photography, open up another world of modifying your images from in front of the lens. The popularity of filters has declined with the rise of digital photography because many of their uses have been replaced by in-camera file adjustments or computer post-processing. Even so, go ahead and dig those simple add-ons out of your photo drawer, or pick some up in the sale bin at your photo store, for there are still a number of ways to use them ingeniously with plastic-lens cameras. Many books on using filters for both black-and-white and color photography cover the options in great detail, but here's a rundown of how to use them on Holgas and on which filters will work with all your plastic cameras.

Filter Holders

A custom filter holder, made by Holga Limited to fit over Holga lenses, creates a home for dedicated filters that come in three different sets. These include a group of solid-colored filters, a collection that has a clear center and mottled-colored haze over the rest of the frame, and several beveled filters that

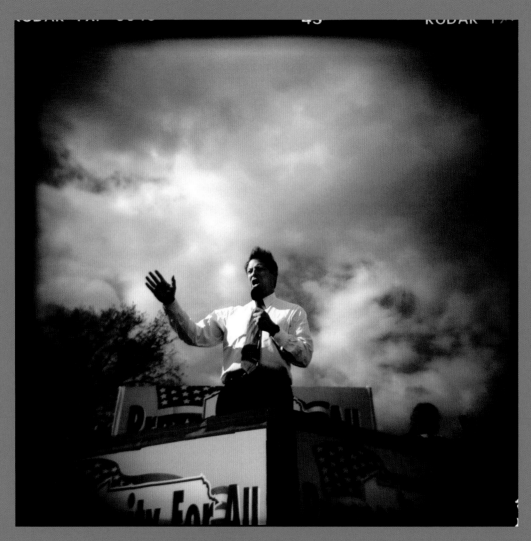

Al Gore Campaigns in Philadelphia Two Days before the Election, 2000, © David Burnett/Contact Press Images, 2000. Holga camera with red filter to enhance the clouds.

create multiple images within a single shot. The convenient slot in the custom holder can also hold any type of gel filter, cut down to size.

In addition to these dedicated Holga filters, there are many types of standard circular filters, widely used on all camera formats. These aren't immediately attachable to Holgas, as they don't have threads in their lens barrels like most lenses do. You can create some by using a step-up ring, which is made for bridging the size gap between larger filters and lenses with smaller threads. Get a ring that starts at 46mm, and screw it right into the soft plastic of the Holga's lens barrel. The larger-sized threads will create a permanent place for attaching filters. These rings step up to many sizes; get one that matches the filter size of your other lenses, and you'll be able to share filters between cameras.

There is no easy way to attach standard filters to Diana or Diana+ lenses, but simply holding a filter in front of the lens of any plastic camera, or taping it on, does the job. A set of 12 tiny colored gels is included with the Diana F+ and flash; these can be used by removing the Diana+'s lens, placing the gel over the shutter, and securing it in place by reattaching the lens.

Filters come in a wide range of colors, densities, and effects. Used with black-and-white films, color filters can alter the tonalities of subjects in the image. For example, red filters intensify skies and contrast and are often used in black-and-white photography. Here are some other filter options.

Neutral Density

Neutral density (ND) filters can be useful when shooting in very bright conditions. Since you can't change Holga's aperture or shutter speed to decrease the amount of light entering the lens, film speed generally provides your only control over exposure in bright light. ND filters block light without affecting color or tonal balance, thus giving you an extra element of control over exposure with both black-and-white and color film. They come in various densities. The most useful ND ones for a Holga are full-stop filters, which block a significant amount of light. The .3 ND filter cuts one stop of light, the .6 ND cuts two stops, and so on. They can also be stacked together for extra light blocking. If you have trouble with overexposed negatives, keep one, or a set of ND filters, handy in your camera bag. Polarizing filters, discussed next, are neutral and light-blocking as well.

Polarizing Filters

Polarizing filters are widely used in black-and-white and color photography to intensify colors and contrast, cut through haze, and decrease or eliminate glare and reflections. These effects are caused by the filtration of light at some angles, and because the effects can't be replicated digitally, they are still useful today. When used on a single-lens reflex (SLR) camera, you can preview the degree of the effect by looking through the camera's viewfinder while turning the filter, which changes the direction of the polarization.

However, because a toy camera's viewfinder doesn't present the view through the lens, polarizing filters are difficult to use. The best way to compensate for this is to not screw the filter on at all. First, hold the filter in front of your eye and view the scene while looking directly through the filter, rotating it to get the desired effect. Then move the lens up against the filter, making sure not to change its angle as you are shooting the image.

It's important to remember that polarizing filters also block a large amount of light—up to two stops. This can be problematic if light is low or useful in bright situations to avoid overexposure. Both linear and the more expensive circular polarizing filters, required for autofocus lenses, are appropriate for use with plastic cameras. They are tricky to use, but can be very helpful once you get to know them.

Macro Filters

Plastic camera lenses are not designed for focusing close up on objects. The Holga's one-head setting will allow you to photograph subjects about 4 feet away, but there's a whole world closer than that. By using a macro filter, a type of magnifying lens made for this purpose, you can take a Holga or Diana down to the ground or up close to a face. See Chapter 8 for a quick Holga camera modification for getting a little bit closer.

Once again, because you can't see through the lens of the any of these cameras to know the effect close-up filters are having on the focus, you'll need to develop a system to learn where the focus

Holga's sets of macro and close-up filters allow shooting from 20″ down to 2″. Other brands of close-up filters can be used, but they don't have the focus distances printed handily on the filter.

points are. Standard macro filters come in different strengths of +1, +2, +3, and up to +10 and can be bought in sets. The down-and-dirty way to get your shot in focus is to shoot a composition several times, using each filter, and hope that one comes out right. This works for the occasional shot, but if you plan to do close-up shooting on a regular basis, you can save lots of film by testing your filters in advance. For Holga users, Holga Limited has created two dedicated sets: the close-up set that focuses at 500, 250, and 120 mm (approximately 20″, 10″, and 5″) and a macro set for focusing at 60 and 30 mm (2.4″ and 1.2″). These are wonderful in that they slide right onto the front of a Holga's lens and take

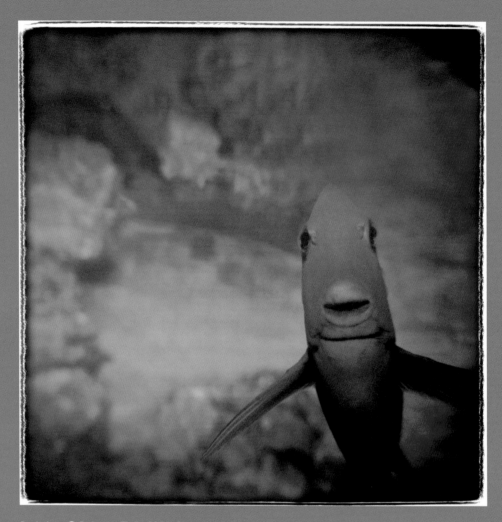

Peekaboo, © Rebecca Tolk, 2006. Shot with a Holga using a hand-held close-up filter on Kodak Portra 800 film, push-processed. Burlton looks through the filter to compose, then places the camera lens behind it to capture the correct framing.

the guesswork out of figuring focus distance. Lensbaby's +4 and +10 filters are too small to attach, but big enough to hold in front of many plastic cameras' lenses.

Here's the drill: make yourself a setup that includes your camera with a bulb setting; an object, sheet of text, or resolution chart; a tape measure; and a loupe or other magnifying glass. You'll also need either a piece of translucent paper, such as waxed or tracing paper, or a piece of ground glass, such as that on the back of a view camera. Set the camera shutter to "B," take the back off, and, if possible, put the camera on a tripod. Tape the ground glass or paper across the two interior dividers, where the film would sit, or onto the camera insert if you use one; this will ensure that you're testing the focus at the proper film plane.

Move the focus ring to the closest setting, click open the shutter, and lock the shutter button down with a cable release or tape it down with gaffer's tape. Place the loupe or other magnifier up against the ground glass or paper and, moving the camera toward your subject, look through the magnifier for the subject to come into focus. Mark down the distance from the subject to the front of the lens. Then, one by one, set your test filters in front of the lens (either screwed into your step-up ring or taped on) and repeat the measurements.

If you want to get even closer, stack the filters (+1 with +2, +1 with +3, +2 with +3, etc.) and test these combinations as well. Draw up a focus distance chart to keep with your filters or mark directly onto a tape measure, make a dedicated bag for the whole kit, and you'll be in focus every time.

	+1 Filter	+2 Filter	+3 Filter	No Filter (on Close Focus Setting)
Distance in front of Holga lens	20–24 inches	13–15 inches	9 ½–11 ½ inches	4–7 feet

Accessory Lenses

A new trend in plastic cameras is the use of many accessory lenses that have become available in the last few years. For the Holga, these include a 0.5× wide angle, a 2.5× telephoto, and two types of fish-eye lenses, one from Holga and one from the Lomographic Society. All slide snugly over the Holga's lens. The Lomographic Society also makes a series of interchangeable lenses for the Diana+ series: the standard 75 mm, a 55 mm wide-angle, 38 mm super-wide with a close-up adapter, and a 110 mm telephoto with an additional soft-focus lens; a fish-eye; and some additional accessories. You can also experiment using lenses made for camcorders and digital cameras.

INSTANT PLASTIC PHOTOGRAPHY

Things have been changing rapidly in the world of instant photography since the first edition of *Plastic Cameras* was published in 2006. In the past few years, several instant film backs for the Holga, variously called Holgaroids, Polgas, and other cute monikers, have been made, discontinued, and reintroduced by several manufacturers. Film choices have also come and gone. As of 2009, Polaroid discontinued making most of the film it pioneered. Fujifilm, however, still makes several instant films that can be used. Reformulated versions of Polaroid films being introduced by the Impossible Project are, unfortunately, not being made in formats compatible with any of these backs.

The first wave of instant backs for the Holga used only the square format, peel-apart Polaroid 80 series films. Subsequent versions were designed to accept both the 80 series and the rectangular Polaroid 660 series. All of these films have been discontinued, including the sorely missed 665 film, which produced a negative as well as a print.

Fujifilm's instant films, 100C (color ISO100), 100B, and 3000B (black-and-white ISO100 and 3000), are made in the same rectangular format as the Polaroid 660 series and work wonderfully in the newer backs. The rectangular film backs are set onto the Holga such that the images are off-center. However, over at Holgamods, Randy Smith will permanently alter your Holga and back so the images fall more in

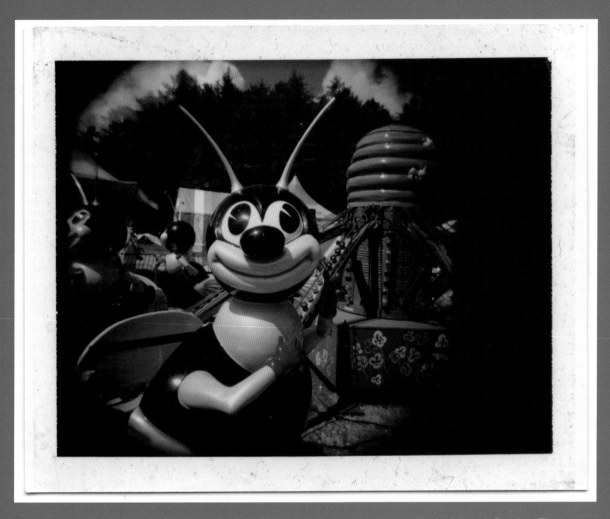

Made with a Holga and instant film back on Fujifilm 100C instant film at a carnival near Penland, North Carolina. The image is off center because of the setup of the back. Photo © Michelle Bates, 2009.

the center of the film. The Diana Instant back, introduced in 2009, uses Fujifilm's ISO 800 Instax Mini film, which spits out integral (non-peel-apart) prints that are just under 2″ × 2.5″.

Because the Holga's instant backs cover the viewfinder completely, composition is determined either by guessing or by using an external viewfinder, which will be at best approximate. The back does not connect very tightly, relying as it does on the Holga's flimsy clips, so tape it on and be gentle. Also, because the film plane is at a different distance from the lens than with roll film, the back comes with a diopter corrective lens that must be used over the lens to get in-focus images. Don't forget to bring it along. The Diana+'s instant back still allows you to see through the camera's viewfinder or use the external viewfinders that come with the accessory lenses, giving you much more control over your composition than is possible with any version of the Holgaroid.

When shooting instant film with a plastic camera, it's a challenge to get good prints. With very few shutter speeds and apertures, there aren't many choices for exposure settings. Because Polaroid and Fujifilm instant prints are the final product, if the light isn't right for those exact settings, you won't get a satisfactory image—similar to working with transparency film. In our dream world, we'll one day again have positive/negative instant film, and with the negative we'll have much more flexibility with exposure and options for making prints later on. For now, here are several things, detailed elsewhere, to use that will increase your chances of achieving good results:

- Flash or studio strobes
- Bulb setting or multiple shutter clicks to build up exposure
- Fast film such as Fujifilm's 3000B or the ISO 800 Instax Mini
- A light meter to determine your proper exposure.
- Filters to cut down extra light.

Working with peel-apart instant film, such as the Fujifilm 100B and 100C, is a hassle. Because these films require different development times depending on the temperature, you'll need a timer or watch

with a second hand and either a thermometer or some sense of what the ambient temperature is. To get started, load the film pack, close the back, and secure the clip. Pull out the black cover sheet completely, then remove the dark slide and store it in the slot on the back. After shooting, first pull the white tab out of the film back, then pull out the print, by the larger tab, and start timing. At the end of processing, separate the print from the backing paper by pulling the corner of the print. If you're confused about where to grab hold of, look for the frame number stamped on the back of the print and start pulling from the closest corner. Once you pull apart the film, you'll have nasty chemical-covered waste paper; fold it over on itself and store in a Ziploc bag until you get to a garbage pail. Give the prints time to air-dry before stacking them or putting them in your bag; when wet they can stick together or scratch easily.

It's not simple, but the instant gratification you get with these setups is irresistible and addictive!

INFRARED FILM

Infrared (IR) film has sensitivity to light beyond the visible spectrum. It detects wavelengths into the infrared spectrum, from 700 to 900 nm, which can't be seen with the naked eye. When used with filters to block some or all of the visible light, IR films create images that alter normal tonal values and have a special luminosity to them. In these images, skin and foliage are represented as almost white, making them seem to glow, while skies and water go dark. Many well-illustrated and informative books and web sites feature IR photography. And as for the question photographers ask: Can IR film be used in a plastic-bodied camera? The answer is yes—try it out yourself.

There are currently three films that take us into the infrared end of the spectrum, all of which are available in 120. Efke IR 820 (formerly sold as Macophot IR820c) is the only true IR film. It is sensitive up to 820 nm and has an approximate speed of 25. Two other films, while not true IR, also give similar effects. Rollei Infrared 400 film dips its toes into the IR realm, capturing wavelengths up to 720 nm, and has a much faster 400 ISO, allowing some use without a tripod. Ilford has its SFX, with 740 nm sensitivity, and an ISO of 200.

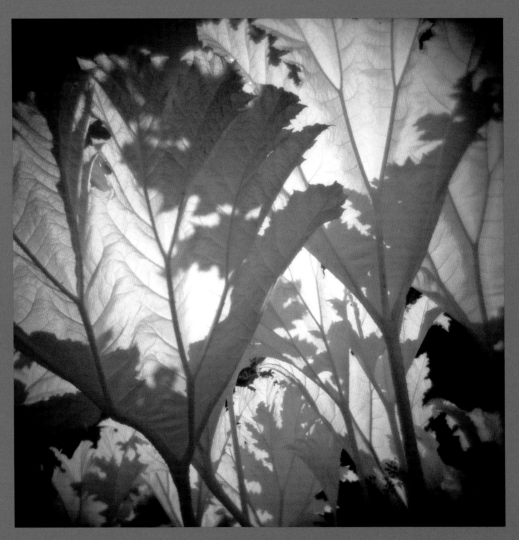

Ethereal 2-11, © Ryan Synovec, 2008. Infrared image made with Efke IR820 film in a Holga, with a Hoya R72 filter blocking all visible light.

Without filters, IR film can be used more or less as normal film, but to record the IR effect, filters must be used over the lens. The lightest filter to use is a #25A red, which blocks about two stops of visible light, allowing the balance to lean more toward the IR effect; its darker cousins, the #29 deep red and B+W's #092/89B, intensify this effect even more. Several filters that are opaque to visible light, such as the Hoya #RM72 and Tiffen #87, can be used as well; these further exaggerate the IR effect, but need much longer exposures. You can't see through these filters at all, which makes the Holga the perfect camera to use them with, as you don't look through the lens to compose anyway. With all these filters, the problems of exposure inherent to plastic cameras are increased by the reduction of light reaching the film. Experiment away: use a Holga or Diana on the bulb setting and with a tripod, sample a variety of combinations of filters and exposure times, and, above all, keep good notes as you go—not later, when you'll have forgotten exactly what you did.

Another nifty trick with infrared film is to put a piece of #87 opaque filter over a flash and use the IR light that gets through to light your shots. With this so-called "dark flash," the illumination is invisible, making it great for interior shots where a normal flash would be distracting.

Creating plastic camera photographs is an ongoing discovery process. Next we move on to modifications for the Holga.

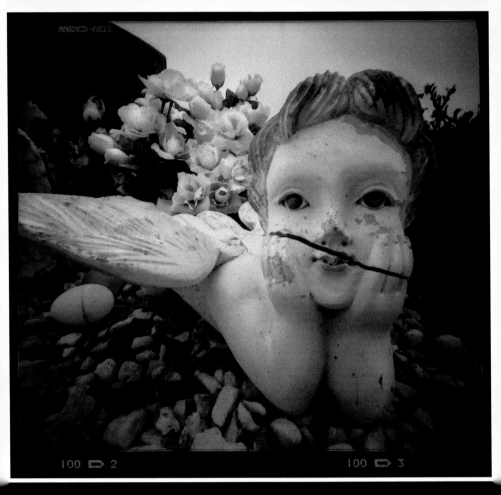

100 ⊏⊐ 2 100 ⊏⊐ 3

Damaged Angel, © Ted Orland, 2001. Pinholga (Holga camera modified with a pinhole) photograph of a
6-inch high statue taken from a distance of 6 inches, on color negative film; edges modified with a dry

chapter eight

Holga Camera Modifications

The workings of plastic cameras are so straightforward that it's easy to get to know how they function. Their minimalism also makes them easy to disassemble, mess around with, and revamp to your own specifications. Here are a few examples of modifications you can do with your Holga. There are volumes of more ideas for the Holga or Diana out there on the web, so get out your tool kit and start creating your own customized photographic accomplice.

SIMPLE HOLGA MODIFICATIONS
Tone Down the Interior

In addition to the basic taping discussed in Chapter 5, some people think that flocking, or painting the interior of their Holga with flat or ultra-flat black paint, helps keep light leaks to a minimum. Flocking is good to know about, although I've never had any issues that I attribute to light bouncing around in the Holga's shiny interior.

Bulb Setting

The original Holga 120S didn't have a built-in bulb setting, so many people rigged them manually. This isn't an issue with the 120N series, but manual rigging is something to consider if you run across an old Holga or other camera without a bulb setting. Instructions are easily found on many web sites.

Go panoramic with 35 mm film in your Holga. This is the cheap way;
premade adapters are also available.

Use 35 mm Film

Medium-format Holga 120N series cameras are meant to take 120 film, but they can also use 35 mm
film. Aside from the advantage of more readily available 35 mm film and processing services, with this
setup you can create a unique type of image—panoramic photographs that spread all the way to the
edges of the film and over the sprocket holes. It's easy to use 35 mm film in your 120 Holga.

Take a 35 mm cartridge and center it in the left side of the Holga. Cut out pieces of foam to go
above and below the cartridge to keep it snugly in place (see figure). Once the cartridge is secure, pull
out just enough film to reach over to the other side and insert the leader into the take-up spool. Tape

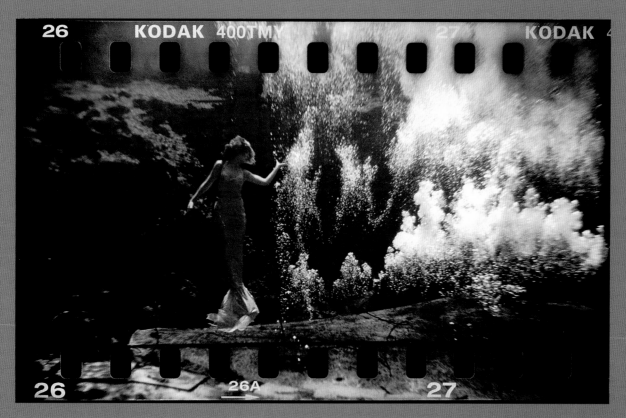

Mermaid, © Gordon Stettinius, 2005. Holga camera with 35 mm film.

the film leader onto the reel to help keep the film in place. Wind the film-advance knob just enough to make sure that the film is centered and will stay on, and close the camera back.

It's very important to remember when using 35 mm film to keep the back counter window covered securely at all times. Because 35 mm film doesn't have a paper backing, opening the window covering *will* expose the film to light through the red window and create obvious splotches on your negatives. Use several layers of opaque tape on the inside and outside of the window.

Winding the film without having numbers from 120 film's paper backing to guide you is somewhat of a guessing game, so you'll need to keep track of frames with the winding knob. Use 1½ revolutions of the knob as a starting point to wind one frame, or count the number of clicks of the knob (which is usually around 34 clicks per frame). With both 35 mm and 220 film, as the take-up spool gets full of film, it takes less winding to advance one frame. Charts are available online that detail the number of clicks to turn for each frame; print one out and tape it to your camera. And since the film at the start of the roll is unusable, having been exposed to light during loading, make sure to wind the film on far enough to get fresh film into the camera body.

When you're done with your roll, place the camera in a changing bag or take it to a light-tight room, pull out the cartridge and take-up reel, and, in total darkness, gently turn the stem on the film cartridge counterclockwise to rewind the film into the cartridge.

If you're really handy, it's possible to make a rewinding lever by poking a hole in the bottom left of the Holga and inserting a screwdriver into the canister stem.

There are a few commercial converter kits that make your Holga ready for 35 mm film. The most basic consists of a solid camera back, to prevent accidental light leaks through the red window, while Superheadz's elaborate insert version fills the inside of the camera and provides precise film advance and rewinding capabilities. A converter kit is also available for the Diana+.

Built-in Close-up Lens

If you don't want to carry around extra filters, but would like closer focusing capabilities, throw long-held ideas about how to treat your equipment to the wind and break your Holga's lens. You heard me right.

Turn the lens to the close-up setting, grab the Holga's body in one hand and the lens in the other, and turn until you hear a satisfying crack. Your lens will probably come all the way off—it's okay, really. Get the threading right and most of the time it will go back on with the old stopping point still keeping it from falling off at whim. Now though, you can turn the lens to focus even closer than the normal 3–4 feet. Use the method in Chapter 7 to determine your focus distances and mark the focus distances on the lens.

Interior Framing and Artsy Insertions

The inside of a Holga is a blank space that holds loads of potential to enhance your photography. Anything that you place between the lens and the film can become part of your image. This could include making a paper edge that creates a unique frame for all your photos, placing figures inside in front of your film that will become silhouettes in the image, or covering the whole image area with a transparent medium with text or other designs on it. Be aware that the image is thrown upside down onto the film, and plan your insertions accordingly.

ADVANCED HOLGA MODIFICATIONS
Two Real Apertures!

If you've been checking your exposures carefully (and really, who does with a Holga?), you'll realize that the aperture switch has, for most of the Holga's history, been useless. The arm that swings out when you flip the switch to the sunny setting has a hole that's larger than the opening to the lens, so in both settings, the effective aperture is the same. And, contrary to what the switch label would have you believe, the flash works on both settings. The only thing the switch *can* do is ruin images if left in between the two settings. But there is a fix—in fact, two: you can give your Holga a smaller aperture or a larger one. Or both! Holgas are now being manufactured with a smaller aperture in the arm, but there are still some changes you can make to expand your camera's range.

To get at the guts of your Holga, remove the screws inside the camera (circled in the figure) with a size zero screwdriver. Take the front of the camera off, being careful to keep the wires intact if you

Remove these two teeny screws to separate the front part of your Holga. Be careful not to lose the screws!

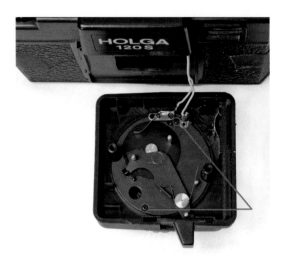

Next undo these two (even teenier) screws to remove the shutter assembly and access the aperture arm.

intend to keep using the hot shoe or built-in flash. Next, remove the two smaller screws that hold the shutter mechanism onto the front part of the camera. Pull the shutter mechanism out and you'll find the aperture arm.

There are two modifications you can do at this point. The first is to make the maximum aperture larger by removing the small black ring set behind the lens (see figure on page 195). This makes the cloudy setting into a slightly wider aperture. Carefully lift out the aperture arm, and then use a small screwdriver to gently pry this ring out. This wider aperture may affect your depth of field, so you might want to store the ring in case you want to glue it back in.

The second modification to try is making the hole on the aperture arm smaller, like the newer versions. Find a piece of cardboard or other material that's the same thickness as, or thinner than, the

aperture arm. Cut a piece the same size as the aperture opening and tape it in place with Scotch or Mylar tape. Anything thicker will interfere with the arm's movement—do not use gaffer's tape here. Then cut out a round opening for the aperture.

Another option is to cover the entire opening on both sides with silver Mylar tape, the kind used for masking slides, and then use a small punch to make your aperture hole. For good measure, color the tape black to minimize reflectivity. When creating your smaller aperture setting, be aware that your images may start vignetting, to the point where they can become circular, if the aperture hole is

Holgas come with the aperture arm hole larger than the main aperture. This is a Holga 120N with bulb setting and tripod port.

A Holga 120S with the modifications described in the text. The camera aperture is larger, and the arm's aperture is smaller. That's silver Mylar tape, colored with a black marker.

too small. If this happens, you can either keep the circular look or make the hole larger until you get whole images again.

Put everything back together and you'll have a Holga with the cloudy setting aperture larger and the sunny aperture smaller than normal, so carry this version with a standard model and you'll have an ample selection of exposures to choose from.

Built-in Filter Changer

While you're in the guts of your Holga, another neat alteration is to tape a piece of colored filter into the aperture arm's opening. This gives you an instant on–off filter switch. A red filter is useful for black-and-white or infrared shooting. Alternatively, if you have problems with overexposed negatives, attach a piece of neutral density filter to the arm to turn your aperture arm into a control for easily cutting the amount of light reaching your film.

PinHolga

If a plastic lens isn't low quality enough for you, you can shoot without a lens at all. You can now buy an official Holga 120 or 35 mm pinhole camera or the fabulous Holga 120WPC extra-wide version, or you can easily convert your Holga into a pinhole camera, lovingly nicknamed a PinHolga. The first step toward creating your PinHolga is to take off the front of the camera. To do this, remove the camera back and unscrew the two interior screws; you'll now see inside the body—see figure in the previous section. Since you won't be needing your flash any more, disconnect the wires. Over the Holga's new front opening, install your pinhole with light-tight tape. The pinhole itself should be made out of thin foil or metal (disposable aluminum pie pans are perfect), but it should be mounted within a sturdier material. Use a lens cap or other piece of opaque material to cover the lens when not shooting, and remove it to make a photograph. Finally, a use for the lens cap!

Pinholes can also be mounted to the front of the lens mount. To do this, remove the lens, mount the pinhole to the front of the lens barrel, and you'll still be able to use the built-in shutter for making exposures. Obviously, this works better on a Holga with a bulb setting.

There are many resources available to help you make the appropriate pinhole sizes, the premier ones being Eric Renner's book, *Pinhole Photography: Rediscovering a Historic Technique* (Focal Press, 2004), and his website, www.pinholeresource.com. Shooting with a pinhole camera takes time and patience. Shutter speeds are slow and the camera needs to be mounted on a tripod. Given that pinhole cameras are always in focus, from up close to infinity, this is one way to get your Holga to increase your camera's depth of field.

Theaters, © Dan Zamudio, 2007. Three separate Ilford HP5 negatives, shot with a Diana camera, sandwiched in the darkroom to make a composite image.

chapter nine

Film Handling and Processing

NOW WHAT?

Now that you've run a few rolls of film through your plastic camera, what do you do with your exposed film?

PROCESSING FILM

The Diana and the Holga, and most of the cameras in this book, still live in the world of film, the analog world. Even if the rest of your final image-making process is going to be digital, it's important to give careful attention to the negatives. Your choice of film and method of processing have a great impact on the success of your shooting and play critical roles in achieving your artistic vision. At the end of this chapter and in Chapters 10 and 11, there's more information about final options in the image-making stage.

Lab Processing

A variety of choices are available for getting your film developed. Black-and-white film can be processed at home by hand, or at a lab, while color-negative (C-41) and transparency (E-6) films require lab processing. As mentioned in Chapter 5, Ilford XP2 and Kodak BW400CN are black-and-white monochromatic films that are processed in standard lab C-41 chemicals, which make these films

a good choice when black-and-white processing isn't available. Not all labs are set up to process 120 film, so call around first. If you can't get your film run locally, there are several mail-order options.

Hand Processing

Processing your black-and-white film yourself gives you the most control over your negatives, through the choice of a wide selection of film stocks and chemistry. The availability of so many options can be particularly useful with plastic cameras, which offer minimal exposure controls and rarely make perfect exposures.

Contrary to popular belief, you can process film at home without having a full darkroom setup; in fact, any sink will do. The only time you need darkness is when rolling the film onto the reels, which can be done in a light-tight closet or a changing bag. I have two changing bags, a small one

Holga 120 negatives come in long strips that are cut to fit in sleeves, shown here on a light table. Note the wide range in exposures even within one roll of film. Image made with a Rollei MiniDigi (no film required!).

for my camera bag, and a larger one that is big enough to fit processing tanks and reels. You can also get a pop-up version of a changing bag, which creates a small tent-like structure that is easier to work in. You can also process film yourself at schools or photo centers that offer rental processing and printing facilities on an hourly basis. Another possibility is to consider starting or joining a darkroom cooperative with other photographers in your area.

The basic equipment required to process film is minimal. You'll need a processing tank and reels, a set of bottles for chemistry, and some way to hang your film to dry. Tanks and reels for 35 mm and 120 film come in plastic or metal. Tanks come in a variety of sizes, from the smallest, that holds one

35 mm reel, up to the largest that can hold eight 35 mm or four 120 reels, or a combination of the two. Chemicals required for processing are a developer, stop bath, fixer, and, ideally, a fixer remover and rinsing solution. Special film washers are made, but film can be cleaned effectively in the tanks as well. For drying, the most elaborate setups are drying cabinets with heating and air filtration systems, but hanging film over a tub in a relatively dust-free bathroom is a functional alternative. Altogether, it is cheap and easy to pull together a home processing setup. To get you started, information is widely available online, in books, and in the many photography magazines on the stands.

The main aesthetic choice in processing is the type of developer you use, which, in conjunction with your film choice, allows quite a variation in the final look of your images. A good starting combination for film shot in plastic cameras is Kodak's Tri-X 400 film and HC-110 developer. Together, these give a wide degree of latitude in the range of tones recorded. Specialized developers can create negatives that have finer grain or higher or lower contrast, while others may be required to develop certain films. The following is an overview of more advanced techniques for getting the most from plastic camera negatives.

Changing Development Times

Push-processing is a useful technique for compensating for rolls of film that were underexposed in the camera. Underexposure is common with plastic cameras because of their relatively fast shutter speeds and small apertures. Film is pushed by processing it in the developer for a longer amount of time than normal development. Extending the development time allows more of the latent image on the film to develop and increases contrast.

Conversely, pull-processing, or decreasing development time, can help save overexposed negatives made on very bright days. This complementary process cuts the amount of time the latent image is allowed to develop, making negatives less dense and decreasing contrast. Both of these processes can be used to compensate for less-than-ideal shooting conditions, as well as mistakes.

Changing the development times can also be an intentional technique for shaping the final look of your images. Tables that detail development times for both push- and pull-processing are often printed

in film packaging, and more detailed charts are usually published online at the manufacturers' websites. You can push- or pull-process at home or ask your lab to do it with any type of film. If your roll is under- or overexposed only partially, then push- or pull-processing isn't a viable option, although a few other techniques may help save your negatives.

If you realize at the time of shooting that your roll of film would benefit from one of these processes, mark the roll clearly with a soft marker before you stash it in your bag. The standard notation for push-processing is "+1" for one stop of extra development, "+2" for two stops, and so on. For pull-processing, you can simply note "−1," "−2," or whatever the film needs.

Negative Intensification

Sometimes the perfect image will be recorded on a less-than-perfect negative. If the frame you love is underexposed, that is, too thin to make a good print, one possible save is negative intensification. Intensifiers include silver, chromium, and selenium, any of which can be used to build up the metal content, and hence the density, of the silver negative. Intensifiers can be applied to entire negatives or selected areas, but because the results are permanent, you'll want to practice on a less precious negative first.

Be aware that these chemicals are quite toxic and must be used with care. Good ventilation and either tongs or gloves to keep the chemicals away from your skin are a necessity. These formulations can be purchased from the Photographers' Formulary or at specialty photo stores.

Negative Reduction

Negatives that are overexposed, or too dense, can also sometimes be improved by a process called *negative reduction*. Products that do this include Kodak's Farmer's Reducer and Photographers' Formulary's line of film reducers. The negative reduction process, like intensification, can be used to modify entire or partial areas of negatives and is permanent.

TROUBLESHOOTING YOUR NEGATIVES

Plastic cameras are not high-tech. They don't think for you, and they don't try to stop you from doing something wrong. Hence, shooting with a Holga, Diana, or other toy will inevitably give you some uneven, or just plain bad, negatives. I usually need to dodge and burn my Holga contact sheets (see Chapter 10) just to see all the frames. What would Ansel think?

In photography, like anything, you're more likely to learn from your mistakes, assuming you know what they are. Keep notes of shooting conditions and your techniques. Compare them to your negatives, and you'll be better prepared the next time out. Here are some common issues.

Underexposed (thin, or light) negatives: These are very common in the low-tech world and result from an insufficient amount of light hitting the negative. Try using faster film, flash, multiple exposures, or a bulb setting. Using a handheld light meter can help you determine if the light is sufficient for shooting or how much you need to compensate.

Overexposed (dense, or dark) negatives: The most common reason for these with N series Holgas is leaving the shutter switch on B, or bulb, making accidental long exposures. Tape the switch to N for general usage. If your negatives are consistently too dark, use slower film or neutral density or polarizing filters, which cut the amount of light reaching the film. Also, be aware of the fact that as Holgas age, the springs that trigger the shutter may get weak or slow, leading to longer or inconsistent exposures.

Light leaks: See Chapter 4 for a detailed discussion of the light leaks inherent to Holgas and how to fix them. Here are some common ones for reference:

- A cone of white coming down into the image from the upper right of the frame: This is caused by light leaking through the two holes above the interior of the camera. Cover them up.
- Streaks of light coming in from the edges of the film, especially toward the end of the roll: This is caused by light leaking through the edges of a "fat" roll, one that wasn't wound tightly. Leaks occur when light hits the wound film after it's been removed from the camera. To prevent such leakage, don't open the camera in bright light, and tighten loose rolls in a changing bag or dark closet.

- Splotches of light in the center of an image, sometimes with text imprinted: This results from excess light coming through the red counter window. Keep the window covered when not in use and uncover it only in subdued light. Original Dianas and Diana clones, especially, need to be fairly well covered with tape along the camera seams to keep out extraneous light.

Blank frames: Did you leave the lens cap on? Lens cap on = no image being recorded, even though when you looked through the viewfinder you could see perfectly well. Even when the lens cap is off, however, very low light situations can fail to expose the film at all. A broken shutter may also be to blame. But if your processed film has no images and no text along its edges, the problem occurred in the processing stage. In that case, check your chemistry or have a chat with your lab.

Overlapping frames: The film wasn't wound properly between frames. Look at the numbers through the back window when winding. Sometimes if a Holga isn't used for a while, the film will loosen, also causing overlap. Some photographers don't mind unexpected overlap, but if you detest it, the only sure precaution is skipping every other frame. Using the square insert also makes overlap less likely, as each frame becomes a bit narrower. Finally, make sure the window arrow is pointing at the 12 if you're shooting square format; if it's set to 16, you won't be winding far enough to separate the full-format negatives.

Vignetting: So your corners are dark? They're supposed to be. The Holga's "four-corners-dark" feature is one of its main draws for many photographers. If it's not to your taste, shoot with the square insert in the camera or crop your images in the printing stage.

CUTTING AND STORING NEGATIVES

Toy camera negatives can have peculiarities that make filing them in negative sleeves or sheets a challenge. In a Holga or a Diana, film is wound manually from one frame to the next with no prompting or guidance from the camera. The winding distance between frames is judged by reading frame numbers through the red window in the camera back. But sometimes the film winds loosely, or the photographer is in a hurry and doesn't look at the numbers, and the images don't end up being spaced

Black-and-white Holga negatives showing edge light leaks and variations in exposure and image spacing.

Color negatives have a strong base color, and light leaks appear green. Rollei Digibase CN200 is an exception, with a clear base. Frame #5 here, by Michelle Bates (© 2008), is the cover image of this book, taken with a Holgamods Holga on Kodak Portra 400VC film on a very bright day.

evenly along the length of the film. Alternatively, a photographer may shoot panoramas intentionally, combining several frames to make one long image. In these cases, someone trying to cut the film into standard-sized strips may ruin good images by cutting apart overlapping frames. To ensure that this doesn't happen, when bringing film to a lab, always specify that your negatives be left as one long strip.

Standard instructions for this are: "Process only, do not cut." Then pay careful attention when getting ready to cut it yourself.

I keep two types of negative pages always on hand: ones that hold four strips of three Holga (6 × 6 cm) frames, and ones for three strips of four frames, shown in the examples on pages 207. For each processed roll, I count out my images, see where the largest gaps are between frames, figure out which pages would best fit the cut strips, and snip accordingly. Sometimes I'll need to split a roll between two negative sleeves to fit different-sized strips. If I need to have the lab make contact sheets, I try to stop by the lab between processing and contact printing to cut the negatives myself. If you're planning to scan your film, check to see if your scanner limits the length of strips it can accommodate.

Negatives from multilens or panoramic 35 mm cameras can also cause confusion for a lab. Make sure you warn them of any strange image details in advance and make your precise wishes known.

Finally, to prevent discoloration and degradation, always use high-quality negative pages and keep them in archival storage folios or boxes.

HANDLING OF FILM

Unprocessed film is precious material. Your images have been created by the interaction of light with the chemicals in the film emulsion, creating a latent, invisible image, but until they are processed, they are vulnerable to damage in a number of ways.

Squishing

120 film doesn't have a built-in protective shell like 35 mm film, so pressure on the rolled film can damage the emulsion and leave marks on your negatives. Handle and store the film carefully. Tupperware-like containers work well, especially for travel, as do the 120 film canisters pictured in Chapter 4.

Light

Although 120 film is wrapped in a cocoon of paper, it is, after all, still just paper. Intense, continuous light can filter through and onto your film, creating very interesting patterns, sometimes including the word "Kodak" superimposed on your images. Once a roll has been exposed, the main way light gets to the film is by leaking under the edges of the paper if the film and paper aren't wound onto the spool tightly. To avoid this, load and unload the camera in subdued light and keep exposed film out of the sun. If you have a "fat" roll, do not try to pull it tight while you're out in the light—working in the light tends to worsen the light leaks. Store the loose exposed roll in a 120 film canister or black bag—those from photo paper boxes are ideal—or wrap the film in foil until you can get to a changing bag or light-tight room. Then you can tighten and seal the roll.

Heat

Undeveloped film is said to be sensitive to heat, but the reality is not as bad as one might generally suspect. Tests done on both amateur and professional color and black-and-white negative films by photographer Ctein (author of *Post Exposure*, Focal Press, 2000) indicate only minimal changes in the sensitivity and contrast of film that was stored for weeks at 110°F. Even so, be wary and protect film in very humid conditions, which can physically, although not chemically, affect both the film and the paper backing if condensation occurs. Ziplocs, Tupperware containers, and dry coolers work well as protection in such conditions.

X-rays

Just as airport security personnel know they can't be too careful about who or what you let on an airplane, the photographer can't be too careful about what kind of rays she lets pass through her unexposed or undeveloped film. Never, under any circumstances, put any unprocessed film in checked bags. Even the airlines admit that the X-rays used to scan checked bags will ruin film, so no question there; just don't do it. As for hand baggage, it's a little trickier to judge what to do. Most airports say their

machines are safe for films under 800 ISO. Therefore, film 800 ISO or higher, or infrared or scientific film, should always be hand-inspected. You can request special treatment for any film, however. While a pass or two under security X-rays probably won't do any damage to slower film, several cumulative passes will, which may be a problem if you're on a long trip with several flights. Also, if you plan to push-process film that has an ISO lower than 800, the processing will make it end up being equivalent to higher-speed film, and thus more vulnerable. Rule of thumb: Whenever possible, get film hand-inspected.

To save precious time in getting past security, always take new film out of boxes and store it in clear containers such as Ziploc bags or plastic boxes. Use new plastic bags; worn ones may carry residues that set off the machines and a more thorough search. With your unboxed, properly stored film, you might get through quickly. More likely, an attendant will still open your container of film and swipe a roll or two with a piece of fabric and run it through a machine. Once though, very cautious staff opened even the foil packages of every one of my 120 rolls of film, which took quite a while. Film expiration dates are printed on these foil wrappers, so rewrite the dates on the roll if you must unwrap them. If you're planning to insist on hand inspection, get to the airport early. And outside of the United States, where there's no telling what the machines will do to your film, insist on hand-inspection whenever possible.

Tracking Your Film

Finally, keep good track of your film. If your film needs special processing, before placing it in your bag, write a technical note gently on the roll, using a marker, not a sharp ballpoint. Then, when you get to the processing stage, you won't need to rely on memory or that notebook that you lost.

An Overview of Options from Film to Final Product

Creating a final image from a plastic camera negative involves many choices, from how to develop the film, how to review the contact sheets of your images and select what to print, and, finally, how to choose what the final output will be. Here is an overview of options in these stages for all the types of film you can run through your plastic camera, whatever it may be. See Chapter 10 for details on how to view your initial images or make final prints.

Film Type	Processing Options	Digital Input	Print and Output Options
Black-and-white	• Home processing • Photo lab	• Negative scanning • Print scanning	• Home or rental black-and-white darkroom printing • Lab prints • Digital prints • Web, digital media
Black-and-white C-41 (Ilford XP2 or Kodak BW400CN)	• Color photo lab	• Negative scanning • Print scanning	• Black-and-white darkroom printing • Color darkroom printing • Lab prints • Web, digital media, and prints
Color negative C-41	• Color photo lab	• Negative scanning • Print scanning	• Digital prints • Web, digital media • Color darkroom printing
Transparency (E-6)	• E-6 photo lab	• Transparency scanning	• Digital prints • Web, digital media • Lab prints • Home Ilfochrome printing

Note: Processing and printing are covered in Chapter 9 and Chapter 10, respectively.

Water Tower, © Dan Zamudio, 2008. An entire roll of Ilford HP5 film, shot in sequence on a Diana camera, and printed as a complete contact sheet. Original Dianas shoot 16 frames per roll.

chapter ten

Prints and Pixels

Once you've finished processing your negatives, there are several different paths to follow to produce your finished images. We're here in this book because we love the simplicity, affordability, unpredictability, soft imagery, or other aspects of making images with plastic and toy cameras. But we must tackle some kind of complex technique to create the final piece of work, whether it be a fiber-based silver print, a virtual image, or a digital print. The options include the same choices for all photographers, plastic or not. Increasingly, digital technology is becoming the favored choice for both groups, while also dominating photography fairs and expos, as well as courses, workshops, and articles in mainstream photography publications.

Here you'll find information about both darkroom and digital options, and, as usual, I encourage you to test a variety out to help you decide what works best for you. Taking workshops or classes, or working in a rental facility, are excellent ways to try different techniques before you take the leap and invest in your own equipment.

Black-and-white darkroom technology has stayed fairly consistent over many decades. It's possible to use the same equipment and chemistry formulations our grandparents did, with spectacular and long-lasting results. Even with the continuity of basic technical tools and skills needed, fine-art darkroom printing is not easy to master, and people spend decades refining their techniques. But the stability of the form allows photographers to deepen their proficiency over time within this classic art form. There

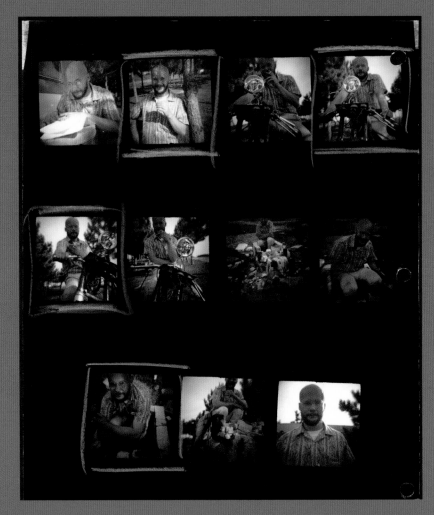

Contact Sheet—1st Roll 1967, © Franco Salmoiraghi, Athens, Ohio. Diana camera contact sheet from the early days. A full Diana roll has 16 frames. See the image created from the four marked frames on page 24.

is a thrill in watching a print come up, bathing in the developer, in the red glow of the safelight, that is a timeless part of the magic of photography, and I hope all plastic camera shooters at least give it a try.

On the other hand, digital equipment, software, and the skills needed to master them change considerably each year. There are some determined photographers who manage to keep up with the costs and skills, while many others struggle to maintain the minimum needed to function within the quickly changing landscape. Like anything else, there is a learning curve to digital printing, and it takes practice and attention to do well. To take advantage of its many conveniences, I use the computer constantly for scanning, emailing, posting, updating my web site, and printing images I shot digitally. But I still make all my Holga exhibition prints in the black-and-white and color darkrooms.

While many photographers will argue that the darkroom is dead, there is still an attraction to exploring beneath the safelight. The beauty and stability of these time-honored techniques are still relevant and accessible. Setting up a traditional darkroom costs less money than a digital setup; in fact, as so many people are moving to digital, darkroom equipment has become available for very little money, or even free. So I hereby encourage and give permission to plastic camera shooters everywhere to continue sloshing around in chemicals in small darkened rooms.

Next we'll take a closer look at both traditional and digital darkroom printing options.

REVIEWING YOUR IMAGES

Before you get into making prints, you'll want to review your images to decide which you like best and, from those, select the ones you want to print first. Because negatives are not easy to interpret, some kind of intermediate positive image must be created for review. This can be done in the darkroom on photo paper, or you can scan negatives and view them on the computer, or make digital prints. Darkroom or digital, reviewing and printing images is a multistep process.

Film Contact Sheets

A traditional contact sheet is made by placing a whole roll of 120 (or 35 mm) film, cut into strips, onto one sheet of 8″ × 10″ or 8½″ × 11″ photo paper and processing it in the darkroom. Contact sheets

Untitled, © Ted Orland, 2008. Proof sheet of individual images for *Tree in Snowstorm* montage (see page 223). This is a complete Holga 120 contact sheet, with numbers doodled by Orland. Kodak Portra 400NC color negative film.

are commonly made for both black-and-white and color negatives and are often done on resin-coated (RC) paper. They can be done by the lab when getting film processed or in your own darkroom. The contact sheet lets you see each actual image so that you can decide what to print. A loupe or other magnifier offers closer viewing and greater detail. Labs can also make individual prints from your negatives, usually 5″ × 5″, but they almost always cut off some of the Holga's bulging frame. Because they don't let you see all of what you've captured, these prints are not ideal for making decisions about what to print, but they are convenient.

Digital Contact Sheets

Negatives can be scanned into a computer on a transparency scanner. Software turns the negative into a positive image, and the resulting digital contact proof sheet can then be viewed onscreen or printed out for review.

Transparency Film

Transparency film is a category unto itself. The final result of processing is a positive image on the film, making for easy review; 120 transparencies are much easier to see than tiny 35 mm slides.

DIGITAL INPUT: SCANNING YOUR FILM

Whatever your final output will be, you'll likely need to scan negatives or prints at some point. To scan negatives and transparencies, you'll want a flatbed scanner with a transparency adapter. They are affordable and convenient, and are able to scan the full width of the film, which is an important consideration for Holga images, which don't stay within the standard 6 × 6 cm format. The more affordable flatbeds will only scan one strip of 120 film at a time, while those that offer the convenience of being able to scan a whole roll at once will cost you more. To round out their usefulness, flatbeds can also be used for scanning prints.

Loup Garou, © Louviere & Vanessa, 2006, from the series *Chloroform.* A composite image; the stilter was shot with a Canon digital SLR and the background with a Holga on Tri-X. Digitally printed on handmade Japanese paper with polyurethane, oil paint, wax, and blood.

Dedicated film scanners are expensive, specialized devices that only scan film (not prints). They yield higher quality scans than flatbeds, but at a much higher price, especially for the 120 versions. Film must be inserted in a holder, so it usually can't be scanned all the way to the edges. If you need a very large or high-quality scan, pay a lab to make a drum scan, which is the highest quality of all, and can also capture the full negative area.

Once you've scanned your negatives, the resulting files are useful for many things. You will likely make separate scans, at different sizes and resolutions, depending on your intended use. Digital files allow you to preview images before going into the darkroom, keep track of images, and create files for digital printing, emailing, or website presentation. Scanned negative files can be retouched or manipulated artistically, giving the photographer many more options than are available in a wet darkroom.

Adobe Photoshop is a mighty tool for not only adding creative touches to files, but also for saving negatives that would otherwise be unprintable and for fixing specific plastic camera quirks such as light leaks. In comparing options for digital darkroom,

I've found Photoshop to have a very steep learning curve, while Adobe's Lightroom is a much simpler interface for cataloguing and doing minor image tweaking. Other cataloging software options are Apple's Aperture, Microsoft's Expressions Media Pro, and iPhoto.

Scans can also be used to output digital negatives for contact printing. Contact printing—where the negative is placed directly onto the photo paper and final prints are the same size as the negative—is used not only in traditional silver printing but in a number of alternative printing techniques, such as platinum and palladium printing.

Combining forces, all the tools and approaches we've mentioned give the imaginative photographer a variety of ways to adapt and exploit the current technology in furthering the creation of their final images. Scanners, printer inks, paper choices, and Photoshop's huge selection of filters and plug-ins can all be played with as elements in the making of a final print or digital output. Just as a wet darkroom and its paper and chemical options are part of the creative process, so too is the digital darkroom. It's even possible to combine all the technologies, for example, by scanning a black-and-white negative, colorizing it in Photoshop, outputting a digital color negative, and making a color darkroom print. See Chapter 11 for examples of alternative process prints, keep an open mind, and experiment to your heart's desire, following, of course, your own vision.

FINAL CHOICES

Final use of your image should be a consideration in how you deal with your negatives. For most commercial and editorial photography, prints have become obsolete, involving extra cost and time; instead, in the few instances where images are still made on film, the negatives are usually scanned for direct use. Fine-art photography is where original prints still have a place, but even there, a growing proportion of images on gallery walls are output digitally. Overall, as the longevity of digital prints has closed the gap with silver prints, computer-generated archival inkjet prints have gained appeal as collectible fine-art pieces. The world of photography is in transition, and it's up to the individual photographer to decide whether to go wet or go digital for printing, or perhaps combine the two.

Darkroom and Digital Printing

There are several ways to create final prints to keep or exhibit. For non-exhibition uses and for speed and simplicity, RC machine prints from a lab can be your final product—if you don't mind, in some cases, having part of the original image cut off. You can also cut up your contact sheets, which in some cases can be quite good, and have little contact prints to play with, put into notebooks to consider for future projects, or to improvise with for other uses, perhaps journal keeping.

For high-quality exhibition prints, you can go into the black-and-white or color darkroom to do your own printing. Alternatively, many fine labs offer high-quality printing of your negatives in a variety of sizes and on different types of paper, as do individuals who specialize in producing prints for others. Prices for labs or expert printers making your prints will depend on size, paper, and the degree of custom attention you require, which goes all the way to having a limited edition portfolio printed. And, of course, you can always take advantage of the incredible leaps in technology allowing you to output digital prints from your scanned film.

Black-and-White

While many people are embracing the seeming ease and daylight of digital printing, fine-art darkroom printing is still very much alive. In fact, this is an excellent time for anyone wanting to set up a darkroom from scratch. Because former darkroom printers are fleeing the safelight in droves, their enlargers and complete darkroom setups can be bought for very low prices, or even obtained free. Great resources for those without home darkrooms are rental darkroom facilities and schools, which have black-and-white and color darkrooms available monthly or by the hour. These public facilities are disappearing though, so like many other things, use them or lose them!

Black-and-white darkroom printing can be a rewarding experience of both artistic creation and meditative solo time. It can also be boring, frustrating, messy, and smelly. But it's an experience that just can't be compared—for better or worse—to sitting in front of the computer and listening to the printer whirr away. Many firmly believe that darkroom prints have a magic that is hard to match

A Fortune Teller in Kabul, Afghanistan, © Teru Kuwayama, 2005. Traditional black-and-white can be a powerful medium for image-making and storytelling, as in this Holga image.

digitally. Others argue that digital printing has broken new ground in excellence. To truly understand the relationship among light, film, and paper, I recommend everyone giving darkroom printing a try.

Black-and-white printing can be done on RC paper, which doesn't hold up very well, or long-lasting prints can be made on fiber-based (FB) paper. FB silver-gelatin prints can also be toned to achieve a variety of different looks. Many images throughout this book were toned. Other looks can be achieved

by using alternative processes, including platinum/palladium, cyanotype, and hand coloring; see Chapter 11 for examples of several of these. Since you're using a plastic camera, why not color outside the lines in the darkroom as well?

Much information is available about basic and advanced techniques: John Hedgecoe's *Workbook of Darkroom Techniques* (Focal Press, 1997) is an excellent introduction, while Ansel Adams' seminal series *The Camera*, *The Negative*, and *The Print* (Bulfinch, 1995) is for the more technically inclined. Many books cover alternative processes, including *The Book of Alternative Photographic Processes*, by Christopher James (Delmar, Cenage Learning, 2009). Although there are thousands of other print and online options for getting information, taking a class is often the best way to get started.

Color Printing

Although color-negative printing has never been as popular as black-and-white, those of us who do it find it both rewarding and exhilarating to control your color output and, especially, to be able to experiment. For years I've made my own color-negative (RA-4) prints. I've been constantly amazed at the vibrancy and quality I've achieved with Holga prints, especially compared with what we generally see from minilabs. It has also been, until recently, the only way for me to make color prints with my extra-special homemade negative carrier, which I would never entrust to a lab. In the digital realm, I now sometimes combine scans of negatives with a scan of my carrier to create image files that look like they were scanned from darkroom prints.

Color printing can be more difficult than black-and-white because color balance, achieved by adjusting color filters on the enlarger, also figures into the printing variables, and paper must be handled and exposed in complete darkness, apart from the light during actual exposure.

Although trays can be used for color printing, it is usually done in tubes or in machines that process the paper in a dry-to-dry process. Some rental facilities offer access to darkrooms and these convenient machines.

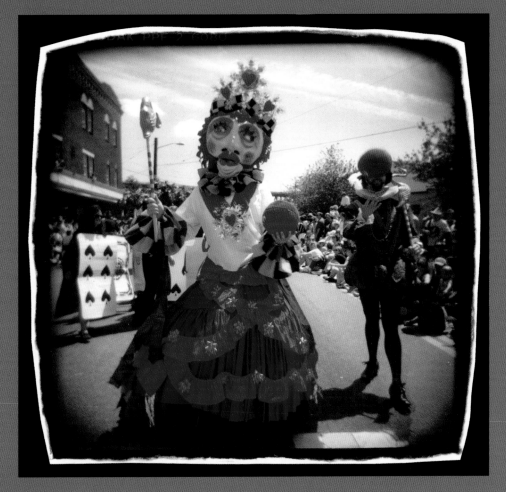

The Queen of Hearts, © Michelle Bates, 1996. This Holga image was made on Kodak PPF color-negative film and printed in a color darkroom with the author's cardboard negative carrier (then, of course, scanned for this book). The Queen is David Ti, with Terry Frank as her consort, in the Fremont Summer Solstice Parade in Seattle.

Digital Printing

In recent years, the quality, affordability, and longevity of color digital printing equipment and materials have increased dramatically, making high-quality options readily available. Perhaps the greatest advantage of printing digitally is repeatability. As anyone who has worked in a darkroom knows, making identical prints of an image that requires complex burning and dodging is nearly impossible. In the digital world, the hard work is in getting your file perfected using the multitude of options you come up against in the digital workflow. Once your file and printer settings are optimized though, it's easy to make as many perfect prints as you like. For all these reasons, digital is not just replacing color darkroom printing but is also opening up the world of color to many photographers who would never have ventured into a color darkroom.

Monochromatic digital printing capabilities have been improving quickly, although getting high-quality black-and-white prints from a digital printer can still be difficult. Most printers now include one or more versions of "light black" cartridges to allow reproduction of fine tonal gradations in black-and-white prints. A few companies also offer full sets of ink made up of shades of gray, or more permanent monochromatic carbon inks, which replace the color cartridges.

The rise of digital processes has also changed the workflow of all photography-related industries. Many images these days never even make it to print. Websites are incredible venues for sharing images, and most competitions now accept only digital submissions. Reproductions in books and magazines are most often created from files that have never been made into prints at all. Online communities allow photographers to meet, share images, and learn from one another.

One downside of all this computer viewing is that the quality of what we're seeing on-screen may be much lower than what we see when looking at a print, slide, or projected image. Computer screens come in a variety of pixel densities—better known as *pixels per inch* (ppi). Prints are generally 300 dpi,

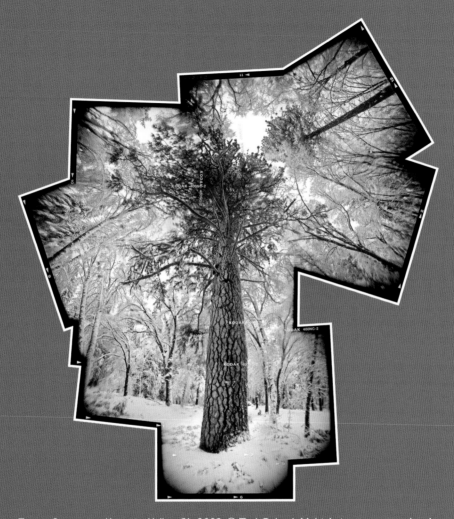

Tree in Snowstorm, Yosemite Valley, CA, 2008, © Ted Orland. Multiple images scanned and merged in Photoshop using layer modes to create blending among the images. The prints are, of course, digital; 20″ × 26″. See the contact sheet on page 214.

or dots per inch, so a monitor may display a high-quality reproduction or one that is a sad imitation of the original print. Another downside to viewing images on a computer is that because every computer monitor represents color and light differently, it's impossible to guarantee that a viewer will see artwork as the artist intended. For this reason, a few galleries and competitions still insist on slides or prints for review, but their number dwindles each year. If you want to create a stable physical copy of an image, even one created digitally, it's now possible to create slides from digital files.

Books on digital image processing and printing are being published daily. The technologies improve at lightning speed, requiring continual upgrading of equipment and skills, but also allowing an ever-expanding number of possible results. In many areas, rental facilities provide access to expensive, wide-format printers that allow creation of large-size prints without a significant personal investment.

So, while you may start off your image-making with a simple tool, the options for creating a unique work of art multiply when considering film, processing, and output choices. Familiarize yourself with what's out there, and then do what you enjoy, what makes your images come to life as you imagined them, and what enables you to keep creating.

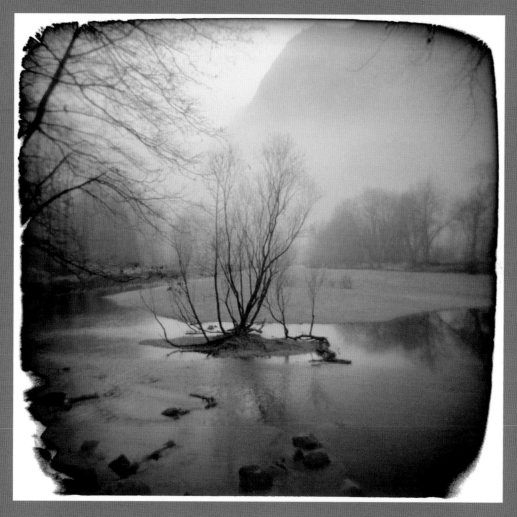

Merced River, Winter, Yosemite Valley, © Ted Orland, 2000. A Holga image on T-Max 400 black-and-white film, scanned, with color added in Photoshop. Orland makes the border disappear using Photoshop's blending options.

Wet Darkroom Tips

I'll leave it to the dedicated darkroom printer to find the details elsewhere, but here is a survey of a few techniques that are helpful for printing plastic camera negatives. Make sure to keep good notes on all your printing techniques, both on the back of your prints and in a notebook, because they are very difficult to repeat accurately when you come back to an image.

Multigrade Paper
Using multigrade paper, which is the standard today, as opposed to old-style graded paper, allows an enormous amount of flexibility in your printing. With this type of paper, you use filter gels, numbered 00–5, in the enlarger to adjust the contrast of your prints. Because Holgas often produce negatives with very high or very low contrast, this is a vital tool for controlling the look of your final prints. I've used the full range of filters in printing my Holga negatives; they truly need them. You can also use more than one filter in the printing of a single image by using each for only part of the exposure. With this method, you can bring out both low- and high-contrast areas of your images. Combining filters allows you a high level of control, making up for the lack of it in the camera.

Dodging
Dodging is standard darkroom technique that is indispensable to plastic camera shooters. It allows you to lighten areas that would otherwise be too dark in the print by selectively blocking light from a portion of the photo paper during the main exposure. You can create special tools for this (they tend to look like little lollipops) or use your hands.

Burning
Burning is another very common darkroom method of making specific areas of a print darker by adding more exposure time after the main exposure. Using a card with a hole in it, your hands, or any other premade or homemade burning tool, turn on the enlarger, blocking light from everywhere except the area you feel is too light. Keep the tool moving and experiment with times for best results. For a Holga user, burning is an essential tool, especially when trying to repair light leaks.

Paper Developers

Just like film, photographic paper also passes through a series of chemicals to develop and stabilize the image. These consist of a developer, stop bath, fixer, and, sometimes, fixer remover. The combination of paper and developer has a profound effect on the resulting look of the image. While mainstream developers work fine for many images, a much finer amount of control is possible with some alternative developer types and formulations. One (that requires mixing of chemicals), Dr. Beers, gives you several different contrast developer solutions to dunk your print into: you use one or more to fine-tune the overall and midtone contrast of your image.

Advanced Darkroom Techniques

Filter Burning: To adjust contrast in part of an image, change the filter in the enlarger after the main exposure and then burn in the specific part of the print. If this would result in too long of an exposure for that area, dodge it during the main exposure. With negatives that have ultra-dense areas, burning in with a very low filter—00, 0, ½, or 1—works wonders in bringing in highlights, such as a bright sky, without overexposing any midtones or shadows in those areas.

Flashing: Flashing is a way to print a negative that has dense areas, or a negative that is very dense, and that would normally need a very long exposure time, sometimes into minutes. In this technique, without the negative in the enlarger, you give the entire paper a fraction of a second, overall "flash" of light before the main exposure, which exposes the paper below its threshold (the minimum amount of light exposure that would show up as a tone on the paper after developing). After this preexposure, the dense areas of the negative will expose the paper with much shorter exposure times, without making shadow areas too dark. Flashing is best done with a separate enlarger adjacent to the one with the negative, using a small aperture, no negative in the enlarger, and very short exposure times.

Adding an Edge: One specific problem Holga users sometimes encounter is light leaks along the edge of a frame. This may be caused by loose rolling of the film, leaks in the camera, or by two frames

running into each other. If you print your images full frame, as I do, and like to have a consistent black border, the lack of a clean edge in this situation can ruin an image. There is a way to restore a border in the darkroom: burning the edge back in without the negative in the enlarger.

To accomplish this, first set up your negative and carrier in the enlarger and tape the carrier down to the enlarger stage. Then expose your image as normal. Next, open the enlarger head to release pressure on the negative carrier, carefully slide the negative out, and reclose the enlarger head. Finally, turn on the enlarger, keeping all of the image area covered, except for the missing edge. Experiment with exposure times, and soon you'll have a matching black border to complete your image.

The ways of looking at images and making prints covered in this chapter may be all you ever need. However, things get both more interesting and more complicated from here. Chapter 11 looks at alternative processes and the wide range of options available for presenting your work in the 21st century.

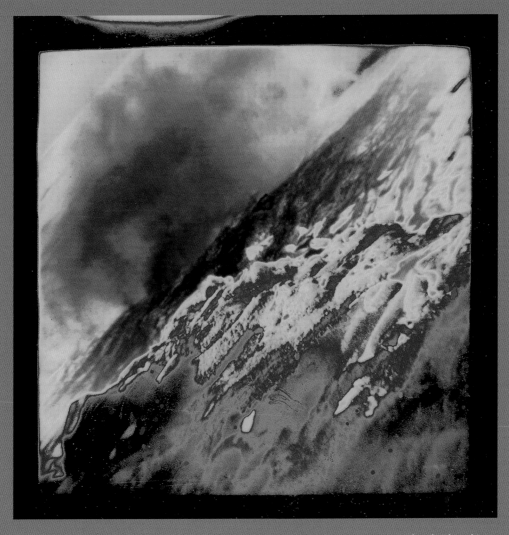

Toxic Seas, © Mary Ann Lynch, 2009. A Diana camera black-and-white image, scanned and colored in Photoshop.

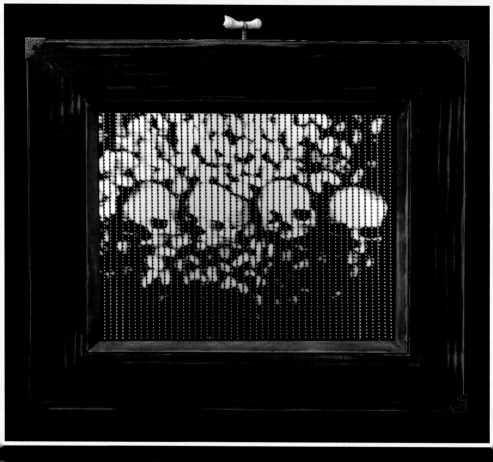

Folie a Deux, Non Ominis Moriar, © Louviere + Vanessa, 2009. This creation began with a traditional Holga image made on Tri-X film. It was then photographed on 3550 frames of Super-8 mm film, with the resulting potential moving image cut up into strips and framed to create this "cineagraph."

chapter eleven

Alternative Processes and Presentations

After you've processed your film and selected the images you'd like to work with further, there are still many choices to confront. Basic printing options were covered in Chapter 10, but there are many other possibilities, some of which are presented in this chapter. After the final print comes another round of decisions: no matter what type of print you choose to create, how you display your work of art is a crucial part of your final presentation to an audience other than yourself. This chapter begins with alternative process printing and then moves on to presentation.

ALTERNATIVE PROCESS PRINTING

Despite the wave of digital photography that's overtaken all types of image making, the last few years have seen not only a renaissance in analog and low-tech photography, but a resurgence in interest in older processes, including ones that date back to photography's 19th-century beginnings. These alternative processes are often time- and labor-intensive, but the variety of looks and the combination of control and unpredictability they offer have earned them loyal followings.

Without getting too far off the standard darkroom track, there are several ways to bring alternative looks to your prints. One process that creates prints with a distinctive look is lith printing.

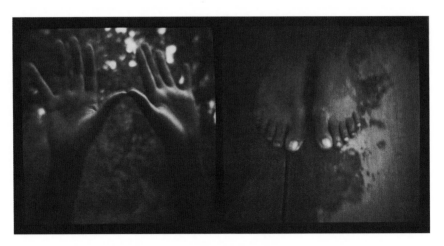

Hands & Feet—Sylvia, © Franco Salmoiraghi, 2002. A Diana camera diptych 5″ × 8″
cyanotype print from a black-and-white negative.

In this method, the negative is projected using a standard enlarger onto a specialized paper. The print is overexposed and then partially developed in a highly diluted lith developer, creating a characteristic grainy look.

Another tool for creating unique prints with a traditional darkroom setup is hand coating your emulsion. There are several varieties of premade, liquid silver-gelatin emulsions available. These allow you to print onto a wide variety of types of paper or other surfaces, from eggshells to automobiles, using a standard enlarger.

Stepping away from the enlarger and out of the traditional darkroom, several processes involve contact printing. In this technique, the negative is sandwiched between glass and paper and is exposed with ultraviolet light using either an artificial light source or the sun. Platinum/palladium, kallitype, cyanotype, Van Dyke brown, and gum bichromate prints are created this way. These require hand-coating of the emulsion, usually done on watercolor or other textured-surface paper.

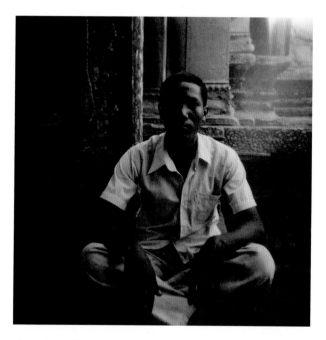

Channdouen, © Shannon Welles, 2006, from the series *Laughter and Forgetting: The Children of Cambodia*. A lith print of a Holga image on Agfa APX 400 film.

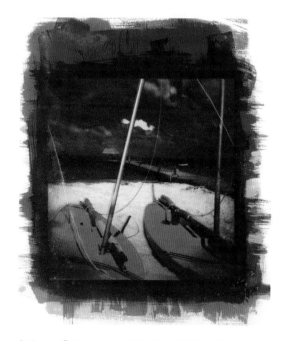

Sailboats, © Marydorsey Wanless, 2002. A 7″ × 7″ gum bichromate print of a Holga Fujicolor NPH400 negative. Made up of one layer of cyanotype and layers of yellow and red pigmented gum bichromate on hot press watercolor paper.

The combination of process types, paper, and coating patterns offers a large amount of latitude for artistic interpretation. Using these processes, the final print is the same size as the negative, which would result in very small prints when using 120 negatives. The computer age allows us to expand the possibilities by creating enlarged digital negatives.

The basic process for creating digital negatives isn't complicated, but, like anything else, it takes knowledge and practice to do well. First, you scan your negative at a high resolution. In Photoshop, set your new print size, then adjust the image's curve according to your negative and print media, following available guidelines. At this point, you can also do more elaborate corrections or artistic interpretations. Finally, print your new negative onto a clear medium, such as Pictorico film. This digital negative can then be used for contact printing, and if it gets damaged, you can simply print out another one. There are several books and websites that detail processes for creating digital negatives: look up methods by Brad Hinkel, Ron Reeder, Dan Burkholder, and Mark Nelson. If you would like to make enlarged contact prints with a true film negative, there are also labs that will output film negatives or transparencies from digital files.

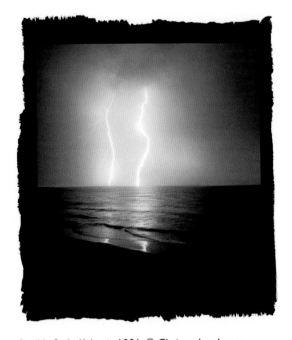

Double Strike/Atlantic 1981, © Christopher James. Kallitype print from a negative made with a modified Diana camera.

Moving into another realm of alternative processes, now we'll look at wet- and dry-plate photography. Wet-plate processes, such as tintypes and ambrotypes, involve the coating of glass or metal plates with collodion emulsion. These plates, while still wet, are immediately placed in the camera, exposed, and processed. Traditionally, wet plates tend to be used in large-format cameras, but they are also being used in Holgas, where your final result is a small plate, with a positive image, the same size as a Holga negative. The resulting plates are actually negatives and appear reversed as positive images due to the opacity of the metal plate or a black coating on the glass plates.

Dry-plate printing is a more modern version of this process. This method uses a different type of emulsion to coat the plates, which can be dried and stored before exposure, creating a much simpler workflow. In addition, you can contact print onto dry plates with enlarged digital or film positive transparencies at any size.

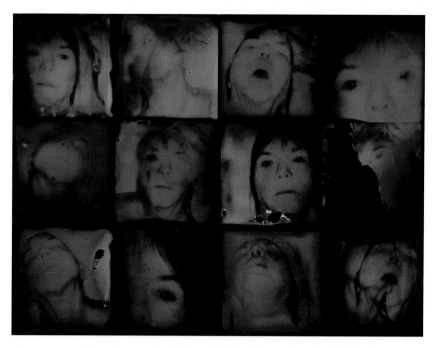

Evidence of Self, © Marydorsey Wanless, 2008. A Holga camera with Arista Ultra 400 black-and-white film. Negatives were scanned, and digital positives were contact printed with AGPlus liquid emulsion on black aluminum as tintypes; 18″ × 24″.

PRESENTATION

The presentation of your photography doesn't end with the printing. In fact, many other choices affect the final look of your images and the experience others have of viewing them. These range from the border you create around your image, to the type of paper you use, toning techniques, and framing options. When your work is ready to show to the world, there are many possible outlets. These include in-person viewing of prints and second-generation sharing of images, either online or in print media. More information about these venues follows.

Borders

When printing plastic camera photographs, an important consideration is the border of your image. Holgas, and Dianas to a lesser extent, create negatives with irregular borders. Holga images' edges bow outward, resulting in a roundish frame that doesn't stay within the straight edges of standard negative carriers. Some photographers opt to use a stock carrier and lose some of the frame. Others file out a metal carrier to include the entire area, and some, including me, achieve this by making their own carriers. You may also want to consider making your own negative carrier for Diana camera photographs, which are a nonstandard size, 4×4 cm; there are no premade carriers for this format. In the digital darkroom, you can create any border you like. This is another place to let your creative juices flow.

When making art prints to hang on walls, don't forget to consider your matting and framing. Don't feel constrained by the traditional white overmat. I cut my images out with scissors (it always feels so rebellious) and mount them onto black photo paper, doing away with white mats altogether. The way you present your images, including the size of the prints and the type of frame, is a critical part of how the images are received and how recognizable they will be as your work. In addition to my unusual matting and framing, see the techniques used by Rosanna Salonia, Matthew Yates, and Gyorgy Beck pictured in the chapter.

Opportunities for sharing and viewing photographs have exploded in the new media of recent years. More traditional venues for interacting with photographs are still in use, and each way has its advantages and disadvantages.

The author's nontraditional framing complements the unusual shape of her Holga images. Fiber-based silver-gelatin prints are cut out, dry-mounted onto identical photo paper (previously processed to be black), then dry-mounted on foam core. The non-glare Plexiglas is separated from the print by spacers.

Galleries

Fine-art exhibitions in galleries are still an important part of the photography scene and are a gratifying way for others to enjoy your images. Someone experiencing a print presented with care shares more than just the content of the image. Most importantly, standing in front of a print allows the viewer to appreciate the image at the size the photographer chose. Seeing a photograph on a computer screen will never match the experience of having your viewing field filled by a massive print, or being able to touch and smell one of Rosanna Salonia's beeswax-coated small prints, which she actually encourages. In person, you are also able to visually enjoy the texture of the paper, the depth of the frame, and the way the light reflects off the image. Other elements of gallery viewing that contribute to the viewing experience include wall colors, lighting, and the layout of the images along the wall. Because galleries are few in number and getting shows and gallery representation is very competitive, photographers often gain exposure for their work in coffee shops and other alternative venues.

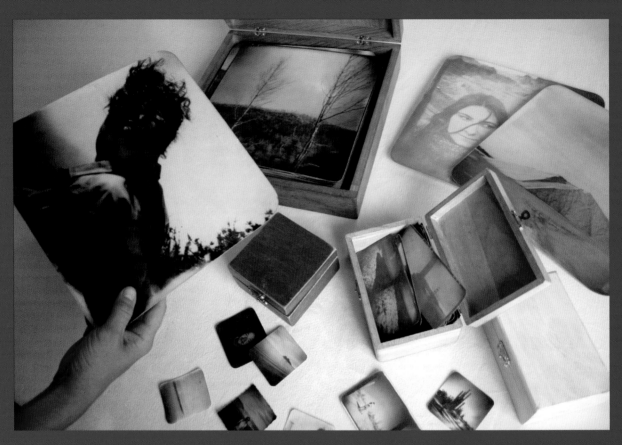

Memory Boxes, © Rosanna Salonia, 2007. Installation view of silver-gelatin prints made with a Holga and a Diana, bleached, toned, beeswax coated, and hand shaped. Prints 2.5″ × 2.5″–10″ × 10″.

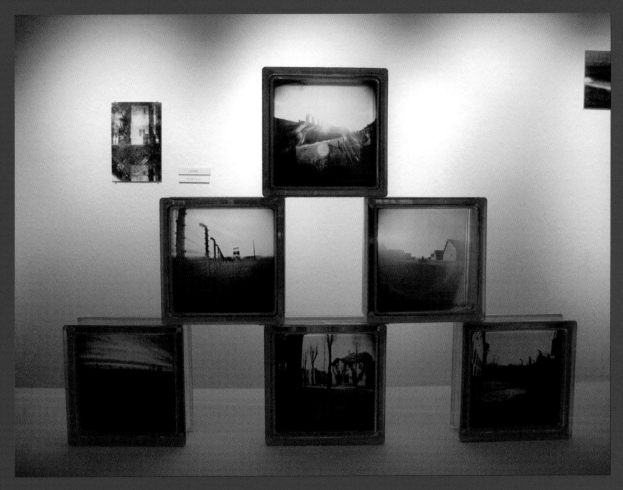

Installation view of *Auschwitz* series, © Gyorgy Beck, 2002. Holga camera inkjet prints on transparent medium encased in glass blocks; 8.6″ × 8.6″.

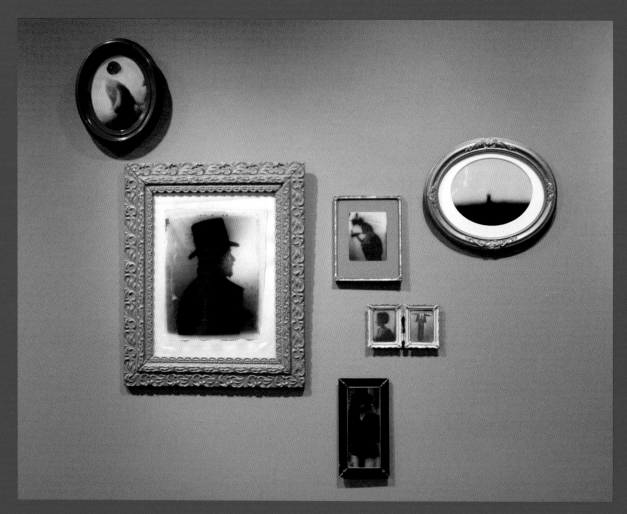

Beautiful Nightmare, installation view II, © Matthew Gordon Yates, 2008. From an exhibition at Benham Gallery in Seattle; tea-toned silver-gelatin prints in vintage frames.

Portfolio Reviews and Photography Conferences

Portfolio reviews have become a very important way to share your work in the fine-art photography world. These occasions bring together photographers with established photography professionals who can offer constructive criticism or other guidance. Viewing of images takes place in scheduled one-on-one meetings, and there are opportunities for informal sharing as well. Generally speaking, images made with plastic cameras can sometimes get a mixed reaction, although occasionally a reviewer will note their specific interest in seeing low-tech work. What's most important to all reviewers are high-quality, well-presented, original images—it's not enough to rely on an unusual camera or image format.

In the United States, the major portfolio review events are FotoFest, in Houston, and Photolucida, in Portland, Oregon. Photography festivals, such as the New York Photo Festival; trade shows, including Photo Plus Expo; and academic organizations, such as the Society for Photographic Education (SPE), which hosts national and regional conferences, are excellent venues for networking. Many other events are also adding portfolio reviews to their offerings. The number of photography-related events around the United States and worldwide has ballooned—you can stay on the road year-round attending as many as you can handle.

Many personal relationships are also forged and strengthened at these events. There is nothing that can compete with face-to-face contact for getting to know people and opening up new opportunities. In the early 1990s, I first met several of the photographers in this book at juried exhibitions we all participated in. Now, as then, group shows draw people from around the country to contribute prints, and many make the journey to attend the opening parties. The annual Krappy Kamera Competition's opening reception at Soho Photo Gallery in New York City is always jammed, with photographers in the show as well as photographers and guests from all over.

Imagery made with plastic cameras has been gaining awareness and acceptance at all different types of photo events. I have been invited to lecture at bookstores and conferences around the country. The cameras themselves are also getting around more, as companies such as Freestyle and the Lomographic Society show off their plastic offerings at trade shows and trade areas of other photo events. Holgas are used widely in high school and university photography classes and have gained a

large and enthusiastic following among students and faculty. Popular courses are also being offered at photography centers and workshops around the country, taught by me and by many other talented toy camera specialists.

Less formal events are also taking off in popularity. The Lomographic Society hosts group photo shoots and gatherings based out of their storefronts in major cities around the world. Flickr toy camera-themed groups host meet-ups to go on photo adventures or trade technical information. And of course, there's World Toy Camera Day, a day each October when plastic camera lovers can feel the power of community, as photographers worldwide pick up their pieces of plastic and start snapping.

The Internet

As important as exhibitions and conferences are, they offer limited exposure to works by those who are not present either in person or in the lectures and presentations. Enter the global network: in a very brief period of time, the convenience of the Internet has made it the preeminent venue for showing and viewing photography. Websites are a vital tool for photographers to share their portfolios and are widely viewed both for enjoyment and for professional review. Having a well-designed web site with concisely edited portfolios is critical to achieving success in the photo world today. Some sites collect multiple portfolios that are more content specific, such as toycamera.com's galleries, which focus specifically on plastic camera images. A few sites are also juried, to share a high level of work. Informal image-sharing sites, such as Flickr and Lomography.com, have become extremely popular centers where anyone can upload as many photos as they wish to share and get feedback from others. This input can foster community and help photographers with the selection of their best images, assisting in the creation of a cohesive portfolio. Blogs have become another public way for photographers to share their own images, write articles, feature other people's work, review cameras, and more. Many of these well-written and informative sites have collected large followings. In fact, a well-done blog can enhance a photographer's reputation substantially. With the Internet offering instant connections between photographers, sources for supplies, and online galleries, it is

the cardinal one-stop location to get information, buy cameras, meet other photographers, and create opportunities.

Magazines

Photography magazines still stand out as an excellent way get your work seen by a wide audience and to learn about who's doing what in the photo world. Even as print media struggles to continue to publish, these publications are well-respected and having your work seen in them can lead to new and exciting opportunities.

The plastic camera community is a microcosm within the broader world of photography, a separate culture that brings people together in silliness, joy, an appreciation for creativity, and a passion for their art.

resources

This section is a selection of resources for you to use in continuing your exploration of the world of plastic cameras. While this list has grown substantially since the first edition, it only skims the surface of what is out there now. Several of the websites listed also have links sections, and you can find even more via Google. But dive in here to see the best of plastic camera websites, shops, books, magazines, articles, exhibitions, and, of course, photographers.

PLASTIC CAMERA WEBSITES TO PERUSE

TOYCAMERA.COM

• **www.toycamera.com** ToyCamera.com is the current home of toy camera photographers worldwide. Galleries, articles, group exhibitions, publications, and an absurdly busy user forum make you know you're not alone in your love of low-tech cameras. The site has over 1000 members, hundreds of galleries, the forum, which has 13 major topics and thousands of threads, and projects including print exchanges, *Light Leaks Magazine*, annual toy camera calendars, World Toy Camera Day (each October), Holgapalooza, the Light Leaks Shop, and the books *Toycam Handbook*, *toycamera*, and *TOYCAM - Lo- Fi Photography*.

LOMOGRAPHIC SOCIETY INTERNATIONAL

• **www.lomography.com** The Lomographic site is a massive conglomeration of cameras and images. You can buy a whole collection of toys here, post your images on LomoHome pages, have your multiframe images animated, or find out about the latest Lomography shindig.

HOLGA INSPIRE

- **www.holgainspire.com** Launched in 2009 by the creators of the Holga camera, this site features all the "Holga Inspire" photographers, along with news of Holga Limited and Holga-related worldwide events. Among the Holga Inspire photographers are seven contributors also included in this book: Michelle Bates, Susan Bowen, David Burnett, Teru Kuwayama, Pauline St. Denis, and Harvey Stein, along with Annu Palakunnathu Matthew, Tammy Cromer-Campbell, and Taiju Fubuki. A traveling exhibition features images by all 10 photographers.

SUPERHEADZ

- **www.superheadz.com** Home of the Superheadz collection, lots of extras and lots of Japanese.

FOUR CORNERS DARK BLOG

- **www.fourcornersdark.com** Photographer Nic Nichols fills this blog with camera reviews, techniques and tips, and the latest toy camera news from around the world. Nic interviewed Hideki Ohmori, founder of SuperHeadz, for the blog in 2009.

THE ORIGINAL TOY CAMERA HOME PAGE

- **www.toycamera.org** Created by Jonathan Winters in 1995, this was the first online place for plastic camera enthusiasts to flock to, but, alas, it no longer exists.

- **Holgablog.com** News, reviews, images, and more by a collection of photo fanatics.

- **Squarefrog.co.uk** A collection of Holga tips and tricks from Paul Williamson.

THE DETRICH COLLECTION

- **www.allandetrich.com/diana.htm** A detailed presentation of a collection of Diana cameras and clones, among other toys, amassed by Allan Detrich and now owned by the Lomographic Society.

- **Filmwasters.com** A collective featuring galleries by Susan Burnstine, Skorj, Leon Taylor, Ed Wenn, and Damion, with guest artists and collaborations.

- **Flickr.com** This photo gallery website lets you post and search for images using keywords or themed photo pools or sets. You can spend days looking at hundreds of thousands of photos made

by any camera you can think of and more. This site is very popular with toy camera photographers, who often give feedback on one another's photos.

RETAILERS

FREESTYLE PHOTOGRAPHIC SUPPLY

• **www.freestylephoto.biz** The U.S. distributor of Holgas carries Holga's complete line, plus many other plastic options, as well as a wide selection of film, papers, and other supplies. Freestyle also specializes in materials for darkroom and alternative processes and publishes *The Holga Manual*, available in print, or as a PDF via their website.

B & H PHOTO

• **www.bhphotovideo.com** This cavernous photographic supply store is a New York City institution and very popular with photographers all over the country. It carries an enormous selection of everything photographic, including hard-to-find films.

HOLGAMODS

• **www.holgamods.com** Get a custom tricked-out Holga here, with a selection of modifications by Holga wizard Randy Smith.

LIGHT LEAKS SHOP

• **www.shop.lightleaks.org** Run by toycamera.com's founder Michael Barnes, this shop features many plastic cameras and accessories in addition to original Dianas and clones, some refurbished; some newer Lomography versions; and back issues of *Light Leaks Magazine*.

FOUR CORNER STORE

• **www.fourcornerstore.com** Part of Nic Nichols' Fourcornersdark.com, this store offers the latest in toy cameras from around the world, a variety of types of expired film, and other accessories.

THE LOMOGRAPHIC SOCIETY

- **www.lomography.com** Home of the Lomo LC-A+, the Diana+ line, several multilens cameras, and other accessories, which can all be purchased here.

PHOTOGRAPHER'S FORMULARY

- **www.photoformulary.com** This Montana-based company sells a huge selection of chemicals as ready-made formulations, in kits, or as individual ingredients for all types of photographic needs. It's heaven for the scientifically minded photographer.

BOSTICK & SULLIVAN

- **www.bostick-sullivan.com** Online source for alternative process materials.

 # MAIL-ORDER FILM PROCESSING

PHOTOWORKS SAN FRANCISCO

- **www.photoworkssf.com** Send any and all of your film here for processing, prints, and/or contact sheets.

FREESTYLE PHOTOGRAPHIC SUPPLY

- **www.freestylephoto.biz** Buy prepaid film processing mailers for black-and-white film.

FRUGAL PHOTOGRAPHER

- **www.frugalphotographer.com** This site sells and offers processing services for old and unusual types of film.

 # TOY CAMERA BOOKS AND MAGAZINES

- ***The Diana Show: Pictures through a Plastic Lens (Untitled 21)*,** David Featherstone (The Friends of Photography, Carmel, CA, 1980). The first plastic camera image compilation, from a 1979 exhibition, with a classic introductory essay by Featherstone.

The Toycam Handbook, a great guide to cameras released before 2006. Let's hope for an update soon.

- *Form and Magic: Contemporary Vision with the Plastic Camera* (PhotoCentral, Hayward, CA, 1997). Only 150 copies were made of this hand-bound catalog of the exhibition at PhotoCentral, curated by Daniel Miller. A rare treat if you can find one.

- *The Toycam Handbook* (Light Leak Press, Ottawa, Canada, 2005) (**www.toycamhandbook.com**) contains a comprehensive collection (pre-2006) of plastic and toy cameras, with images, specs, and fun facts. Also features tips, featured photographers, and images galore.

- *toycamera* is a group project by Light Leak Press, Ottawa, Canada, 2005. This black-and-white collection contains images by 26 photographers who frequent **toycamera.com**.

- *TOYCAM lo-fi photography* is another group project by the toycamera.com community, published in summer 2010 on blurb.com. **www.toycamerabook.com**.

- The Lomographic Society publishes books for all the cameras it produces and sells. Their books are full of images, tips, and interviews with photographers and are available either separately or packaged with cameras. Titles include *Holga: The World through a Plastic Lens (2005)*; *Lomo LC-A Big Book (2009)*; *Don't Think Just Shoot (2002)*; *Through a Women's Lens—Selected Dianalogues Part 1 (2009)*; and *Diana+: True Tales and Short Stories (2007)*.

SELF-PUBLISHED COLLECTIONS
- **Krappy Kamera XI and XII** on **blurb.com**
- **Plastic Photo Show**—The Book by Georgina Campbell, **lulu.com** 2186974
- **Toy Cameras**: Culture and Celebration by Chelsea Klukas, **lulu.com** 4240987

MONOGRAPHS
Here is a selection of monographs featuring or including plastic camera photos. Many of these titles are out of print and hard to find; try Abebooks, **www.abe.com**, **www.alibris.com**, or **www.amazon. com**. Many, many books of images made with plastic cameras have been self-published and are available as print-on-demand on sites, including **www.blurb.com** and **www.lulu.com**.

PUBLISHED MONOGRAPHS AND SOLO EXHIBITION CATALOGS

- *Iowa*, Nancy Rexroth (Violet Press, 1977). Violet Press, distributed by Light Impressions of Rochester, NY, 1977. The first monograph done with a Diana. Rexroth explores the mental landscape she calls Iowa.

- *Faces*, Nancy Burson (Twin Palms Publishers, Santa Fe, NM, 1993). A collection of Diana images of children with a variety of diseases that affect the way they look.

- *Angels at the Arno*, photographs by Eric Lindbloom (David R. Godine, Boston, MA, 1994). A monograph of Lindbloom's Diana camera images of Florence, Italy.

- *36 Views of Mt. Fuji* (exhibition catalog), K. P. Knoll, with an essay by David Featherstone, (G.I.P., Tokyo, 1997). Knoll's interpretation of the classic woodcut series of Mt. Fuji images, shot with a Holga.

- *Beach*, Tim Hixson (Bangalley Press, Avalon Beach, Australia, 1998). A collection of beach photos made with four different plastic cameras.

- *End Time City*, Michael Ackerman (Scalo, Zurich–Berlin–New York, 1999). This stunning book of Benares, India, mixes Holga images with a variety of other formats.

- *Imagining Antarctica* (exhibition catalog), Sandy Sorlien (List Gallery, Swarthmore College, 2000). Sorlien's imaginings of what Antarctica would look like, if only she could get there. Holga images interspersed with emails from her brother, who did make it to Antarctica.

- *Fiction*, Michael Ackerman (Kehayoff Verlag, Munich, Germany, 2001). Another collection of Ackerman's work, including some Holga images and entire Holga contact sheets.

- *Seeing and Believing: The Art of Nancy Burson*, Nancy Burson (Twin Palms Publishers, Santa Fe, NM, 2002). Includes some of the *Faces* series, some follow-up images of the same children, and a later series, *Healers*, done with the Holga.

- *Mes Vacances avec Holga*, Frederic Lebain (Lomographic Society International, Vienna, Austria, 2002).

- *Nonfiction*, Christopher Anderson (de. MO, Millbrook, NY, 2004). An assortment of color Holga images in a specially designed box.

- *Fruit of the Orchard: Environmental Justice in East Texas*, Tammy Cromer-Campbell (University of North Texas Press, Denton, TX, 2006). A Holga documentary project about a town affected by industrial chemical pollution.

- *The Last Harvest: Truck Farmers in the Deep South*, Perry Dilbeck (University of Georgia Press, 2006). Dilbeck's Holga documentation of a disappearing way of life in the American south.

- *Chicago Neon Signs: Neighborhood and Downtown Landmarks through a Toy Camera*, Dan Zamudio (Wicker Park Press, 2008).

- *Amy Blakemore: Photographs 1988–2008*, Amy Blakemore (Museum of Fine Arts, Houston, 2009). Blakemore's Diana work is also included in *The 2006 Whitney Biennial Catalogue*.

SELF-PUBLISHED MONOGRAPHS

- *The Photographs of d. price*, self-published by Dan Price, originator of *SHOTS Magazine*. www.moonlightchronicles.com.

- *Broken Dreams*, Ray Carofano

- *Silent Nests—Pigeonniers of Northern France*, Vicki Topaz

With the explosion of on-demand self-publishing, it would be impossible to create a comprehensive list of current titles. Here are a few selections on Blurb.com (with their Blurb ID #):

- **Almost Perfect (377989) and Travels with a Toy Camera (378321)**, Lee Frost

- **Bayfield, Lake Superior—Stories of Beauty and Isolation**, Don Albrecht (391238)

- **Diana—Before Holga, There Was Diana**, Frank Lavelle (575779)

- **holga & diana in japan**, Akemi Ishikawa (997593)

Fruit of the Orchard | Environmental Justice in East Texas

Photographs by
Tammy Cromer-Campbell
Essays by
Phyllis Glazer
Roy Flukinger
Eugene Hargrove
& Marvin Legator

Tammy Cromer-Campbell's *Fruit of the Orchard*. Her Holga images are distinctive for their close-up compositions and internal black border.

On the magazine cover:

Light Leaks

Issue 6 — Low Fidelity Photography

ISSN 1911-429X

Exploring "Self" With Anne Arden McDonald

DIY: Light Writing and Holga Stereoids

Gallery: "Me, Photographer and Subject"

Showcase: Susan Bowen and Eirik Holmøyvik

Review: The Shurny and Benz Gant

Issue #6 Light Leaks Magazine.

- **The Japanese Haunting—A visual journey through Japan impressions,** Luca Lacche (481019)

- **Living in the Borderlands,** Katarina Agnes Fagering (770791)

- **Srebrenica,** Alessandro Ciccarelli and Danilo Palmisano (719847)

MAGAZINES

- **Light Leaks**—Low Fidelity Photography (**www.lightleaks.org**)

 The publication for anything about plastic cameras from the toycamera.com community. Full-color collections of images, tips, articles, interviews, and resources, including a full interview with Mr. T.M. Lee, inventor of the Holga, in issue #2.

- *SHOTS Magazine* (**www.shotsmag.com**)

A general photography magazine with high-quality black-and-white reproductions, along with interviews, including contributors Mary Ann Lynch (#60), Nancy Rexroth (#65), Mark Sink (#68 and #79), Gordon Stettinius (#70) and Anne Arden McDonald (#71). Edited by Russell Joslin since 2000. Previously edited by Robert Owen (Issues 47–68) and Daniel Price (Issues 1–46), who founded it in 1986 and published for many years from a tipi in Oregon.

- **Plastic Fantastic**

This magazine, dedicated to the art of toy camera photography, had a short life span (2005–2006). Just images—big, bold, and black and white.

PLASTIC CAMERA-RELATED ARTICLES

Here are selected articles of historical significance in the world of toy cameras. Since the first edition of this book, news and popular coverage of this realm and its photographers have ballooned, making it impossible, and unnecessary, to try to collect everything here. You know the drill: go online and Google.

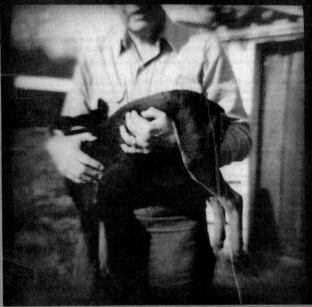

shots 53

Dad and Dusty Eddie Wexler

toy camera
work II

The second Toy Camera Work issue of *SHOTS Magazine*, from 1996.

- "$1 Toy Teaches Photography," *Popular Photography*, 1971, Elizabeth Truxell.
- Invitation to Photography I, *Popular Photography*, Spring 1977, "Diana: She takes the picture you do the rest," Don Cyr.
- Photography How-to Guide, *Popular Photography*, Fall 1977, "Visions of Diana—How to use a plastic camera as your window on the world," Don Cyr.
- *SHOTS Magazine*: Dedicated toy camera issues were "Toy Camera Work," Issue #12 (1988), "Toy Camera Work II," Issue #53 (1996), and "Toy Camera Work 2000," Issue #68 (2000).
- **"Alternate View"**: published by the Maine Photographic Workshops in 1997, this one-time newsletter had a wide variety of articles and images done with low-tech cameras.
- *SHOTS* #56, "Contemporary Vision with the Plastic Camera," an exhibition of photographs at PhotoCentral Gallery in Hayward, California, April 25–June 5, 1997, p. 44, by Peggy Sue Amison.
- **Camera Arts**, February/March 1999, pp. 40–46, "Soho Photo Gallery Krappy Kamera Competition," by Mary Ann Lynch and Sandra Carrion.

 These letters in *SHOTS Magazine* track the history of the Diana in the late 1960s:
- *SHOTS* #67, March 2000, *Letter from Arnold Gassan* and *Nancy Rexroth—Response to Arnold Gassan's letter to SHOTS Magazine.*
- *SHOTS* #68, June 2000, *Letter from William Messer*, pp. 44–45, and *Letter from Timothy Hearsum*, p. 47.
- Out of My Imagination: Interview with Mr. T.M. Lee, inventor of the Holga, by Tony Lim and Skorj, *Light Leaks Magazine*, Issue #2.
- Interview with Hideki Ohmori, founder of SuperHeadz, by Nic Nichols, on FourCornersDark.com, 2009.

A SELECTION OF OTHER PHOTOGRAPHERS WITH PLASTIC CAMERA PORTFOLIOS:

- Jonathan Bailey, "Summer Ice," www.jonathan-bailey.com

- Thom Bennett, "The Mythology of Mardi Gras," www.thombennettphotographs.com

- Meg Birnbaum, "Corn Dogs and Blue Ribbons," www.megbirnbaumphotography.com

- Ray Carofano, "Mohave," www.carofano.com

- Sandra Carrion, "Museum Studies," www.sandracarrion.com

- Tammy Cromer-Campbell, "Fruit of the Orchard," www.tccphoto.com

- Ann Cutting, www.cuttingphoto.com

- Heidi Kirkpatrick, "From My Window Seat" and "Iceland," www.heidikirkpatrick.com

- Christine Laptuta, www.christinelaptuta.com

- Isa Leshko, "Thrills and Chills," www.isaleshko.com

- Karen Marshall, www.karenmarshallphoto.com

- Carl Martin, "Men of Georgia," www.carlmartinart.com

- Annu Palakunnathu Matthew, "Memories of India," www.annumatthew.com

- Deon Reynolds, www.deonreynolds.com

- Kathy Smith, "In Plain View—Seattle," and "Savannah in Plain View," www.kathysmithphotos.com

- Aline Smithson, "Manzanar," www.alinesmithson.com

- John Stanmeyer, "Balinese Mystics," www.stanmeyer.com

- Gayle Stevens, "Pass," www.sgaylestevens.com

- Vicky Topaz, "Pastorale," and "Silent Nests," www.vickitopaz.com

- AnnMarie Tornabene, "A Self-Portrait Journey," **www.annmarietornabene.net**

- Tread, "Boy," **www.gotreadgo.com**

- Robert Vizzini, "Alcatraz," "Baseball," and "Cuba: A Land Baked in Time," **www.robertvizzini.com**

- Kai Yamada, **www.kaiphoto.com/diana**

TOY CAMERA EXHIBITIONS, PRESENT AND PAST

SELECTED ANNUAL EXHIBITIONS

- "Krappy Kamera® Competition," Soho Photo Gallery, New York, NY. Started in 1997 by Sandra Carrion and Mary Ann Lynch. **www.krappykamera.com**.

- "Plastic Camera Show," Obscurity Pictures, Australia. Obscurity Pictures hosts this show every year since 2002. **www.obscuritypictures.com**.

- "International Juried Plastic Camera Show," Rayko Photo, San Francisco. **www.raykophoto.com**.

2008 National Krappy Kamera® Competition • Soho Photo Gallery • New York
juror: Jill Enfield

EVI ABELER, MARTIN R. ANDERSON, BILL BARBER, **MICHELLE BATES**, SCOTT BEAVIN, MAY PERKINS BENTON, IAN BOOTH, MARA BROD, DOUG BUNDREN, RUSSELL BUSH, PAMELA J. BUTLER, CAROL BJERKE CHASE, GEMMA COMAS, **PAM CONNOLLY**, KATHLEEN M. DAILEY, TONY DeBONE, ADRIENNE DEFENDI, LAURA FARRELL, **BOB GERVAIS**, MONICA T. GOETZ, STEVE GRIFFIN, SHARON HARRIS, MARK C. HICKMAN, ROBIN RENEE HIX, ANITA KALINOWSKI, BRIDGET KANE, **MARKY KAUFFMANN**, GREGG D. KEMP, BOB KUBIAK, **SUSAN LIRAKIS**, CHRISTOPHER LUHAR-TRICE, NEHA LUHAR-TRICE, SUSAN MACEDO, ERIN MALONE, C. GARY MOYER, TOOTIE NIENOW, **J.E. PIPER**, SCOTT SANDLER, PAUL SHARRATT, NANCY SIESEL, SKIP SMITH, WILLIAM JOHN SMITH, SHANNON STONEY, ANN TEXTER, JOSEF TORNICK, **BILL VACCARO**, MEHRDAD VAGHEFI, EDDIE WEXLER, **BRENT WOOD**, JOYCE WOOLLEMS

place winners in bold

From more than 1000 entries, these images were chosen by Jill Enfield for the 2008 Krappy Kamera® Competition exhibition at Soho Photo Gallery.

- "Holgapalooza", **toycamera.com**.
- "Holga Show", Photo Media Center, online at **www.photomediacecnter.com**.

OTHER SELECTED EXHIBITIONS

- "Holga Works," International Center of Photography bookstore, New York, NY, 1994.
- "Reverse Technology," Benham Gallery, Seattle, WA, June, 1997.
- "The Camera Obscured," FotoCircle Gallery, Seattle, WA, 1997.
- "Plastic Fantastic," E3 Gallery, New York, NY, 1997.
- "Contemporary Vision with the Plastic Camera," PhotoCentral, Hayward, CA, 1997.
- "Toy Stories," Orange County Center for Contemporary Art, Santa Ana, CA, 1998.
- "About Toy Cameras," Caffe Al Teatro, Prato, Italy, July–August 2001.
- "City TTL," Caffe Al Teatro, Prato, Italy, July 2003.
- "The Prospect of Light," The University of Maine Museum of Art, Bangor, ME, 2004.
- "Holga Inspire," organized by Holga Limited, makers of the Holga, this group exhibition showed in Bangkok, Thailand; at TCC Photo Gallery in Longview, TX; Umbrella Arts in New York; and the Hallmark Institute of Photography in Turners Falls, MA, in 2009 and 2010.

Group toy camera exhibitions have become very popular around the world. Show titles, and the gallery names, run the gamut from clever or light-hearted to ironic or punny. Here are just a few gems:

"Curious Camera," "Toyland," "Cheap Shots," "Toy Joy," "Toy Stories," "Toy Polloy," "Camera Obscura: Click the Light Fantastic," "Low Fidelity," "Crap Shoot," "Plastic Fantastic," and "Unrefined Light".

◻ CONTRIBUTORS

Michael Ackerman	www.agencevu.com
Thomas Michael Alleman	www.sunshineandnoir.com
Erin Antognoli	www.erinantognoli.com
Jonathan Bailey	www.jonathan-bailey.com
James Balog	www.jamesbalog.com
Michelle Bates	www.michellebates.net
Phil Bebbington	www.philbebbington.com
Gyorgy Beck	www.gyorgybeck.net
Susan Bowen	www.susanbowenphoto.com
Laura Corley Burlton	www.lauraburlton.com
David Burnett	www.davidburnett.com
Nancy Burson	www.nancyburson.com
Perry Dilbeck	www.perrydilbeck.com
Annette Elizabeth Fournet	www.hometown.aol.com/radosti
Jill Enfield	www.jillenfield.com
fotovitamina	www.fotovitamina.com
Brigitte Grignet	www.brigittegrignet.com
Eric Havelock-Bailie	www.erichavelockbailie.com
Christopher James	www.christopherjames-studio.com
Michael Kenna	www.michaelkenna.com
Wesley Kennedy	
Teru Kuwayama	www.terukuwayama.com
Louviere & Vanessa	www.louviereandvanessa.com
Mary Ann Lynch	www.maryannlynch.com
Anne Arden McDonald	www.AnneArdenMcDonald.com

Ted Orland	www.tedorland.com
Sylvia Plachy	www.sylviaplachy.com
Dan Price	www.moonlightchronicles.com
Becky Ramotowski	www.astrobeck.com
Nancy Rexroth	rexnex@cinci.rr.com; www.weinstein-gallery.com
Francisco Mata Rosas	www.franciscomata.com.mx
Richard Ross	www.richardross.net
Franco Salmoiraghi	francohawaii@yahoo.com
Rosanna Salonia	www.rosannasalonia.com
Jennifer Shaw	www.jennifershaw.net
Nancy Siesel	www.nancysiesel.com
Mark Sink	www.gallerysink.com
Kurt Smith	www.kurtsmithphotography.com
Sandy Sorlien	www.sandysorlien.com
Pauline St. Denis	www.paulinestdenis.com
Harvey Stein	www.harveysteinphoto.com
Gordon Stettinius	www.eyecaramba.com
Ryan Synovec	www.aspectraphotography.com
Rebecca Tolk	www.rebeccatolkphotography.com
Marydorsey Wanless	www.marydorseywanless.com
Shannon Welles	www.shannonwelles.com
Matthew Yates	www.matthewyatesphotography.com
Dan Zamudio	www.danzamudio.com

index

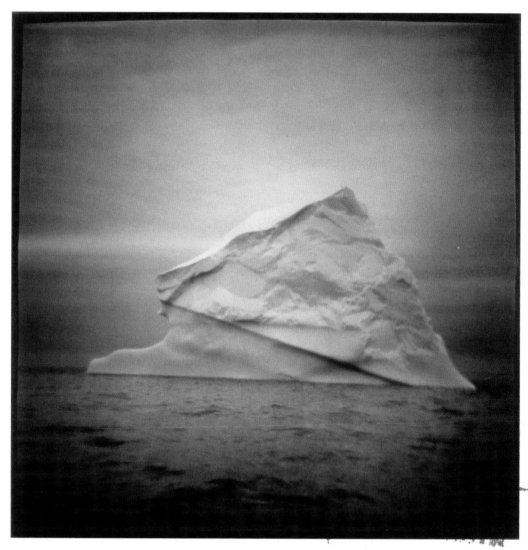

Iceberg #13, © Jonathan Bailey, 2004, Bonavista, Newfoundland. Gold-toned Diana print.